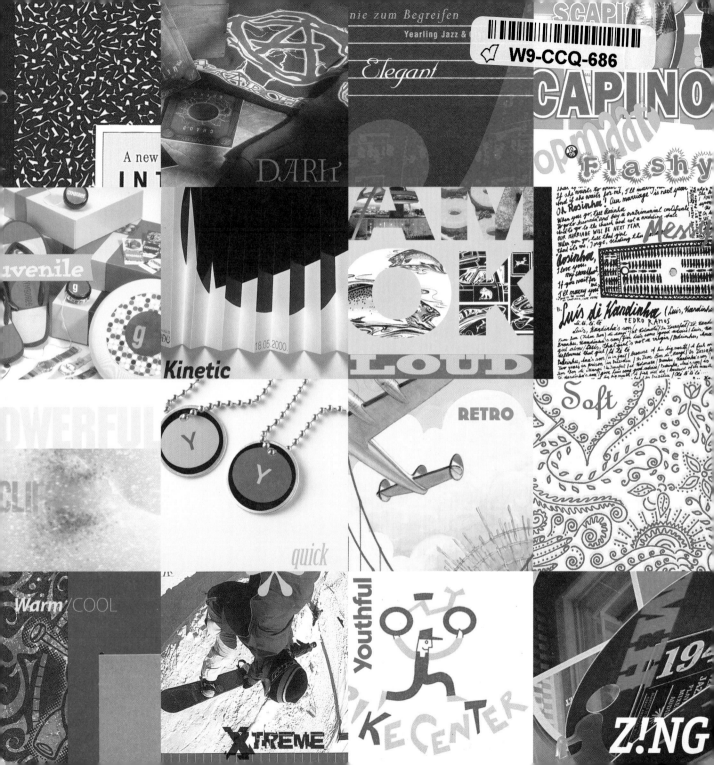

A PICTURE IS WORTH A THOUSAND WORDS...

graphically SPEAKING

A VISUAL LEXICON FOR ACHIEVING
BETTER DESIGNER–CLIENT COMMUNICATION

LISA BUCHANAN

HOW
DESIGN BOOKS
CINCINNATI, OH
WWW.HOWDESIGN.COM

07 06 05 04 03 5 4 3 2 1

Library of Congress Cataloging-in-Publication Data

Buchanan, Lisa.
 Graphically speaking: a visual lexicon for achieving better designer–client communication / Lisa Buchanan.
 p. cm.
ISBN 1-58180-291-9 (pob : alk. paper)
 1. Computer graphics. 2. Design services. I. Title.

T385 .B818 2002
741.6--dc21

2002069069

Editor: Amy Schell
Editorial Assistance: Clare Warmke
Designer: Lisa Buchanan
Production Coordinator: Kristen Heller
Photographers: Al Parrish, F&W Publications & Brian Steege, Guildhaus Photographics for interior shots; Tim Grondin, F&W Publications for cover shot; Teri Buchanan for author shot
The credits on page 240 constitute an extension of this copyright page.

ABOUT THE AUTHOR

Before becoming the art director for HOW Design Books, Lisa Buchanan worked with clients on a freelance basis designing logos, brochures, Web sites, and identity systems—all the while developing her insights into the client–designer relationship. Since arriving at F&W, she has earned an Art Director's Award for the cover of *Creative Edge: Brochures*. Some of her recent book designs include *Powerful Page Design, Designer's Survival Manual, Designing Web Sites for Every Audience, Idea Revolution*, and *The Pocket Muse*. To contact Lisa, email her at lisa@graphicallyspeaking.us.

DEDICATION

I attribute all my blessings to Jesus Christ
and it is to Him that I dedicate this book.

ACKNOWLEDGMENTS

I'd like to thank my family and friends who supported me while I worked on
this project, especially my mother and father, Teri and Terry Buchanan; my sister
Kelly Shields, her husband Jason, and their children Faith and Grant; and my
friends Missy McWhorter, Mark Stroessler, and Leah Woltmann. I'm so lucky to
have them and their endless support in my life.

I'd also like to acknowledge Peg Faimon, whose instruction and influence in my
life has been so significant. I would like to thank Clare Warmke—who believed
in this book from the beginning—and Amy Schell for their tireless efforts to
keep me sane during this project. I am grateful to Clare Finney, Richard Hunt and
David Lewis for giving me this amazing opportunity, and to all the contributors
featured in this book for their wonderful insights throughout its creation.

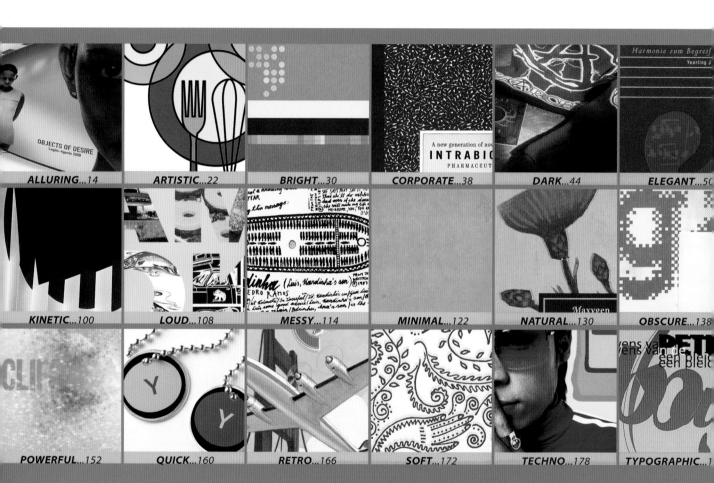

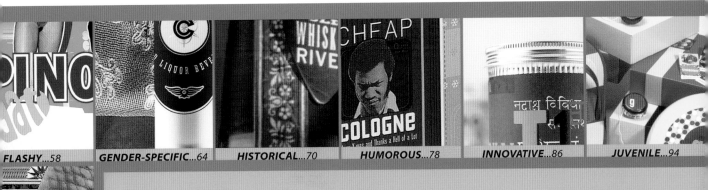

TABLE OF CONTENTS

SAY IT... SO THEY SEE IT

►►►►►► "FROM THE FIRST TIME OUR GROUP MEETS WITH A CLIENT, WE BEGIN BUILDING A SIMILAR VOCABULARY. THIS MEANS DEFINING TERMS SPECIFIC TO DESIGN, AS WELL AS WORDS ASSOCIATED WITH THE CUSTOMER'S INDUSTRY. BY ACTIVELY SEEKING TO BETTER UNDERSTAND EACH OTHER, EVENTUALLY YOU WILL SPEAK A SIMILAR LANGUAGE. AND WHEN YOU COMMUNICATE COMFORTABLY, YOUR CLIENTS ARE MORE WILLING TO TAKE CREATIVE RISKS AND IT BECOMES EASIER TO SELL YOUR IDEAS."

—CHRISTOPHER GORZ

INTRODUCTION

Yes, we all can relate to it. It occurs too frequently. It leaves us confused, angry, and often mentally and creatively exhausted. We waste too much of our time, money, and creativity on it. We set up meetings, attend conferences, and pay for classes to try to improve it. We continue to write page after page of company procedures and policies to try to make it easier. After all this hard work...why can't we improve communication with our clients and get it right the first time? Simple...because we're just not speaking the same language.

Graphic designers and their clients historically do not communicate in the same way. This difference in communication styles comes from numerous factors. Different career choices are the obvious results of varying backgrounds, personalities and lifestyles.

We are all well aware of the client's stereotype of graphic designers.

They awaken from their nightly three-hour nap, glancing in the mirror to make sure their hair is messy enough to be seen in public. Then they are faced with their exhausting wardrobe decision: gray or black? Sprinting out the door with the usual half gallon of coffee, they grab their fashionably trendy 1950s eyeglasses, and head straight to Starbucks, knowing a second buzz will be necessary before hitting the office.

Once at work, their day usually consists of working alone at their computer—usually in a small cubicle—with an occasional meeting or proposal to break up the day. If the company or firm they are working for is a little more liberal, they may be seen breaking up their computer time with periodic games of foosball or ping pong. The goal, of course, is to release that creative block they are struggling with.

Typically extreme workaholics, these designers may still be found laughing, as they are most often the masterminds behind office pranks.

On the other hand, the average client that these creative designers work for could be considered a polar opposite. A typical day for the client starts by waking up rested and having a well-balanced breakfast. Their appearance is well-groomed in their conservative black or navy-blue business suit. After checking the stocks and skimming the headlines for world events, they grab their morning coffee and are on their way to work in the Porsche.

At work, they sit behind a large desk and can be found discussing the "bottom line" or be heard informing each other what the "sales reports show." They are rational, analytical and logical thinkers and communicators, focused on the cold hard facts.

When these two personalities mesh in the union of the designer-client relationship, problems often arise. We all can relate to the typical first meeting in which a client starts off explaining the cold hard facts about their company, what they stand for and the proposed project outline. After that, the designer, focused on making sure the client understands what a designer's role is, starts off with their speech about what design is, what *they* do differently from all the *other* firms, and how they like to work with clients. The client may be responsive to these points, but usually is in unfamiliar territory.

Once discussion starts about the actual project—say for instance it's for a logo design—the client might ask the designer to make their new logo "innovative" yet "corporate." They want it to project the feeling to their customers that they stand for growth and are the most experienced and knowledgeable company out there. The designer latches on to a key word, "innovative," and immediately starts brainstorming creative new ways to render the company logo.

Then the inevitable occurs. At the second meeting, the designer's logo sketches look nothing like what the client thinks they asked for, and both are left frustrated and confused. Why the difference in ideas? Why the miscommunication leading to a loss of time, money and creativity? It boils down to the difference between how a right-brained person, the typical designer, and the left-brained person,

the typical client, think and communicate their thoughts.

The right side of our brain is used in developing creative concepts. It's where we combine information we receive into new ideas. It's the nonconformist side that's persistent, curious and independent. It's observant and humorous. Often it uses imagery rather than words to process ideas. People that are dominant right-brain thinkers may have a good memory, often prefer to work alone, and can be very original and sensitive. They frequently ask themselves why things are the way they are, and how they can change them to make them better. They pursue new experiences with relentless enthusiasm.

The left side of our brain is where we process cold hard facts. This side is very logical, where 2 + 2 always equals 4. The left brain is extremely rational and analytical. The people that are dominant left-brain thinkers are usually organized and may not be considered overly spontaneous or emotional. They may find comfort in routine, and are focused on results. It's these differences that often muddy the waters of communication between the two types of people.

Clients should be aware that in order for designers to do their best they need to be provided with an atmosphere where there is a willing suspension of judgment and an openness to experience the new and unknown. Often people who are dominant left-brain thinkers (the typical client) may create an atmosphere of judgment, tight control, and unnecessary pressure that constricts and constrains the creativity that could be released. They can emit a sense of anxiety or overriding doubt, because they may be worried about how this new design will represent or impact their business.

Likewise, to clients, designers may seem to place too much importance on "thinking outside the box," rather than communicating that the client's need is most important. Their passion can be misinterpreted as the driving force for the project, rather than the need defined by the client. They might appear elite and unapproachable, and their language about the principles of design, foreign.

There will always be these two conflicting types of people in the designer–client relationship. The key to success is to learn how to deal with these differences in communication. One typically effective tool can be the use of a survey to better understand the needs of the client and the desired outcome for the project. The following is a questionnaire derived from over fifty different design firms' responses to the question, "What questions do you typically discuss with a client?"

SURVEY

1. Define the problem.
2. What is your budget?
3. Who is your target audience? Define and characterize them as clearly as possible.
4. What is your company's mission and short-term and long-term marketing strategies?
5. What is the market opportunity?
6. Who is the ultimate decision-maker? What is the internal approval process of this design project?
7. What is the key message that you want to communicate to the viewer? (in three sentences or less).
8. What response or call-to-action is needed?
9. How do you define success for this project?
10. What is your time frame?
11. What are people's current opinions of the company/product? What are its strengths and weaknesses?
12. Who is your competition? Do you need to work with them or in opposition to them?
13. Can you reference any previous successful design solutions or campaigns?
14. Is there a particular approach you would like the designer to explore and why?
15. If you could say only one word about your product or service, what would that be?
16. What differentiates you from your competition? What are some key selling points?
17. What do you not want? Why?
18. Do you have available market research?
19. Are there any mandatory requirements for this project that we need to know?
20. What is the life expectancy of this project? How long is it expected to be effective?
21. Why did you choose our firm? How did you hear about us?

Unfortunately, the client's answers to these questions will help only so much between a visual and non-visual person. What is needed is a tool for both the designer and client to look at in order to develop a shared language. When discussing market strategies or the intended mood of the piece, in order to be absolutely sure that you are both speaking clearly, a visual representation is needed.

The tired cliché turns out, in fact, to be quite true: "A picture is worth a thousand words." Designer Tiffany Larson says, "I usually ask a client to describe a 'feeling' they want their specific piece to have. Then we discuss the elements that might be designed in the piece to help deliver this 'feeling'. If possible, I ask the client to show me an example that illustrates what they are thinking—this helps close the gaps between what is desired, the words that are used to describe it, and what is designed."

Graphically Speaking is intended to be that resource tool for you to develop the desired communication between designer and client. Contained in this book are over thirty words heard most often at that first client–designer meeting. Many words are thrown around, but most of the time both the designer and the client are unsure what the other really means.

The benefit of this book is that you can flip to the section most similar to the words the client is using and both of you can browse the color schemes, fonts, and various designs. Of course, this book is meant to educate, not be a mix-and-match recipe book for the client; it should merely provide a common ground for the designer and the client.

If a client is using a word not listed in the table of contents, try the word bank located in the back of the book. You'll likely find a similar section to direct them to. Each chapter also contains the definition of the particular style and a piece of communication advice from a top designer. In addition, thought-provoking questions are given to help clarify what the client really wants. This way the designer can interpret the needs and wants of the client, or show them that what they want isn't necessarily in line with what they need.

This book was made to triple as a client communication guide, a designer reference, and an inspiring collection of various styles of designs. My hope is that *Graphically Speaking* will be a time-saver and a money-saver for designers, so that less of their day is spent with the client trying to work out communication differences, and more of it is spent creating new ideas, thoughts, and designs.

Balmoral
ABCDEFGHIJKLM
NOPQRSTUVWXYZ
abcdefghijklmnopqrstuvwxyz 1234567890

OPTI Announcement
ABCDEFGHIJKLMNOPQRSTUVWXYZ
abcdefghijklmnopqrstuvwxyz
1234567890

Hoefler Text
ABCDEFGHIJKLM
NOPQRSTUVWXYZ
abcdefghijklmnopqrstuvwxyz
1234567890

Snell
ABCDEFGHIJKLMN
OPQRSTUVWXYZ
abcdefghijklmnopqrstuvwxyz
1234567890

Carolina
ABCDEFGHIJKLMN
OPQRSTUVWXYZ
abcdefghijklmn
opqrstuvwxyz
1234567890

Fine Hand
ABCDEFGHIJKLM
NOPQRSTUVWXYZ
abcdefghijklmn
opqrstuvwxyz
1234567890

C0 M69 Y100 K30
C0 M0 Y0 K100
C27 M9 Y0 K0

C31 M51 Y68 K31
C83 M0 Y30 K56
C34 M0 Y0 K38

C0 M51 Y87 K0
C38 M0 Y15 K0
C0 M0 Y0 K100

C0 M91 Y72 K23
C0 M27 Y43 K76
C34 M0 Y0 K38

C0 M100 Y43 K18
C0 M91 Y34 K38
C79 M100 Y0 K6

C51 M65 Y30 K0
C47 M34 Y0 K0
C25 M15 Y6 K0

C76 M0 Y60 K69
C0 M16 Y55 K27
C34 M0 Y23 K9

C79 M100 Y0 K6
C30 M23 Y0 K0
C0 M0 Y0 K100

Alluring

Design that is classified as alluring often has a type of unexplained magnetism. You can't keep your eyes off it, and you want whatever it's selling. Many alluring designs sell products that claim they have a way to better your life (you be the judge.)

"If you can get the client to clearly articulate what their communication goals and design objectives are—in other words, define the problem—the designer's job is half done. Now we just need to bring the solution to life so the client can see it."
—Michael Osborne

Definition ✵

alluring (adj.)
1. To be highly, often subtly attractive
2. Enticing
3. Attractive because of something desirable

Questions for Client ✵

➤ What are you trying to sell?
➤ What is the hierarchy of importance in your content? What do you want the audience to see first, second, and third?
➤ What is the age range of your audience? Are they male or female?

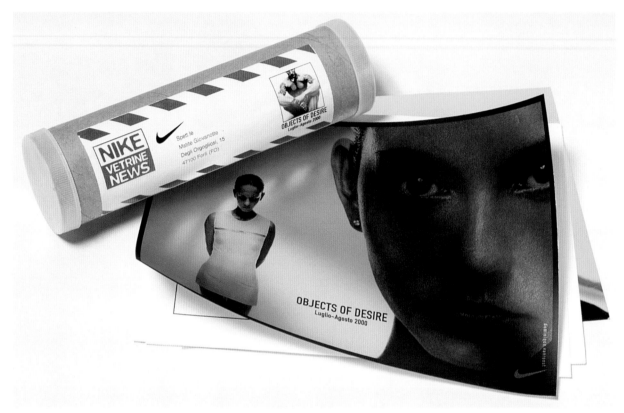

(left)
NAME OF PIECE: Octopus Garden logo
STUDIO NAME: Emma Wilson Design Company
DESIGNER: Emma Wilson
CLIENT: Self promotion
SPECIAL TECHNIQUES: "I needed typography that could swim and you just can't buy that. I started with a sketchbook and tried to emulate the flow of the swimming motion of the octopus's tentacles," says Wilson. She then scanned and refined it in FreeHand.

We would sing and dance around/because we know we can't be found/I'd like to be under the sea/in an octopus's garden in the shade.

—Octopus's Garden, the Beatles

"As a designer, you find your inspiration from many sources. I love the Beatles and have had this song buzzing around in my head forever!" reveals Emma Wilson.

(above)
NAME OF PIECE: Nike Vetrine News: "Objects of Desire" July/August 2001
STUDIO NAME: Matite Giovanotte
DESIGNER: Giovanni Pizzigati
CLIENT: Nike Italy
SPECIAL FEATURES: Tube packaging and silver polyester cover

Giovanni Pizzigati explains that the concept for this piece was based on the already existing Nike campaign, "Objects of Desire." The captivating close-up of the woman is effective in drawing the audience in to take a second look.

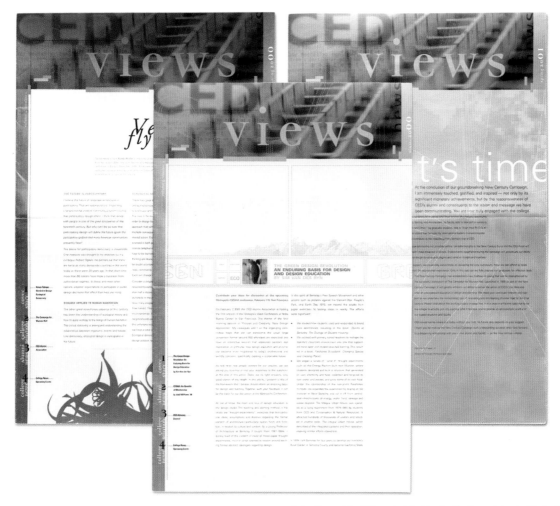

NAME OF PIECE: CED "Views" newsletter series
STUDIO NAME: Chen Design Associates
ART DIRECTOR: Joshua C. Chen
DESIGNERS: Spring 2000, Justin Thomas Coyne; Winter 2000, Max Spector; Spring 2001, Leon Yu
ILLUSTRATORS: Spring 2000, Justin Thomas Coyne; Winter 2000, Sim Van Der Ryn
CLIENT: College of Environmental Design, University of California, Berkeley

Joshua Chen explains, "CDA conceived the design for this tri-annual alumni publication to reflect the school's forward-thinking approach to environmental design issues. The dean particularly wanted to create a newsletter that would be a forum for varying—even controversial—perspectives and voices on the college campus. He also wanted to incorporate a sense of the internet and the future of environmental design. We began with a photo of their well-known building and used it in an untraditional way. We changed its orientation, then created a dynamic collage of words, lines and mosaic patterns that are used throughout the four tabloid pages. The use of a cool metallic ink lent itself to the progressive ideas to be published."

CLAUDIA DI LORETO
TRADUZIONI

CLAUDIA DI LORETO
TRADUZIONI

VIA G. FERRARI 21 · 02 100 RIETI
TEL. E FAX +390746496 147
CELL. +39 335 656 97 17
P. IVA. 00737690578
E-MAIL: CDILORETO@LIBERO.IT
WWW. CLAUDIADILORETO.IT

CLAUDIA DI LORETO
TRADUZIONI

VIA G. FERRARI 21
02 100 RIETI

VIA G. FERRARI 21 · 02 100 RIETI · TEL. E FAX +390746496 147 · P. IVA 00737690578
E-MAIL: CDILORETO@LIBERO.IT · WWW.CLAUDIADILORETO.IT

(left)
NAME OF PIECE: Traduzioni identity system
STUDIO NAME: CAPDESIGN
DESIGNER: Carlo Alberto Perretti
CLIENT: Claudia Di Loreto
CLIENT'S SERVICE: English translation

"I wanted to show that the client works very hard, night and day, and I imagined a woman, a moon, and a cat. She is translating from the leaf under her left hand to the writing on her right," explains Carlo Alberto Perreti.

(below)
NAME OF PIECE: Disney's Beach Club
 Resort® logo
STUDIO NAME: Disney Design Group
ART DIRECTOR: Bob Holden
DESIGNERS: Ryan Lorei, Thomas Scott
CLIENT: Disney's Beach Club Resort

"The inspiration for this piece was the Northeastern–New England style theming of this Walt Disney World Resort. The lighthouse, a focal point of the resort, was used to convey the image of the property," explains Ryan Lorei. Image © Disney.

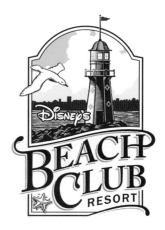

NAME OF PIECE: Pat Metheny Group CD
STUDIO NAME: Sagmeister Inc.
ART DIRECTOR: Stefan Sagmeister
DESIGNERS: Stefan Sagmeister, Hjalti Karlsson
PHOTOGRAPHER: Tom Schierlitz, stock
CLIENT: Warner Jazz

"All the type on the Imaginary Day *cover for the Pat Metheny Group,"* explains Stefan Sagmeister, *"has been replaced by code. The images connect to the songs and mood of the album and can be decoded by using the diagram printed onto the CD itself."* This code intrigues viewers and invites them to become more involved by decoding the hidden messages.

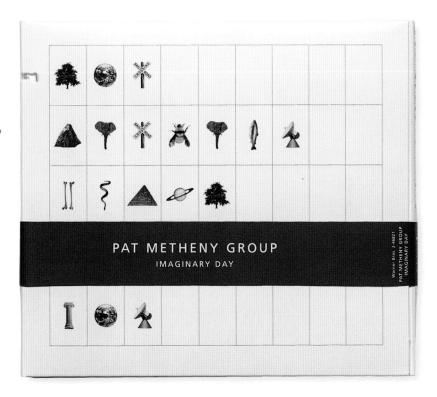

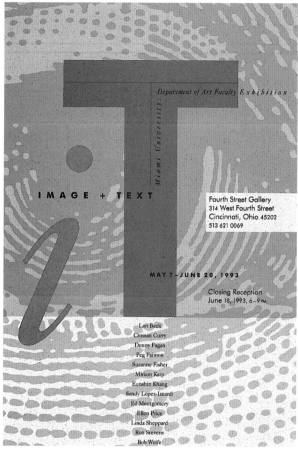

NAME OF PIECE: Image + Text exhibition poster
STUDIO NAME: Peg Faimon Design
DESIGNER: Peg Faimon
CLIENT: Miami University Department of Art

"I needed an image which was universal among art disciplines," says Peg Faimon. "I used the eye, which is commonly associated with art, in a unique way by incorporating texture and dramatic cropping to abstract the image. I also highlighted the name of the exhibition through the use of the typographic elements."

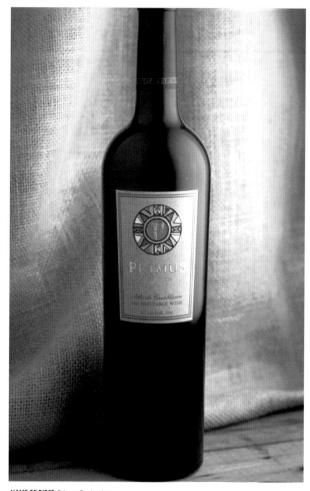

NAME OF PIECE: Primus Packaging
STUDIO NAME: MOD/Michael Osborne Design
ART DIRECTOR: Michael Osborne
DESIGNER: Nicole Lembi
CLIENT: Franciscan Estates
SPECIAL PRODUCTION TECHNIQUE: The craft background texture was matched and printed on white pressure-sensitive paper and the medallion line art was foil-stamped and embossed.

Michael Osborne explains that the inspiration for this piece comes from "ancient Chilean Mapuche Indian art and its color palette." The use of the gold foil stamping with rich warm tones is unique and inviting to the viewer.

NAME OF PIECE: ACT Theatre environmental graphics
STUDIO NAME: Michael Courtney Design
ART DIRECTOR: Michael Courtney
DESIGNERS: Michael Courtney, Michelle Rieb
CLIENT: ACT Theatre
CLIENT'S PRODUCT/SERVICE: Live theater

Describing the source of his inspiration, Michael Courtney explains that "generations of Seattlites attended performances at this well-loved, historic theater. With the ghosts of entertainers from 1940s big bands to Jimi Hendrix looking over our shoulder, we designed lively environmental graphics for the new theaters and public areas." The bold use of line, pattern and color make this environmental design both exciting and entertaining.

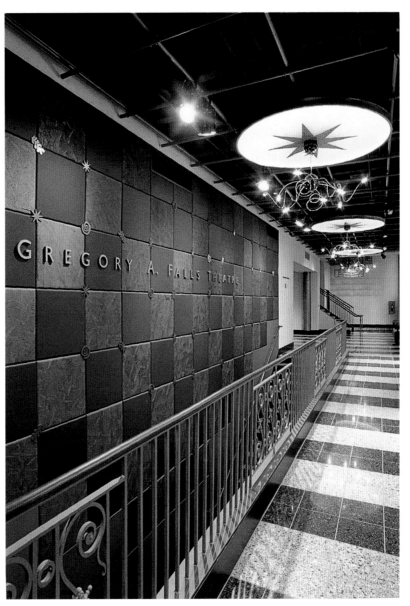

Monet
ABCDEFGHIJKLM
NOPQRSTUVWXYZ
abcdefghijklmnopqrstuvwxyz
1234567890

Ovidius
ABCDEFGHIJKLM
NOPQRSTUVWXYZ
abcdefghijklmnopqrstuvwxyz
1234567890

Pablo
ABCDEFGHIJKLM
NOPQRSTUVWXYZ
abcdefghijklmnopqrstuvwxyz
1234567890

Pepita
ABCDEFGHIJKLMN
OPQRSTUVWXYZ
abcdefghijklmnopqrstuvwxyz
1234567890

Spring
ABCDEFGHIJKLMN
OPQRSTUVWXYZ
abcdefghijklmnopqrstuvwxyz
1234567890

Sonata

C100 M85 Y35 K0
C10 M40 Y100 K0
C15 M75 Y100 K0

C20 M75 Y75 K15
C0 M0 Y0 K100
C0 M3 Y30 K0

C0 M94 Y94 K6
C76 M65 Y94 K0
C0 M15 Y76 K0

C0 M0 Y0 K100
C0 M30 Y83 K0
C0 M9 Y65 K0

C0 M6 Y38 K18
C76 M65 Y94 K0
C0 M94 Y94 K6

C9 M62 Y78 K22
C0 M0 Y30 K18
C0 M0 Y0 K100

C55 M35 Y25 K10
C20 M30 Y40 K0
C20 M70 Y75 K0

C85 M35 Y0 K14
C15 M9 Y8 K15
C11 M15 Y33 K6

SYNONYMS | *aesthetic, creative, cultured, fine, harmonious, imaginative, refined*

SIMILAR SECTIONS | *alluring, elegant, messy, ornate*

ARTISTIC

Art, by definition, is anything that is aesthetically pleasing. As you can imagine, this covers a wide range of materials that can be used for inspiration, including paintings, sculptures, music, drama, dance—nothing is excluded. A famous painter or a particular piece may even provide inspiration. A word of advice: while the audience drawn to artistic design is often educated and refined, this is not always the case.

> *"There is additional challenge in creating design for projects that begin with existing artistic visions. After discussing the practical requirements of the project, I often ask the client what their vision of the project is. I write down all descriptions and adjectives that they have in mind, then select a few of their ideas and ask for further description."*
> —Janine Vangool

DEFINITION

artistic (adj.)
1. Relating to or characteristic of art or artists
2. Satisfying aesthetic standards and sensibilities
3. Aesthetically pleasing

QUESTIONS FOR CLIENT

➤ Does a certain artist, technique or work particularly fit the image you want to portray? Bring options.

➤ Is there a medium that best suits the project? Playful pen and ink? Rich oil paintings? Modern lithographs?

➤ What special techniques would complement the artistic style of the piece?

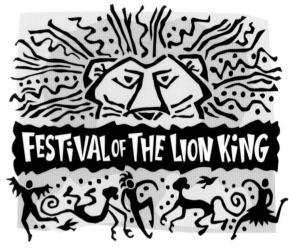

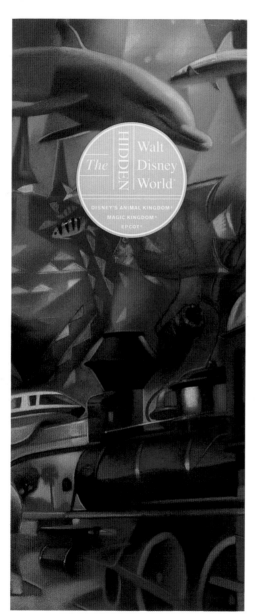

(above)
NAME OF PIECE: Festival of the Lion King
STUDIO NAME: Disney Design Group
DESIGNER: Natalie L. Bert
CLIENT: Disney's Animal Kingdom®

The bright colors and the fluid motion of the illustrated figures all lend themselves to a distinctly artistic interpretation of this show." Image © Disney.

(left)
NAME OF PIECE: The Hidden Walt Disney World
STUDIO NAME: Disney Design Group
ART DIRECTOR: Bob Holden
DESIGNER: Ryan Lorei
ILLUSTRATOR: Larry Moore
CLIENT: Disney Tours®
CLIENT'S SERVICE: Behind-the-scenes and special
 in-depth tours of Walt Disney World Parks

"I feel that the bright, intense cover illustration and hints of color used throughout the piece convey the richness of Disney heritage that can be seen through these tours," says Ryan Lorei. Image © Disney.

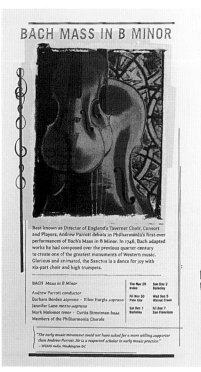

BACH MASS IN B MINOR

Best known as Director of England's Taverner Choir, Consort and Players, Andrew Parrott debuts in Philharmonia's first-ever performances of Bach's Mass in B Minor. In 1748, Bach adapted works he had composed over the previous quarter-century to create one of the greatest monuments of Western music. Glorious and animated, the Sanctus is a dance for joy with six-part choir and high trumpets.

BACH *Mass in B Minor*		
Andrew Parrott conductor	Thu Nov 29 Irvine	Sun Dec 2 Berkeley
Barbara Borden *soprano* · Ellen Hargis *soprano*	Fri Nov 30 Palo Alto	Wed Dec 5 Walnut Creek
Jennifer Lane *mezzo-soprano*	Sat Dec 1 Berkeley	Fri Dec 7 San Francisco
Mark Molomot *tenor* · Curtis Streetman *bass*		
Members of the Philharmonia Chorale		

"The early music movement could not have asked for a more willing supporter than Andrew Parrott. He is a respected scholar in early music practice."
— WGMS radio, Washington DC

"Eduardo López Banzo was the man of the hour …for conducting a performance – fiery, witty, affectionate – that one can't imagine being improved upon." – The Boston Globe

"Hardly ever is a voyage of discovery this much fun." – The Boston Globe

MODERN-DAY PREMIERE
¡VIVA ZARZUELA!

ANTONIO LITERES *Júpiter y Semele*

Eduardo López Banzo conductor	Sat Feb 9 Berkeley	Fri Feb 15 San Francisco
Marta Almajano *soprano*		
Lola Casariego *soprano*	Sun Feb 10 Berkeley	Sat Feb 16 Palo Alto
Mimi Ruiz *soprano*		

A rich and rhythmic music-theater art form, *zarzuela* came to life in 1650s Spain. Named after the King's hunting lodge set in a countryside thick with *zarzas* or brambles, this Baroque entertainment offers a clever, juicy story combined with music of extraordinary diversity. Spanish-born López Banzo is a champion of rediscovering these early works. "Complex rhythms recreate this atmosphere," says Banzo. "It is absolutely different from the rhythms of Italian, French and German music."

NAME OF PIECE: Philharmonia Baroque Orchestra season brochure
STUDIO NAME: Chen Design Associates
NAME OF PIECE: Philharmonia Baroque Orchestra season brochure
ART DIRECTORS: Joshua C. Chen, Kathryn A. Hoffman
PHOTOGRAPHER: Vincent Atos
CLIENT: Philharmonia Baroque Orchestra
SPECIAL PRODUCTION TECHNIQUES: CDA used register stamping on the cover to simulate letterpress quality and to enhance the tactile nature of the cover.

When designing this piece, the goal was to "visually connect to the unique historical authenticity that Philharmonia offers in their performances, which makes them stand apart from other orchestras," explains Joshua Chen. "We used bold typography and musical design elements to give tension to the classic imagery we styled in order to provide a contemporary feel. Our objectives were to speak to new audiences while retaining their many loyal subscribers, and to convey that Philharmonia is bringing the best of their tradition strong into the 21st century."

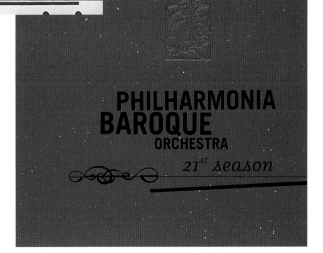

PHILHARMONIA BAROQUE ORCHESTRA
21ˢᵗ season

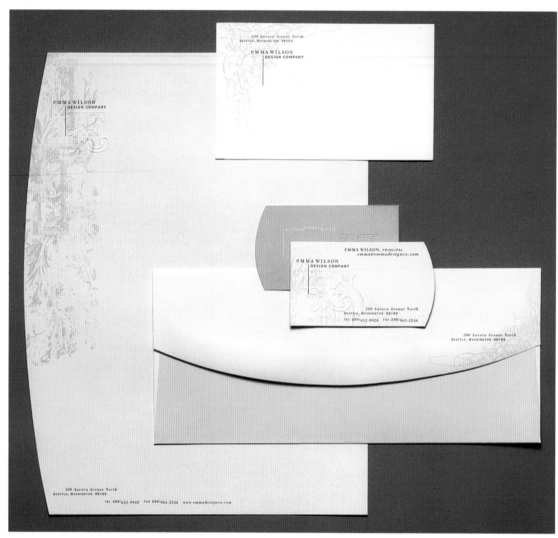

NAME OF PIECE: Emma Wilson Design Company stationery
STUDIO NAME: Emma Wilson Design Company
DESIGNER: Emma Wilson
SPECIAL PRODUCTION TECHNIQUES: Embossing and a special curved die cut for each piece (even the mailing label!)

This stationery system is "a little bit country and a little bit rock-n-roll," says designer Emma Wilson. "I wanted to paint with graphic by-product (borders and calligraphic swirls). The typography represents the classy, clean side of the firm, while the graphic by-product represents the down-and-dirty craft portion of our process. The lower case e in Emma Wilson Design Company expresses appropriate whimsy. The emboss is subtle and elegant. The die-cut curve is consistent on each piece and makes us more approachable."

The goal, explains Joshua Chen, was to showcase "the song-writing and singing talents of local independent artist Staci Frenes. We wanted to develop a look and feel for her that would pick up on the Bay Area urban vibe, which informs her acoustic-rock, textural, original and accessible music. This is a songwriter who knows that performance is connection with people, and connection with people means having something compelling to say."

"I was given the challenge to create a logo that would portray the event and also represent the venue where the event was to be held: Walt Disney World® Resort," explains Joe Andrews. "After sketching some ideas, I settled on the silhouette of Mickey Mouse's head and cooking- and serving-ware for the visuals. I then combined them so that the utensils and pans abstractly hinted at Mickey's silhouette in a stained-glass-like design." The result: a very artistic interpretation that is reminiscent of a Mondrian painting. Image @ Disney.

STACI FRENES EVEN IN A NOISY WORLD, THE RIGHT VOICE COMPELS YOU TO LISTEN.

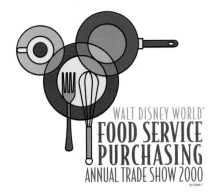

WALT DISNEY WORLD®
FOOD SERVICE
PURCHASING
ANNUAL TRADE SHOW 2000
© DISNEY

ARTISTIC

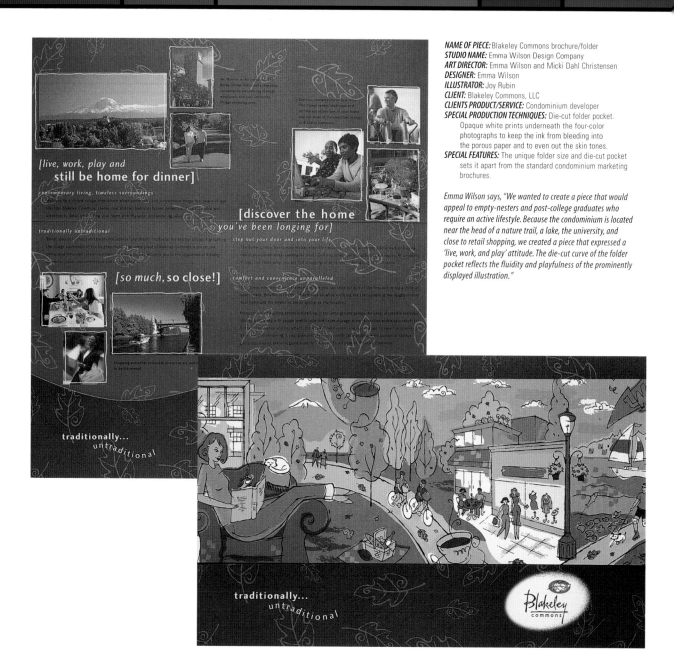

NAME OF PIECE: Blakeley Commons brochure/folder
STUDIO NAME: Emma Wilson Design Company
ART DIRECTOR: Emma Wilson and Micki Dahl Christensen
DESIGNER: Emma Wilson
ILLUSTRATOR: Joy Rubin
CLIENT: Blakeley Commons, LLC
CLIENTS PRODUCT/SERVICE: Condominium developer
SPECIAL PRODUCTION TECHNIQUES: Die-cut folder pocket.
Opaque white prints underneath the four-color
photographs to keep the ink from bleeding into
the porous paper and to even out the skin tones.
SPECIAL FEATURES: The unique folder size and die-cut pocket
sets it apart from the standard condominium marketing
brochures.

*Emma Wilson says, "We wanted to create a piece that would
appeal to empty-nesters and post-college graduates who
require an active lifestyle. Because the condominium is located
near the head of a nature trail, a lake, the university, and
close to retail shopping, we created a piece that expressed a
'live, work, and play' attitude. The die-cut curve of the folder
pocket reflects the fluidity and playfulness of the prominently
displayed illustration."*

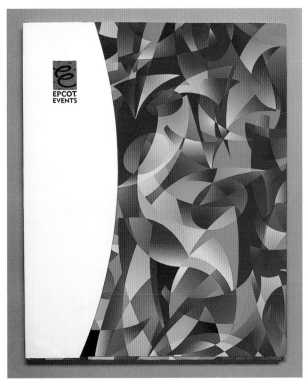

NAME OF PIECE: Epcot Events brochure/folder
STUDIO NAME: Disney Design Group
ART DIRECTOR: Patrick Scanlan
DESIGNER: Ryan Lorei
ILLUSTRATOR: Ryan Lorei
CLIENT: Epcot Events
CLIENT'S SERVICE: Special event production and planning
SPECIAL FEATURES: The piece folds in on itself, allowing it to contain
information and matching letterhead. A special curved, die-cut
flap folds over the cover and seals the piece with Velcro.

"The inspiration was the unique event and party atmosphere and environment that this company produces. I wanted to convey the excitement, originality, and vibrance this company can bring to a client's special event," describes Ryan Lorei. Image © Disney.

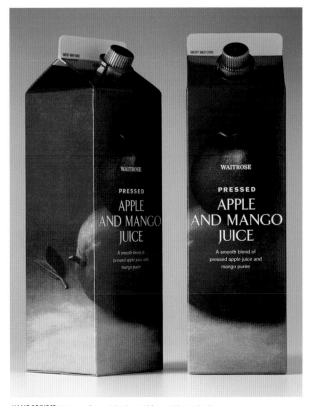

NAME OF PIECE: Waitrose Pressed Apple and Mango Juice packaging
STUDIO NAME: Lewis Moberly
ART DIRECTOR: Mary Lewis
DESIGNERS: Daniela Nunzi, Ann Marshall
PHOTOGRAPHER: Juliet Piddington
CLIENT: Waitrose Limited
SPECIAL PRODUCTION TECHNIQUES: The background of the photograph was
created in pastels by artist Sophie Kelly. The illustrative marks fuse
with the real fruit, giving the photograph the feel of a still-life painting.

The amazingly realistic pastel painting of fruit on these packages makes this a great example of artistic design. "The assignment was to reflect the premium quality of this range of pressed juices and differentiate it from competitors'. The category is confusing to shop and overcrowded with messages, so these juices are packaged to project absolute fruitiness and clarity of information," explains Mary Lewis.

C0 M11 Y94 K5
C69 M34 Y0 K0
C30 M91 Y0 K0

C100 M17 Y0 K51
C0 M30 Y100 K0
C33 M0 Y100 K16

C50 M90 Y0 K0
C0 M100 Y91 K0
C0 M0 Y0 K100

C0 M100 Y0 K23
C91 M43 Y0 K0
C20 M0 Y100 K20

C0 M27 Y100 K6
C69 M34 Y0 K0
C0 M56 Y100 K18

C0 M0 Y0 K0
C0 M15 Y94 K0
C0 M100 Y0 K15

C0 M100 Y15 K0
C100 M43 Y0 K0
C100 M0 Y91 K6

C100 M9 Y0 K6
C11 M0 Y79 K0
C94 M94 Y0 K0

C56 M18 Y0 K0
C0 M91 Y72 K0
C0 M15 Y39 K0

C23 M0 Y51 K11
C69 M38 Y0 K0
C0 M72 Y43 K0

C0 M56 Y100 K8
C80 M25 Y0 K0
C0 M16 Y79 K0

C0 M95 Y100 K29
C0 M0 Y100 K18
C100 M43 Y0 K18

BRIGHT

Unwilling to blend in with the crowd, a brightly designed piece usually leans toward the juvenile or the creatively daring. Either way, its purpose is to grab your attention. Once that is achieved, its color schemes and imagery will quickly communicate whether the meaning is ironic or just playful. Be careful with your color schemes: the wrong hue in your design can make it look too gaudy or dated.

> "When I am discussing a concept or strategy with a client, I am sure to reiterate what I think they are saying in my own words. After leaving a meeting, I write an overview of our discussion for them to read and/or edit to ensure that we stay on the same page."
>
> —Emma Wilson

DEFINITION ※

bright (adj.)
1. Emitting or reflecting light in large amounts
2. Having striking color
3. Splendid

QUESTIONS FOR CLIENT ※

➤ What season should your color scheme fall in? Cool spring, warm summer, earthy fall, or icy winter?
➤ What is this piece celebrating?
➤ What do you want to communicate after you've captured your audience's attention? Try to slim it down to one sentence.

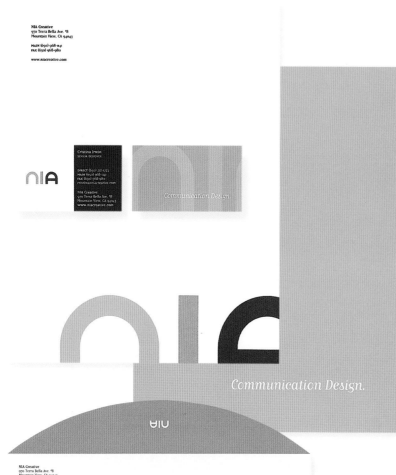

(left)
NAME OF PIECE: NIA stationery
STUDIO NAME: NIA Creative
ART DIRECTOR: Robbie Sinclair
DESIGNER: Robbie Sinclair
CLIENT: Self promotion

The bold use of color and the playful placement of the logo peeking up from the bottom of the letterhead makes this stationery system both modern and whimsical. "The large colorful type and white space captures your attention quickly," explains Robbie Sinclair.

(below)
NAME OF PIECE: ARTS at Miami logo
STUDIO NAME: Peg Faimon Design
DESIGNER: Peg Faimon
CLIENT: School of Fine Arts, Miami University

"A very similar letterform combination of A, R, T, and S was originally used in a masthead design which I created for the same client's alumni magazine," explains Peg Faimon. "I took this earlier design, which focused on the concepts of transformation and process, and combined it with the oval form which was intended to imply a spotlight. The letters are encircled by the oval shape, symbolizing the collaboration and community of the client's arts activities."

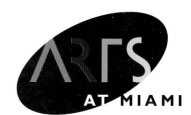

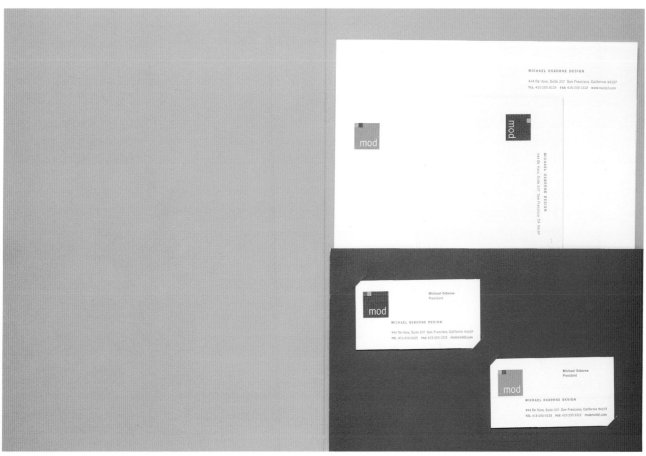

NAME OF PIECE: MOD identity system
STUDIO NAME: MOD/Michael Osborne Design
ART DIRECTOR: Michael Osborne
DESIGNERS: Michelle Regenbogen, Paul Kagiwada

"After twenty years in business, I decided to make two of my senior designers partners. We decided to update the identity to clearly represent both me and my two partners," explains Michael Osborne. This brightly colored identity system contains elements of minimalism, and its primary color palette catches the viewer's eye.

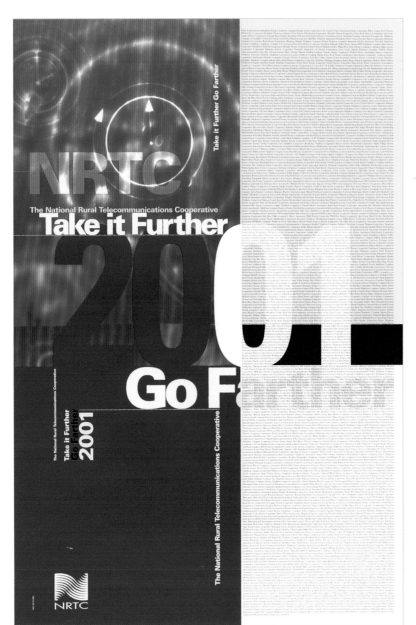

(left)
NAME OF PIECE: "Go Farther" poster
STUDIO NAME: NRTC
ART DIRECTORS: Sherilyn Bringhurst-Holmes, Jeanine Clough
DESIGNER: Sherilyn Bringhurst-Holmes
CLIENT'S PRODUCT/SERVICE: Telecommunications
SPECIAL FEATURES: This poster was designed to fold down to a 7½" x 10" (19cm x 25cm) insert that was tipped-on to a matching full-color ad. The poster had to look good folded and flat.

"This poster and a complementary ad were designed as part of the client's thousandth member celebration," says Sherilyn Bringhurst-Holmes. *"Placement and timing of the project were focused on increasing membership and driving foot traffic to the client's booth at its national trade show."* The client's one-thousand members were listed on the poster displayed at the booth, and extra copies of the poster were also given away.

(below)
NAME OF PIECE: Bravo Bus logo
STUDIO NAME: DogStar
ART DIRECTOR: Jeff Martin
DESIGNER/ILLUSTRATOR: Rodney Davidson
CLIENT: Birmingham Metropolitan Arts Council
CLIENT'S SERVICE: Touring theatre troupe

"The Bravo Bus is a traveling theatre which performs in underserved communities in Alabama," explains Rodney Davidson. *"Performers wearing multicolored uniforms create an on-site stage using colored blocks. Creating the bus using the colored blocks seemed like the perfect solution."*

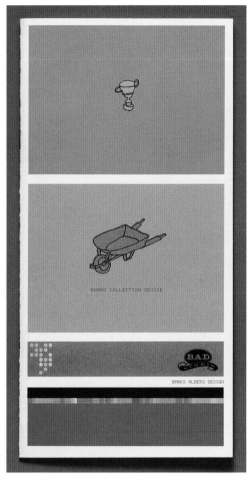

NAME OF PIECE: BAD award brochure
STUDIO NAME: BAD Studio
ART DIRECTOR: Scott Banks
DESIGNER: Kevin Fitzgerald
ILLUSTRATOR: Kevin Fitzgerald

Bright unusual colors mixed with rudimentary sketches make for an unusual and captivating award brochure. One of the unique features of this piece is the translucent tip-in page with various numbers and a trophy printed on it. This sheet allows the color blocks and wheelbarrow to show through, creating the illusion that the trophy is in the wheelbarrow. The numbers also align perfectly within the circles.

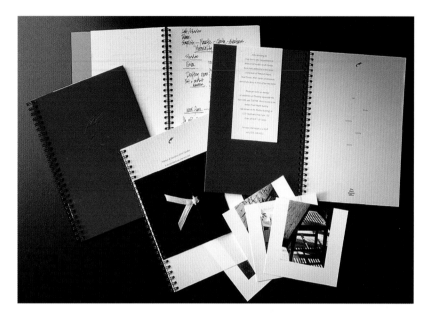

NAME OF PIECE: Mahlum & Nordfors moving announcement
STUDIO NAME: Michael Courtney Design
ART DIRECTOR: Michael Courtney
DESIGNERS: Michael Courtney, Michelle Rieb, Bill Strong
CLIENT: Mahlum & Nordfors
CLIENT SERVICE: Architectural firm

"The client wanted a one-of-a-kind open house invitation for a new office they were opening," according to Michael Courtney. "We designed a piece with three chapters: the past life of the building; sketches from the architects; and a teaser section of the new, hip spaces. The piece was wildly successful—the attendance was higher than expected and the client used the piece as self-promo for their office for the next two years."

(middle)
NAME OF PIECE: Kilimanjaro Safaris® whimsical animals
STUDIO NAME: Disney Design Group
DESIGNER: Natalie L. Bert
CLIENT: Disney's Animal Kingdom®

The inspiration for these animals, explains Natalie L. Bert, was "the Kilimanjaro Safaris® ride at Disney's Animal Kingdom®." The fun, playful typography against the bright colors and patterns in the animals make this piece a great example of bright design. Image © Disney.

(bottom)
NAME OF PIECE: Spotlight Solutions logo
STUDIO NAME: DogStar
ART DIRECTOR: Clyde Good/HSR Business to Business
DESIGNER/ILLUSTRATOR: Rodney Davidson
CLIENT: SpotlightSolutions.com
CLIENT'S PRODUCT: Retail clothing inventory software

"The client wanted to play off the word spot by using a dog," explains Rodney Davidson of his logo design concept. The strong contrast of the yellow against the black shapes make this logo both eye-catching and innovative.

(top)
NAME OF PIECE: Double Meaning
STUDIO NAME: Hutter Design
DESIGNER: Lea Ann Hutter
CLIENT: John Manno Photography

"As I reviewed over fifty potential images for inclusion in this promotion, I made selections that were conceptually related to each other and created a list of themes that played on words and appearances, such as wall (condom, bricks)," describes Lea Ann Hutter. *"The double meanings gave the photography impact by connecting seemingly incongruous images, and brought a fresh context to the images that had been used in past promotions."*

(bottom)
NAME OF PIECE: NIA brochure
STUDIO NAME: NIA Creative
ART DIRECTOR: Robbie Sinclair
DESIGNERS: Cristina Irwin, Kimara Mitchell
SPECIAL PRODUCTION TECHNIQUES: Deboss of logo on the front cover and Web site on the back cover, die cut on last page for a business card, and a CD which showcases the company's multimedia capabilities
SPECIAL FEATURES: Binding with a grommet and washer, subtle spot varnish on the vellum sheets

Designer Christina Irwin says, "The inspiration for this piece was a concept I did while in school"—a good reminder to us all not to throw anything away! This unique package revolves around a nut-and-bolt binding, transparent pages and bright colors. It is also shipped in a unique transparent envelope.

Academy Engraved
ABCDEFGHIJKLMN
OPQRSTUVWXYZ
abcdefghijklmn
opqrstuvwxyz
1234567890

Centaur
ABCDEFGHIJKLMN
OPQRSTUVWXYZ
abcdefghijklmn
opqrstuvwxyz
1234567890

Baker Signet
ABCDEFGHIJKLMN
OPQRSTUVWXYZ
abcdefghijklmn
opqrstuvwxyz
1234567890

Filosofia
ABCDEFGHIJKLMN
OPQRSTUVWXYZ
abcdefghijklmn
opqrstuvwxyz
1234567890

Bernhard Modern
ABCDEFGHIJKLMN
OPQRSTUVWXYZ
abcdefghijklmn
opqrstuvwxyz
1234567890

COPPERPLATE GOTHIC
ABCDEFGHIJKLMN
OPQRSTUVWXYZ
1234567890

C100 M65 Y75 K0
C0 M0 Y0 K70
C0 M0 Y0 K0

C6 M0 Y27 K27
C0 M0 Y0 K0
C0 M0 Y0 K100

C0 M0 Y0 K100
C0 M100 Y100 K0
C0 M2 Y20 K0

C0 M60 Y94 K0
C43 M30 Y6 K0
C0 M0 Y69 K9

C60 M0 Y27 K0
C0 M15 Y27 K56
C0 M50 Y60 K10

C100 M18 Y0 K65
C60 M0 Y0 K30
C30 M0 Y0 K15

C100 M87 Y0 K34
C25 M15 Y25 K0
C60 M40 Y46 K0

C0 M0 Y47 K18
C100 M18 Y0 K65
C38 M0 Y18 K56

Corporate

Designing for the conservative, corporate market does not mean you need to be conventional. As you see on the following pages, designers have taken calculated risks to produce a unique approach to their corporate projects. This style does not have to equal cookie-cutter design. Take some chances with your audience; they are probably ready to see something new.

> *"Nothing works better than success. The best client relationships we have are the ones in which we have established a track record. Success allows for greater trust and a belief in the competencies of everyone working on a project."*
>
> —Thomas Scott

DEFINITION ~

corporate (adj.)
1. Of or belonging to a corporation
2. Done by or characteristic of individuals acting together
3. Organized and maintained as a legal corporation

QUESTIONS FOR CLIENT ~

➤ Who is your audience? Are they conservative or nonconservative?
➤ What is the key message that you want to communicate?
➤ What is your company's mission and what are their marketing strategies?
➤ What can you do to spice up the design without overstepping any boundaries?

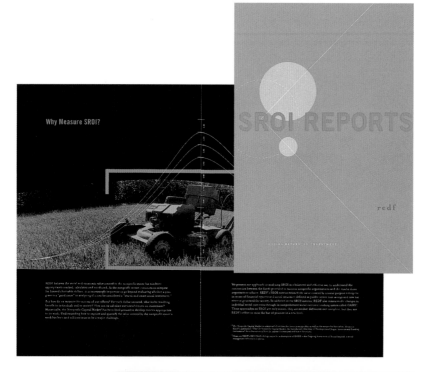

(top)
NAME OF PIECE: Roberts Enterprise Development Fund's Social Return on Investment (SROI) reports 2000
STUDIO NAME: Chen Design Associates
ART DIRECTOR: Joshua C. Chen
DESIGNERS: Max Spector, Leon Yu
PHOTOGRAPHER: Jenny Thomas
CLIENT: Roberts Enterprise Development Fund
CLIENT'S SERVICE: Venture philanthropy

Joshua Chen explains that he wanted to juxtapose the human and the technical: "We chose to represent social return through the people who benefit directly from the work of REDF. We used simple, direct images of optimistic, empowered men and women in work environments...we also employed graphic elements of a technical nature (shown). Grid lines, dashes and geometric shapes all became important aspects of the new REDF design motif. The overall visual impact is one of confidence, dependability, and hope."

(bottom)
NAME OF PIECE: Ronnisch name change announcement
STUDIO NAME: Group 55 Marketing
DESIGNER: Jeannette Gutierrez
CLIENT: Ronnisch Construction Group
CLIENT'S SERVICE: Commercial and industrial construction
SPECIAL PRODUCTION TECHNIQUE: Die cuts

According to Catherine Lapico, "the client's cutting-edge approach to all their jobs" was the inspiration behind this piece. The unique die cuts simulating the ground of a construction site give this piece a unique three-dimensional quality.

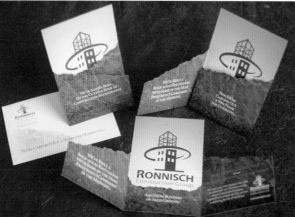

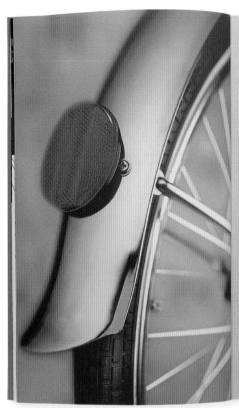

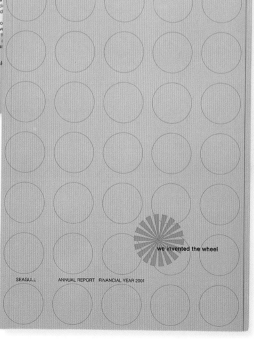

safer.

building on bedrock, eliminating points of failure

By definition, e-business requires software. New software development projects take a long time, cost a lot of money, and have high failure rates. So, anytime you can reduce the amount of new software code it takes to deliver an e-business project, you can reduce risk.

Underlying all e-business is the unchanging need for fundamental functions like inventory, order entry, claims processing, logistics, customer records (the list goes on...). The systems that perform these functions today are reliable, scalable and proven. If you've already got part of the e-business job done, why reinvent that wheel?

SEAGULL solutions specialize in enabling customers to re-purpose their core business systems – making it easier to turn them into "services" that can be called by new Web users
only are our so
assets, our soft
even eliminate

Another importa
they are "non-in
changes to the c
implemented wi

While re-purpos
every project, it
time when busin
as they await cl
is highly valued

e-Business pro
technology have
within budget; t
of companies;
and software as

SEAGULL reduces risl

we invented the wheel

SEAGULL ANNUAL REPORT FINANCIAL YEAR 2001

NAME OF PIECE: SEAGULL 2001 annual report
STUDIO NAME: Corporate Reports Inc.
DESIGNER: Ronda Davis
CLIENT: SEAGULL
CLIENT'S PRODUCT/SERVICE: Enterprise software
SPECIAL FOLDS/FEATURES: Fold-out front cover

"We worked with the client to come up with the concept 'We invented the wheel' because the client wanted to indicate that their software solutions are proprietary," explains Brooke Fumbanks. "The images used were all types of wheels that illustrated a specific point. For example, one spread's title was 'Safety' and the graphic elements were the back wheel of a bicycle and a bike reflector."

NAME OF PIECE: Boalt Hall Transcript Summer 2000
STUDIO NAME: Chen Design Associates
ART DIRECTOR: Joshua C. Chen
DESIGNERS: Joshua C. Chen, Leon Yu
CLIENT: Boalt Hall School of Law, University of California, Berkeley
SPECIAL PRODUCTION TECHNIQUES: Perfect-binding; every other issue includes an annual report of giving and these issues have a die-cut window on the reply panel.

The concept of this piece was "a modern progressive look for a modern progressive law school," explains Joshua Chen. "This issue of Transcript *was based on a redesign we did for Boalt Hall in the previous year. In keeping with the original intent of the redesign, we wanted the publication to have a smart, modern, clean, current look to offset the copy-heavy nature of a law school publication."*

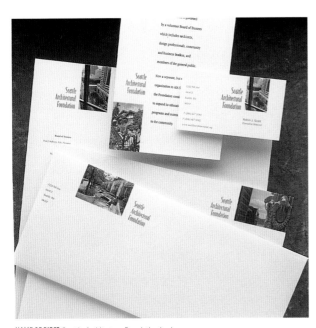

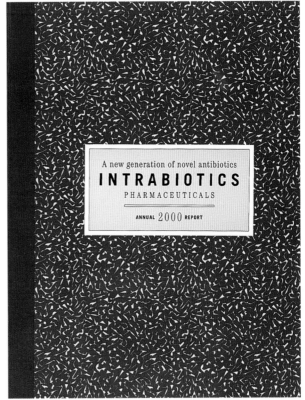

NAME OF PIECE: Seattle Architecture Foundation business papers
STUDIO NAME: Michael Courtney Design
ART DIRECTOR: Michael Courtney
DESIGNERS: Michael Courtney, Dan Hoang
CLIENT: Seattle Architecture Foundation
CLIENT'S SERVICE: Nonprofit educational programs

"This foundation runs the best architectural educational programs in the U.S.," says Michael Courtney. "Our mission was to develop a 'kit of parts' to convey a professional look and feel to both participants and funders. We chose photography to convey the feel of being on a tour of Seattle's diverse architecture, and then used these elements on the business and marketing papers."

NAME OF PIECE: IntraBiotics Pharmaceuticals, Inc. 2000 annual report
STUDIO NAME: ProWolfe Partners, Inc.
ART DIRECTOR: Bob Prow
DESIGNERS: Bob Prow, Susan Ammann
CLIENT: IntraBiotics Pharmaceuticals, Inc.
CLIENT'S PRODUCT: New antibiotic drugs
SPECIAL PRODUCTION TECHNIQUES: Cover includes a clear foil stamp and binder's tape wrapped around the spine to give the effect of a lab book.

"IntraBiotics is still in the exploratory and research phases of product development," explains Bob Prow. "We played up the scientific aspect of research and development by giving this annual report a university 'lab book' feel."

violation
abcdefghijklmn
opqrstuvwxyz
1234567890

DEVOTION
ABCDEFGHIJKLMN
OPQRSTUVWXYZ
1234567890

Matrix Tall
ABCDEFGHIJKLMNO
abcdefghijklmnopq
1234567890

DEVICE
ABCDEFGHIJKLMN
OPQRSTUVWXYZ
1234567890

Elliotts
subluxation perma
ABCDEFGHIJKLMN
OPQRSTUV"WXYZ
abcdefghijklmn
opqrstuvwxyz
1234567890

C73 M60 Y75 K0
C70 M88 Y97 K0
C51 M94 Y100 K0

C0 M0 Y0 K100
C0 M11 Y38 K76
C0 M94 Y94 K6

C0 M87 Y83 K30
C100 M100 Y100 K0
C0 M37 Y100 K34

C87 M0 Y60 K65
C0 M76 Y56 K56
C38 M94 Y0 K65

C0 M50 Y81 K38
C0 M83 Y60 K51
C0 M18 Y100 K27

C83 M0 Y51 K87
C0 M18 Y100 K56
C0 M27 Y100 K34

C9 M0 Y6 K47
C15 M0 Y11 K69
C15 M0 Y27 K83

C34 M0 Y34 K100
C27 M0 Y87 K51
C0 M0 Y11 K45

DARK **ģ** color

DARK

Dark design often has a sort of grim reality behind it. Whether you're showing the truth about cigarette smoking or trying to portray the heartache of poverty, there is a message that you want to convey. You might also choose this style because your audience is attracted to the morbid, ominous or mysterious. Regardless, a dark style should evoke a strong, immediate emotion.

> *"Questions, questions, questions. We are always asking and forcing the client to repeat the goal in other words. The more you talk and the more you use words, the more you avoid misunderstanding. We ask the clients to be open-minded and to get rid of their own visions of the expected design. They should not expect things they have seen before to be adapted for their needs."*
>
> —Laurenz Nielbock

DEFINITION ⊱

dark (adj.)
1. Devoid or partially devoid of light or brightness; shadowed
2. Having a dark hue
3. Stemming from evil characteristics or forces

QUESTIONS FOR CLIENT ⊱

➤ What makes this a dark piece?
➤ What is your message? How obvious or straightforward do you want that message to be?
➤ What evil(s) are you trying to portray? How can these be most effective?

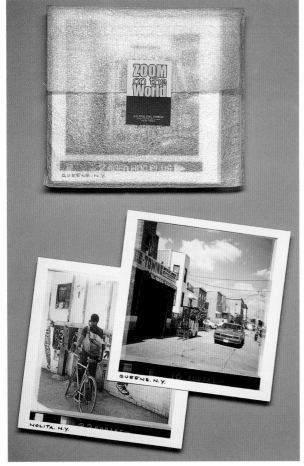

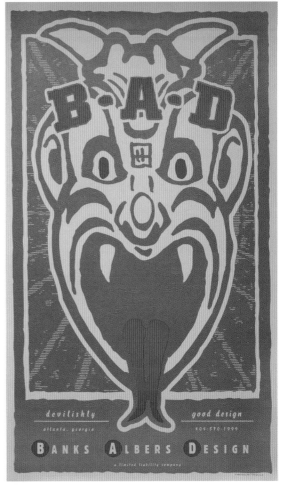

NAME OF PIECE: New York Portrait
STUDIO NAME: Matite Giovanotte
ART DIRECTOR: Antonella Bandoli
DESIGNER: Barbara Longiardi
PHOTOGRAPHER: Simon
CLIENT: Yien Group
CLIENT'S PRODUCT/SERVICE: Promotional campaign
SPECIAL FEATURES: Special packaging

A type of graphic realism, this piece shows a perspective of New York that isn't usually on the tourism brochures. Wrapped in a styrofoam-like material, these gritty images are as intriguing as they come, candidly showing back streets and alleys.

NAME OF PIECE: BAD Devil self promotion
STUDIO NAME: BAD Studio
DESIGNER: Scott Banks

"If clients weren't scared by this, they might want to work with us," jokes Scott Banks. This promotional poster for BAD Studio is definitely "dark." Its richly ornate and decorative lines frame an almost humorous interpretation of the devil.

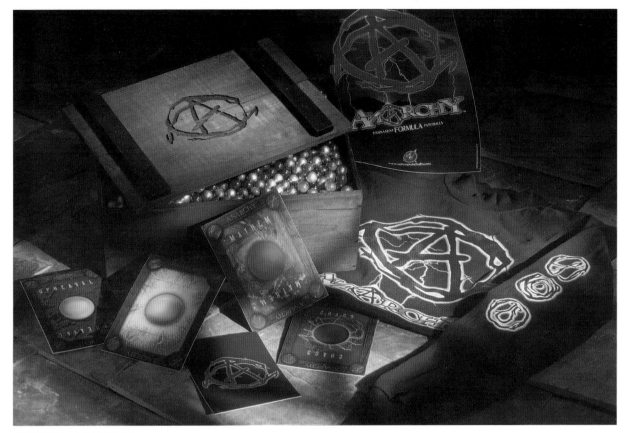

NAME OF PIECE: Anarchy Paintball Symbols
STUDIO NAME: Thinking Cap Design
ART DIRECTOR/DESIGNER/ILLUSTRATOR: Kelly D. Lawrence
PRODUCTION DESIGNER: Mark Hoffman
PHOTOGRAPHY: AL Photographer, Lading Freelance Photography, Dynamic Graphics (stock)
CUSTOM BOX: Dufeck Wood Products
PROJECT COORDINATION: Dave Willems, Paul Willems (Willems & Company)
CLIENT: Nelson Paintballs
SPECIAL TECHNIQUES: Typeface manipulation. The icons were constructed by cutting apart letters and numerals from the Rougfhouse font system. "This font was perfect for the rough, twisted look we wanted. Then thorns were added to give the feel of what players actually crawl through while playing the game of paintball," explains Lawrence.

"We researched old alchemy symbols and found icons that were representative of the product's key features," says Kelly D. Lawrence, "We also watched medieval period movies and listened to gothic rock music" for inspiration.

TOURNAMENT FORMULA PAINTBALLS

THICK FILL ACCURATE PEARL SHELL ANARCHY

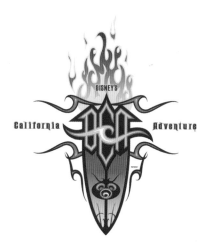

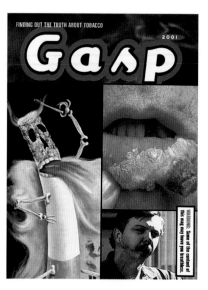

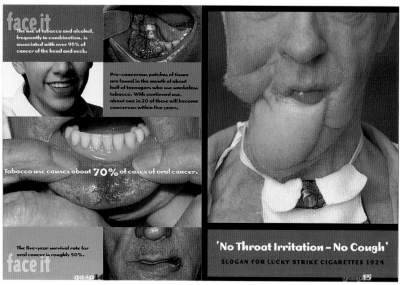

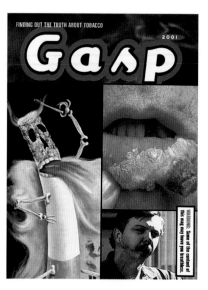
(top left)
NAME OF PIECE: DCA surf tattoo
STUDIO NAME: Disney Design Group
DESIGNER: Darren Wilson
CLIENT: Disneyland Resort
SPECIAL PRODUCTION TECHNIQUES: Tattoo transfer and heat
tee transfer

To describe this logo, designer Darren Wilson uses words
like "surf-inspired," "aggressive," and "sharp, hard lines."
Wilson explains that he "tried to develop a surfboard that
transformed into flames with a wave that reads DCA."
Image © Disney.

(top right and below)
NAME OF PIECE: *Gasp* magazine
STUDIO NAME: Suburbia Studios
ART DIRECTOR: Jeremie White
DESIGNER: Jeremie White
ILLUSTRATORS: Kathy Boake, Adam Rogers, Russ Willms,
Jeremie White
CLIENT: British Columbia Ministry of Health/Now
Communications
CLIENT'S PRODUCT: Anti-smoking initiative directed at teens

Designer Jeremie White explains that "the inspiration for Gasp
came from the world that young people inhabit. In many ways, it
is a different world than we live in as adults. Kids are bombarded
by images, colors and sounds, and stimulation from television,
radio, CDs, music videos, movies and magazines. Their world is
fast-paced and constantly changing. Gasp was designed to
appeal to this very discerning audience, whose 'radar' for the
'uncool' is extremely acute. The stories are hard-hitting, factual,
and accompanied by graphic and sometimes unsettling
images, both illustrated and photographic."

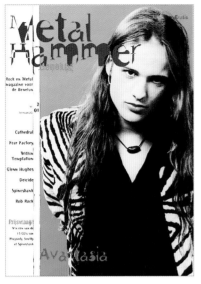

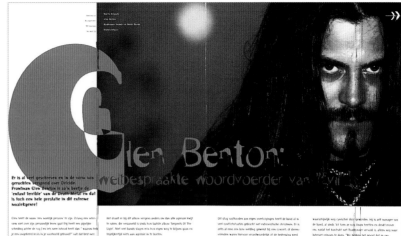

(above)
NAME OF PIECE: Metal Hammer Benelux magazine
STUDIO NAME: Erwin Zinger Graphic Design
DESIGNER: Erwin Zinger
ILLUSTRATORS: Henry Knegt, Rita van Poorten
CLIENT: De Matrix Publishing

Designer Erwin Zinger wanted to provide the hard rock, heavy metal and hardcore music scene with a high quality, professionally designed magazine as an alternative to the typically amateurish fanzines on the market. He says, "I did use some elements that look like failures because I was inspired by those not-very-well-designed magazines." However, all the elements together work very well.

(right)
NAME OF PIECE: *We are not alone* poster
STUDIO NAME: Andreas Karl Design
ART DIRECTOR/ILLUSTRATOR: Andreas Karl
CLIENT: OSRAM Germany
CLIENT'S PRODUCT: Light bulbs

Andreas Karl describes how he received the inspiration for this piece: "One morning I had to change a bulb over my bathroom mirror. The empty box was lying on the shelf in front of the mirror and the name OSRAM flipped into MARSO. For a graphic designer who has visited the Roswell site and strongly believes in extraterrestrial life, it was only a small step to turn a bulb illustration into a smart-looking alien."

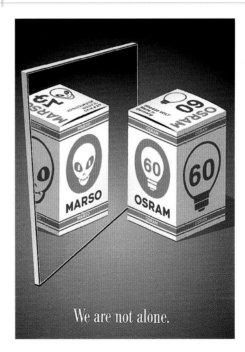

Bickham Script
ABCDEFGHIJKLM
NOPQRSTUVWXYZ
abcdefghijklmnopqrstuvwxyz
1234567890

Carpenter
ABCDEFGHIJKL
MNOPQRSTUVWXYz
abcdefghijklmnopqrstuvwxyz
1234567890

Nuptial Script
ABCDEFGHIJKLM
NOPQRSTUVWXYZ
abcdefghijklmnopqrstuvwxyz
1234567890

Mona Lisa
ABCDEFGHIJKLMN
OPQRSTUVWXYZ
abcdefghijklmnopqrstuvwxyz
1234567890

Ex Ponto
ABCDEFGHIJKLMN
OPQRSTUVWXYZ
abcdefghijklmnopqrstuvwxyz
1234567890

Kuenstler Script
ABCDEFGHIJKLM
NOPQRSTUVWXYZ
abcdefghijklmnopqrstuvwxyz
1234567890

C91 M72 Y27 K0
C0 M0 Y23 K15
C0 M0 Y0 K100

C20 M35 Y80 K0
C35 M45 Y80 K0
C0 M0 Y100 K80

C34 M50 Y70 K25
C0 M72 Y79 K47
C0 M0 Y0 K0

C60 M0 Y51 K80
C16 M0 Y18 K36
C0 M0 Y0 K0

C0 M0 Y0 K100
C5 M91 Y100 K0
C0 M0 Y0 K0

C70 M57 Y30 K0
C80 M70 Y30 K0
C90 M90 Y50 K0

C87 M72 Y100 K0
C61 M65 Y82 K0
C65 M65 Y51 K0

C72 M94 Y0 K27
C100 M94 Y0 K34
C100 M0 Y9 K65

Elegant color

Elegant

In today's society, elegance in design often seeks to convey wealth or refined beauty. Serif fonts are popular, and some commonly used colors include royal shades of ruby, emerald and sapphire. Your target audience is likely in the middle or upper social class—or aspires to be a part of it. This graceful design style evokes a sense of perfection that almost everyone desires.

"Bringing examples and sketchbooks to meetings is essential. It helps to show and sketch as the conversation goes along (since the intellectual needs to meet the tactile). This can be done by surfing [web] sites to compare styles, by browsing through Pantone chip books to differentiate color ideas, or by just taking a pen and sketching on the fly."
—Fabian Geyrhalter

Definition ⇝

elegant (adj.)
1. Refined and tasteful in appearance or behavior or style
2. Suggesting taste, ease, and wealth
3. Of seemingly effortless beauty in form or proportion

Questions for Client ⇝

➤ Does your audience tend to be upper middle class?
➤ Will the message work well with a design that is dignified and majestic?
➤ What is the age of your audience? (Different colors will speak to different age groups.)

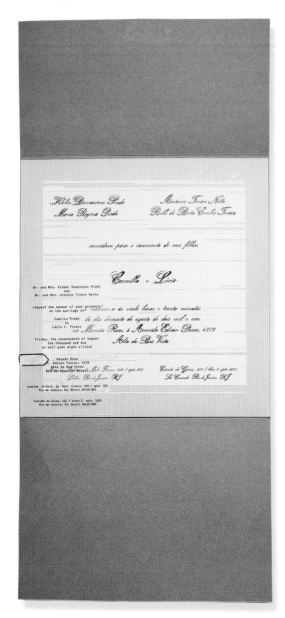

NAME OF PIECE: Mr. & Mrs. Tinoco's wedding invitation
STUDIO NAME: ponto p | design
ART DIRECTOR: Fabiana Prado
CLIENT: Mr. & Mrs. Tinoco
SPECIAL PRODUCTION TECHNIQUES: Glossy "stains" were printed on the envelope. This effect was obtained by using an ink of a similar color to the paper; the porous paper absorbed some of the shiny varnish, so it was not too bright.
SPECIAL FEATURES: The envelope was assembled with two simple folds and closed with traditional golden sealing wax. Because the invitations were hand-delivered, a sealed envelope was not necessary.

When creating this wedding invitation, Fabiana Prado tried to "transmit the sophistication and modernity of the fiancés and their wedding ceremony through an unusual presentation, while at the same time leaving no doubt it was a wedding invitation." To do this, some traditional elements were kept, but in a modified form. Prado created special typography where each word was individually constructed. He explains, "The traditional monogram appears blown up on the envelope, and is part of the graphical background. The combination of contrasting types of paper—rustic for the envelope and sophisticated for the invitation— generates a harmonic strangeness."

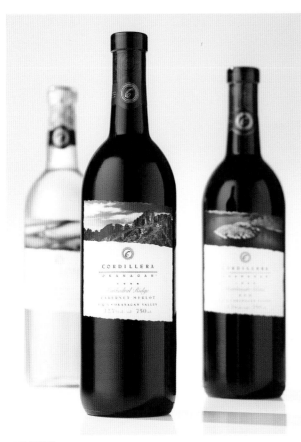

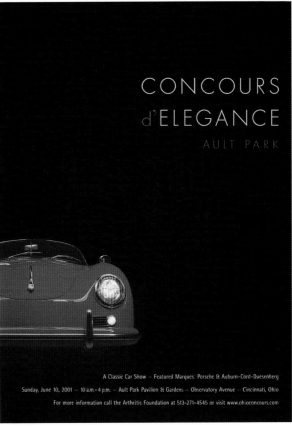

NAME OF PIECE: Cordillera Wine label
STUDIO NAME: dossiercreative inc
CREATIVE DIRECTOR: Don Chisholm
DESIGNER: Eena Kim
CLIENT: Mission Hill Winery
SPECIAL PRODUCTION TECHNIQUES: Foil stamping, sculptured embossing and a deckled die cut

"Our desire was to link a new series of wine to the Okanagan region where the wines are produced," explains Patrick Ho. "We explored different ways of articulating the connection— from identification with indigenous fauna to historical sites. We decided to anchor each variety to a distinctive landmark around the region to suggest the varied scope of the majestic landscape."

NAME OF PIECE: Concours d'Elegance poster
STUDIO NAME: Rahmin Eslami Design
DESIGNER: Rahmin Eslami
PHOTOGRAPHER: Dave Wendt
CLIENT: The Arthritis Foundation

When asked what the inspiration was for this piece, Rahmin Eslami replied, "I wanted to treat the poster more like a painting than a car show poster. The cars at this event are the best of their makes. Therefore, they deserve a level of sophistication that isn't traditionally found in the car show poster. I achieved this sophistication by placing the car in the lower left, as opposed to centered on the page, and cropping off the passenger side. Also, the beauty shot of the car was scaled to a much smaller than standard car show poster size. The color palette is based on the German flag and the typefaces are predominantly German."

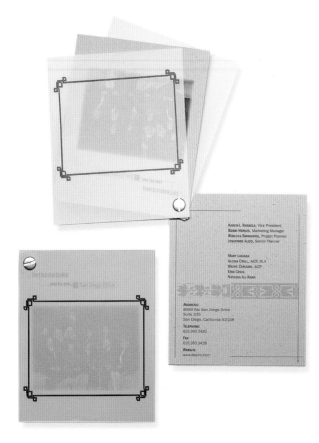

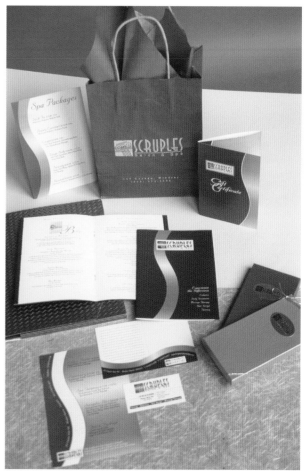

NAME OF PIECE: San Diego office announcement
STUDIO NAME: David Evans and Associates, Inc.
ART DIRECTORS: Theresa P. Van Ert and Tanya Boyer
DESIGNER: Theresa P. Van Ert
SPECIAL PRODUCTION TECHNIQUES: The piece was printed in-house, and assembled and cut by hand.
SPECIAL FOLDS OR FEATURE: There is a screw and post in the upper-left corner.
CLIENT: Self promotion

"We wanted to create something elegant yet fun and tangible," explains Theresa P. Van Ert. "I wanted it to be something that would not get filed away in a desk drawer. I was inspired by the ideas of an old-style photo album and address book; something that people can enjoy holding onto and flipping through to find our information. We wanted it to be a piece that our clients would keep on top of their desk, ready to call us for any of their needs."

NAME OF PIECE: Scruples retail identity
STUDIO NAME: Group 55 Marketing
ART DIRECTOR: Catherine Lapico
DESIGNER: James Peraino
CLIENT: Scruples Salon & Spa, Canada

Michael Lapico wanted to mirror "the client's relentless pursuit of visual elegance" to portray the sophistication of this spa. The graceful, fluid lines and silver printing make these pieces things of beauty.

(right)
NAME OF PIECE: Stuart Crystal retail identity
STUDIO NAME: Lewis Moberly
ART DIRECTOR: Mary Lewis
DESIGNER: Paul Cilia la Corte
CLIENT: Stuart Crystal
CLIENT'S PRODUCT: Crystal glassware

"The assignment was to create a new identity, repositioning Stuart Crystal as a modern, design-led brand," explains art director Mary Lewis. "The new logo aims to reflect the slender elegant shapes of crystal glass and how light falls on it. Printed across carrier bags and packaging, it creates an abstract image around the forms. The palette of blue, gray, black and white creates a crisp, clean, contemporary image."

(below)
NAME OF PIECE: Pegasus logo
STUDIO NAME: DogStar
ART DIRECTOR: Ken Joy
DESIGNER: Rodney Davidson
CLIENT: Pegasus
CLIENT'S PRODUCT/SERVICE: Air freight

"Creating a mark which looked powerful and swift was the objective," says designer Rodney Davidson. "I began by creating full-figured winged horses with powerful torsos, but they all looked chunky and slow. I decided to concentrate on speed instead and to take a more abstract approach by showing only a portion of the horse's torso. The horse appears as a flash in the sky and the lines of movement define the neck and imply wings as they trail off."

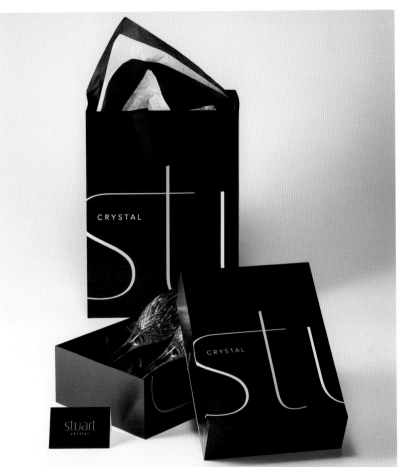

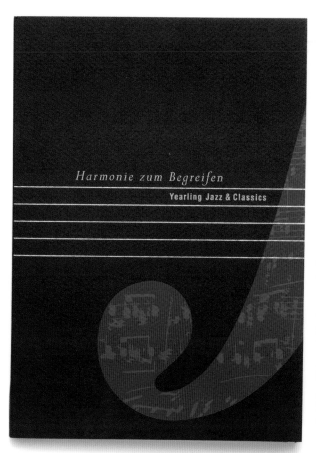

NAME OF PIECE: Yearling Paper promotion: *Harmonie zum Begreifen* (To Grasp the Harmony)
STUDIO NAME: Q
ART DIRECTOR: Thilo von Debschitz
DESIGNERS: Tanja Mann, David Bascom
COPYWRITER: Christoph Kohl
ILLUSTRATORS: Tanja Mann, David Bascom
CLIENT: Arjo Wiggins
CLIENT'S PRODUCT: Fine papers

"In order to communicate the special surface quality and texture of the two paper types, *Yearling Classic* and *Yearling Jazz*, we played with the double meaning of the word grasp," explains art director Thilo von Debschitz. "We invite the reader to grasp the paper in the most literal sense, while simultaneously learning a few technical terms related to the harmonies of classical music and jazz. Imaginative typography and special finishing techniques (like punching, die stamping, blind and hot-foil embossing) enable them to be 'grasped' both physically and mentally."

(top and bottom left)
NAME OF PIECE: Sound Transit signage program
STUDIO NAME: Michael Courtney Design
ART DIRECTOR: Michael Courtney
DESIGNERS: Michael Courtney, Dan Hoang
CLIENT: Sound Transit
CLIENT'S SERVICE: Regional transit system

"Our studio worked to create a 'kit of parts' that was appropriate for a high tech, regional transit organization moving into a historic rail station," explains Michael Courtney.

(bottom right)
STUDIO NAME: Disney Design Group
NAME OF PIECE: Disney's Palm logo
DESIGNER: Eric Caszatt
CLIENT: Disney's Park and Resort Merchandise

"The client I worked with supplied me with tear sheets of various golf memorabilia and also allowed me to visit the golf course for inspiration," explains Eric Caszatt. Image © Disney.

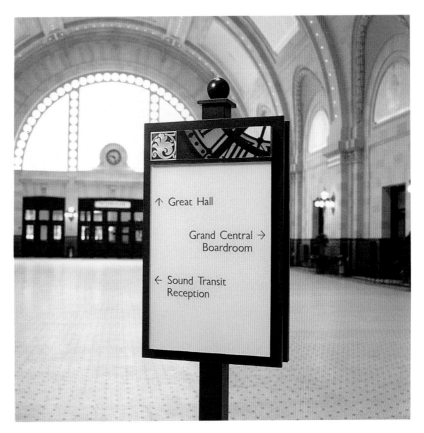

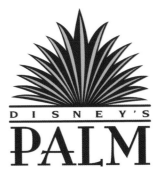

Deelirious
ABCD#FGHIJKLM
OPQRSTUVWXYZ
#BCD#FGhijklMN
opqrstuvwxyz
1234567890

Staccato
ABCDEFGHIJKLMN
OPQRSTUVWXYZ
abcdefghijklmn
opqrstuvwxyz
1234567890

Fenice
ABCDEFGHIJKLMN
OPQRSTUVWXYZ
abcdefghijklmn
opqrstuvwxyz
1234567890

Ribbon
ABCDEFGHIJKLM
NOPQRSTUVWXYZ
abcdefghijklmnopqrstuvwxyz
1234567890

Elliotts
Jigsaw Dropshadow
ABCDEFGHIJKLM
NOPQRSTUVWXYZ
abcdefghijklm
nopqrstuvwxyz
1234567890

C90 M0 Y0 K0
C0 M70 Y100 K0
C40 M0 Y100 K0

C0 M65 Y100 K0
C100 M0 Y47 K0
C0 M0 Y100 K8

C70 M39 Y0 K26
C6 M0 Y100 K27
C0 M0 Y100 K18

C0 M34 Y3 K0
C100 M96 Y0 K8
C0 M0 Y0 K100

C79 M94 Y0 K0
C65 M0 Y100 K0
C0 M51 Y87 K0

C0 M91 Y76 K0
C0 M0 Y100 K6
C60 M0 Y79 K0

C75 M80 Y0 K0
C0 M91 Y94 K30
C0 M87 Y91 K0

C100 M0 Y0 K51
C0 M0 Y100 K43
C56 M0 Y43 K0

Bold and brassy, this style loves to be the center of attention. A flashy design has flair that will definitely be noticed. It quickly captures the market's attention with unusual use of flamboyant colors and loud typography. A word of warning: Be sure that your piece's life expectancy is not long. This style is likely to quickly date itself, though it won't be soon forgotten.

> "How does my firm tackle the ongoing struggle of client communication? In a word...persistently. Not in a demanding way, but just by persevering and asking questions to clarify client feedback. Many times clients don't know what they want until they see it. Designers get a sense of what a client may want after working with them for a while. It is a two-way communication—education process."
> —Brooke Fumbanks

DEFINITION ❋

flashy (adj.)
1. Dazzling for a moment; making a momentary show of brilliancy; transitorily bright
2. Fiery; vehement; impetuous
3. Showy; gay; gaudy

QUESTIONS FOR CLIENT ❋

➤ Who is your target audience? Why is this style appropriate?
➤ What is the life expectancy of this project?
➤ Is there a specific culture or event that could be an inspiration for this piece?

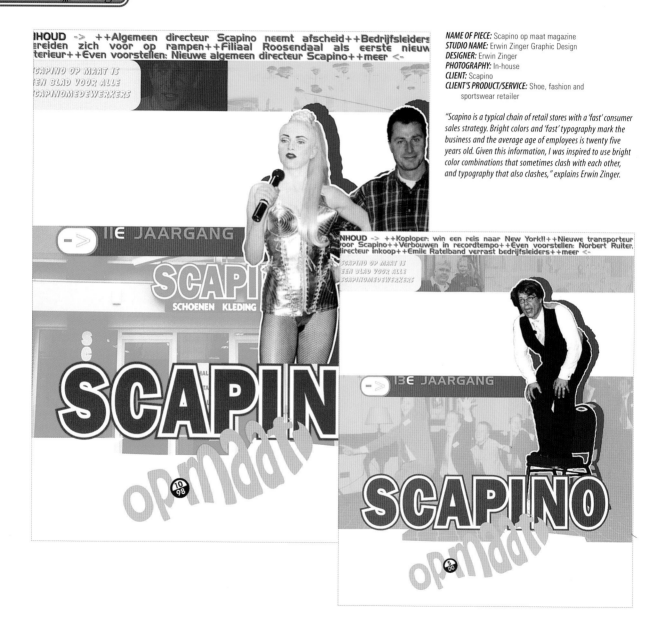

NAME OF PIECE: Scapino op maat magazine
STUDIO NAME: Erwin Zinger Graphic Design
DESIGNER: Erwin Zinger
PHOTOGRAPHY: In-house
CLIENT: Scapino
CLIENT'S PRODUCT/SERVICE: Shoe, fashion and sportswear retailer

"Scapino is a typical chain of retail stores with a 'fast' consumer sales strategy. Bright colors and 'fast' typography mark the business and the average age of employees is twenty five years old. Given this information, I was inspired to use bright color combinations that sometimes clash with each other, and typography that also clashes," explains Erwin Zinger.

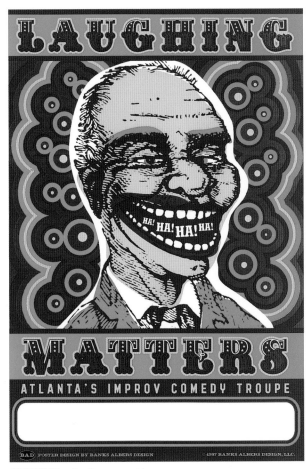

NAME OF PIECE: Laughing Matters event night poster
STUDIO NAME: BAD Studio
CLIENT: Laughing Matters
CLIENT'S SERVICE: Improvisational comedy

1970s psychedelic posters were the inspiration for this poster, according to Scott Banks. The bold use of color and fluid lines continuously direct your eye around the design. Also, the circus-like font is flooded with detail and color, making it hard not to notice this poster.

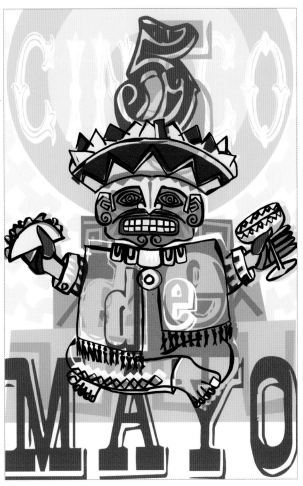

NAME OF PIECE: Cinco de Mayo logo
STUDIO NAME: Emma Wilson Design Company
DESIGNER: Emma Wilson
CLIENT: Self promotion

Emma Wilson says the goal of this piece was "to cross-pollinate the look of a Mexican mural with a bullfight poster—and give it a twist. Yes, Cinco de Mayo began as a celebration of Mexico's victory over the French, but today in the United States it is a chance to celebrate Mexico and the Mexican culture. Even though the party's over, this bad boy will live on—along with the margarita hangover—until next year's party."

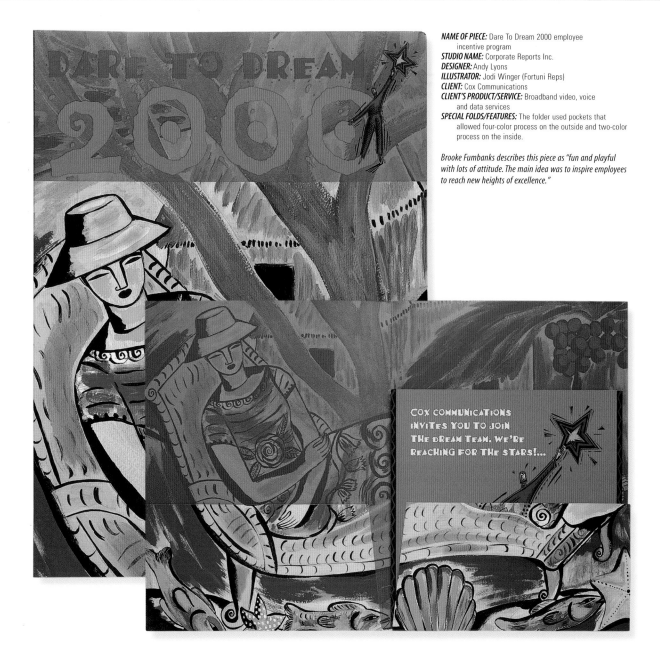

NAME OF PIECE: Dare To Dream 2000 employee
incentive program
STUDIO NAME: Corporate Reports Inc.
DESIGNER: Andy Lyons
ILLUSTRATOR: Jodi Winger (Fortuni Reps)
CLIENT: Cox Communications
CLIENT'S PRODUCT/SERVICE: Broadband video, voice
and data services
SPECIAL FOLDS/FEATURES: The folder used pockets that
allowed four-color process on the outside and two-color
process on the inside.

*Brooke Fumbanks describes this piece as "fun and playful
with lots of attitude. The main idea was to inspire employees
to reach new heights of excellence."*

COX COMMUNICATIONS
INVITES YOU TO JOIN
THE DREAM TEAM. WE'RE
REACHING FOR THE STARS!...

(top)
NAME OF PIECE: DART resident retention direct mail program
STUDIO NAME: Group 55 Marketing
ART DIRECTOR: Catherine Lapico
DESIGNER: Jim Coburn
CLIENT: DART Properties
CLIENT'S SERVICE: Property management

The inspiration for this piece built off the target audience's love for trinkets and bright colors. Phone cards and magnetic gifts were attached to the postcard as part of the printing process.

(bottom)
NAME OF PIECE: Mohawk Digital Papers swatch book
STUDIO NAME: ProWolfe Partners, Inc.
DESIGNER: Tiffany Larson
PHOTOGRAPHY: Todd Studios (St. Louis), stock imagery
CLIENT: Mohawk Digital Papers
SPECIAL FOLDS/FEATURES: The cover folds out to reveal information about the available paper stocks for specific digital presses. The first tab is die cut and folds out to reveal the stock sizes available for Mohawk Navajo. There are stepped sample sheets of paper weights and colors behind each tab. The last tab has five digitally printed samples from five digital presses for reference.

Mohawk wanted a swatch book that displayed its line of successful digital papers, but wanted the piece to be user-friendly and informative about digital printing as well.

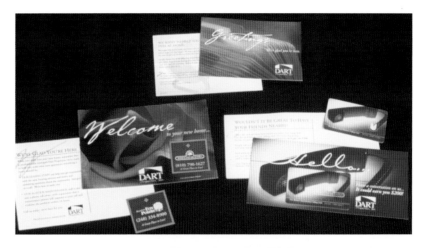

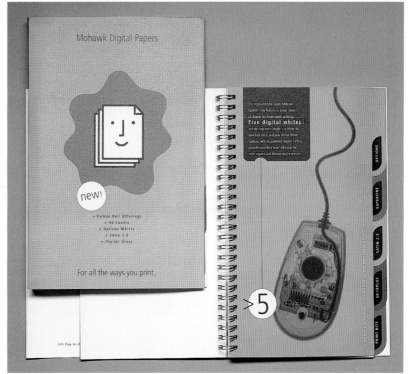

Dorchester Script

ABCDEFGHIJKLM
NOPQRSTUVWXYZ
abcdefghijklmnopqrstuvwxyz
1234567890

Isadora

ABCDEFGHIJKLM
NOPQRSTUVWXYZ
abcdefghijklmn
opqrstuvwxyz
1234567890

Shelley Andante

ABCDEFGHIJKLM
NOPQRSTUVWXYZ
abcdefghijklmnopqrstuvwxyz
1234567890

C10 M80 Y25 K0
C10 M50 Y20 K0
C5 M15 Y5 K0

C0 M91 Y76 K0
C63 M52 Y51 K100
C0 M9 Y23 K0

C50 M20 Y0 K10
C15 M20 Y0 K0
C0 M0 Y0 K0

C0 M34 Y54 K0
C6 M6 Y51 K0
C0 M15 Y23 K0

GENDER-SPECIFIC ⚥ MASCULINE

Caslon Antique

ABCDEFGHIJKLMN
OPQRSTUVWXYZ
abcdefghijklmn
opqrstuvwxyz
1234567890

WheresMarty

ABCDEFGHIJKLMN
OPQRSTUVWXYZ
abcdefghijklmn
opqrstuvwxyz
1234567890

STENCIL

ABCDEFGHIJKLMN
OPQRSTUVWXYZ
1234567890

C100 M50 Y0 K0
C50 M25 Y0 K0
C20 M10 Y0 K0

C0 M0 Y0 K100
C6 M0 Y0 K34
C0 M0 Y100 K6

C0 M27 Y100 K69
C34 M0 Y0 K94
C0 M0 Y23 K69

C100 M0 Y23 K79
C72 M15 Y0 K56
C0 M6 Y6 K34

SYNONYMS ⊶ *macho, manly, masculine*
SIMILAR SECTIONS ⊶ *xtreme, messy*

Synonyms ⚥ *feminine, maternal, womanly*
Similar Sections ⚥ *alluring, elegant, soft*

Gender- SPECIFIC

Beware of stereotypes! Limiting your audience to a specific gender can lead to wild success or an unfortunate disaster. Be clear before you begin your project how the design can be best oriented in the market. Be sure that you are really speaking to a specific gender, and not simply repeating tired or offensive clichés. Side note: remember that even though your target market may be one particular gender, the primary buyers of the product may actually be of the opposite gender.

> *"Often nonvisual people need to see to believe that a certain direction isn't the best one to communicate their message. At the same time the designer needs to educate the client by showing them options they would not have conceived."*
> —Peg Faimon

Definition ⚥

gender-specific (adj.)
> 1. Of, for, or associated with persons of one gender to the exclusion of the other

Questions for Client ⚥

➤ Is your market orientation largely male or largely female? How would you characterize them? What motivates them to buy?
➤ What is the typical age of your audience, or to what generation do they belong?
➤ Why have you chosen to limit your audience? Define the reason.

KELLWOOD

2000 ANNUAL REPORT

VALUE
CREATING THE
BEST QUALITY
PRODUCTS TO
MEET A PRICE
POINT

FASHION
INTERPRETING THE
LATEST TRENDS TO
BRING AFFORDABLE
FASHION TO
CONSUMERS

DIVERSITY
PROVIDING
A WIDE ARRAY
OF PRODUCTS
TO ALL CHANNELS
OF DISTRIBUTION

NAME OF PIECE: Kellwood 2000 annual report
STUDIO NAME: ProWolfe Partners, Inc.
NAME OF PIECE: Kellwood 2000 annual report
ART DIRECTOR: Bob Prow
DESIGNERS: Bob Prow, Karin Caracci
CLIENT: Kellwood Company
CLIENT'S PRODUCT: Consumer soft goods, primarily women's apparel

The inspiration for this piece came directly from the newsstands. Bob Prow explains, "Kellwood is primarily an apparel company, and wanted to focus on fashion in this annual report. There are three themes in the narrative part of the book: value, fashion, and diversity. We researched a number of fashion magazines to give this annual report an authentic magazine look, and shot photos that were more fashion than product oriented."

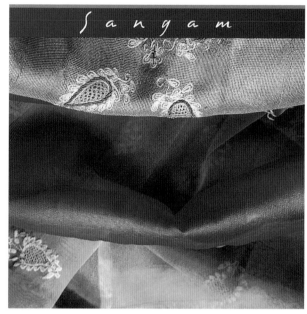

Sangam

NAME OF PIECE: Sangam postcard and logo design
STUDIO NAME: Q
ART DIRECTOR: Sanjana Kapur
PHOTOGRAPHER: Soren Coughlin, Glazer Photography
CLIENT: Sangam
CLIENT'S PRODUCT: Curtains

Sanjana Kapur explains the inspiration for this piece: "Sangam is a place in India where three rivers meet. Thus Sangam for my client is a meeting point of all the design elements to create a wonderful product—in this case, curtains."

(right)

NAME OF PIECE: Mafalda Minnozzi: Angelo Blu
STUDIO NAME: ponto p design
ART DIRECTOR: Fabiana Prado
GRAPHIC COORDINATOR: Marciso "Pena" Carvalho
PHOTOGRAPHER: Nico Tucci
CLIENT: Som Livre
CLIENT'S PRODUCT: Recording studio
SPECIAL FEATURES: The handmade typeface was created by André Rola.
SPECIAL PRODUCTION TECHNIQUES: The pages that contain photos are printed in CMYK and the pages that contain text and thin lines are printed in two Pantone colors, in order to avoid registration errors.

Designer Fabiana Prado visually translated the name of the CD, Angelo Blu, and in doing so created an angelic image for the singer. The photo images were cropped closely and the original black and white photos color-tinted with blue and purple. These colors are woven throughout the project.

(below)

NAME OF PIECE: Red Ella logo
STUDIO NAME: Born to Design (for Bonneau Production Services)
ART DIRECTORS: Todd Adkins, Terry Bonneau
DESIGNER: Todd Adkins
ILLUSTRATOR: Todd Adkins
CLIENT: Red Ella
CLIENT'S SERVICE: Boutique

"The boutique was named for the owner's grandmother who, while very stylish, was also remembered for being full of vitality and life. A loose, retro illustration style along with whimsical hand-drawn lettering convey a sense of freedom and playfulness, while the illustration itself maintains a unique reserve, style and class," explains Todd Adkins.

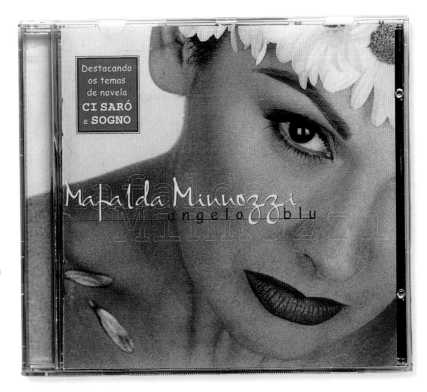

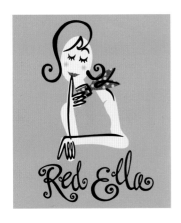

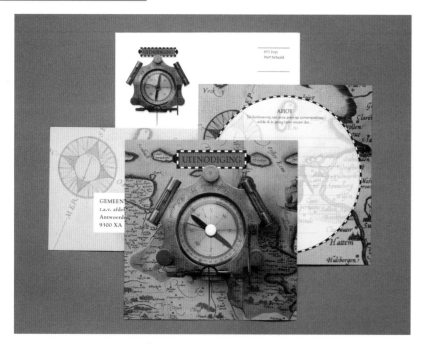

(left)
NAME OF PIECE: Retirement party invitation
STUDIO NAME: Erwin Zinger Graphic Design
DESIGNER: Erwin Zinger
PHOTOGRAPHER: John Stoel
CLIENT: Gemeente Noordenveld (City of Noordenveld)
SPECIAL FOLDS/FEATURES: A three-dimensional pointer was attached after printing.

Erwin Zinger used photography of an antique compass and a map to emphasize a sailing theme, since this was a hobby the mayor was planning to pursue after his retirement.

The lower left image contains three hand-bound books with masculine mahogany covers and brass engraved plates. Erwin Zinger explains, "We took the reception cards that people filled out and bound them together with the photos made during the various receptions." The final product is a handsomely bound collection of memories.

(below)
NAME OF PIECE: *Cigar Aficionado* magazine logo
STUDIO NAME: DogStar
ART DIRECTOR: Martin Leeds/*Cigar Aficionado* Magazine
DESIGNER: Rodney Davidson
ILLUSTRATOR: Rodney Davidson
CLIENT: *Cigar Aficionado* magazine

Rodney Davidson describes the process he went through to create this logo. He says, "The client wanted to capture the essence of a cigar lover in the simplest form. I purchased a Mexican cigar to get me in the mood. I began drawing Mexicans wearing sombreros and discovered that C and A could be combined to create a fedora-wearing cigar smoker."

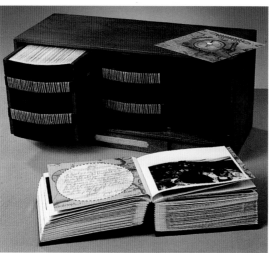

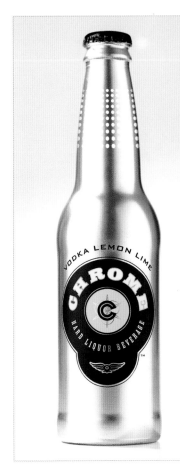

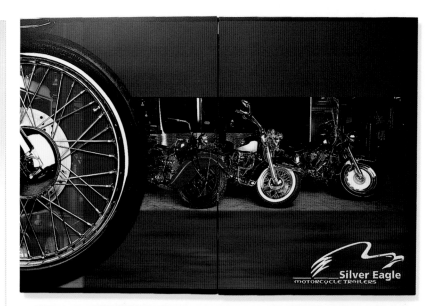

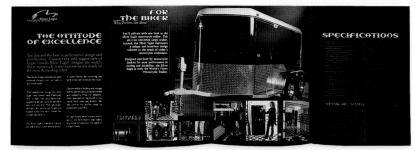

NAME OF PIECE: Chrome Hard Liquor Beverage packaging
STUDIO NAME: dossiercreative inc
CREATIVE DIRECTOR: Don Chisholm
DESIGNER: Peter Woods
CLIENT: American Vintage Beverage Co.

"We developed a concept which captures the nuances of a clear white liquor product named Chrome. We picked up on the cool, rebel factor of vintage motorcycles and related iconography to support the concept. Our team wanted to devise a brand which would offer a badge of distinction for the fashion-conscious, usually black-clad cosmopolitan crowd," explains Don Chisholm.

NAME OF PIECE: Silver Eagle gatefold
STUDIO NAME: Dutro Communications
ART DIRECTOR: Ed Quinlan
DESIGNER: Paul Fleming McCullagh
PHOTOGRAPHER: CD Photography
CLIENT: Logan Coach
CLIENT'S PRODUCT: Motorcycle trailers
SPECIAL PRODUCTION TECHNIQUES: Stochastic printing with an aqueous flood to reduce fingerprints.
SPECIAL FOLDS/FEATURES: Gatefold with ⅛ inch (3 mm) between flaps when folded

The Dutro Communications team wanted to show the harsh, rugged lifestyle of people who would use the trailer, as well as its features. The epitome of masculinity, this brochure is emblazoned with motorcycles and metallic-like fonts which are perfect for its primarily male audience.

Attic
ABCDEFGHIJKLMN
OPQRSTUVWXYZ
abcdefghijklmn
opqrstuvwxyz
1234567890

San Marco
ABCDEFGHIJKLMN
OPQRSTUVWXYZ
abcdefghijklmnopqrstuvwxyz
1234567890

Engravers Old English
ABCDEFGHIJKLMN
OPQRSTUVWXYZ
abcdefghijklmnopqrstuvwxyz
1234567890

CASTELLAR
ABCDEFGHIJKLMN
OPQRSTUVWXYZ
1234567890

ROSEWOOD
ABCDEFGHIJKLMN
OPQRSTUVWXYZ
1234567890

Love Letter Typewriter
ABCDEFGHIJKLMNOPQRSTUVWXYZ
abcdefghijklmnopqrstuvwxyz
1234567890

C0 M65 Y100 K32
C0 M65 Y100 K11
C0 M0 Y15 K6

C69 M87 Y100 K0
C91 M79 Y100 K0
C20 M60 Y100 K0

C100 M79 Y0 K0
C0 M91 Y87 K0
C0 M0 Y0 K0

C0 M0 Y0 K100
C18 M30 Y56 K0
C100 M79 Y0 K27

C30 M0 Y30 K55
C0 M85 Y85 K11
C0 M15 Y25 K0

C50 M75 Y75 K0
C10 M20 Y100 K10
C70 M0 Y30 K35

C20 M60 Y100 K0
C25 M10 Y75 K0
C4 M45 Y65 K0

C70 M25 Y5 K30
C100 M0 Y80 K40
C20 M20 Y25 K10

HISTORICAL ❖ COLOR

HISTORICAL

Historical designs often convey a sense of nostalgia. This style might indicate that your product or service has been around for a long time and it's not going anywhere, or that you have an advantage because you have learned from past experience. Even though your design has roots in the past, that doesn't mean it can't explore new territories.

> "To ensure that what we have heard is accurate, a creative brief is outlined and presented before we begin to work conceptually. Throughout the design process, the creative brief is measured against the original brief to ensure that consistency is maintained in strategic direction, and that client goals and objectives are being met. This approach ensures that the creative is on target."
>
> —Jeremie White

DEFINITION ❧

historical (adj.)

1. Of or relating to the study of history
2. Of what is important or famous in the past
3. Having once lived or existed or taken place in the real world as distinct from being legendary

QUESTIONS FOR CLIENT ❧

➤ Do you want the target audience to know that your business has a long and solid history?

➤ Will your audience appreciate the historical significance of your design?

➤ Does your audience tend to be older and more mature?

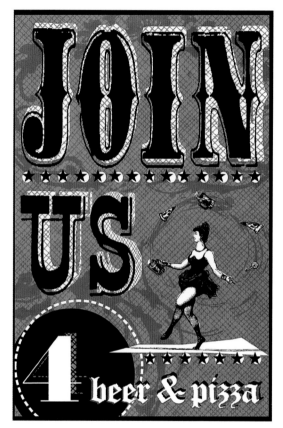

(top)
STUDIO NAME: Emma Wilson Design Company
NAME OF PIECE: Join Us invitation
ART DIRECTORS: Emma Wilson, Larry Asher
DESIGNER: Emma Wilson
CLIENT: School of Visual Concepts
SPECIAL PRODUCTION TECHNIQUE: Indigo printing

Emma Wilson explains, "The school wanted an invitation that recognized and celebrated its teachers and those who have made a contribution to the school, while also nodding to the fact that sometimes it felt like a circus. I was reminded of those lovely (and I mean that) circus sideshow banners and wanted to emulate that look and feel."

(bottom left)
NAME OF PIECE: Crossings at the Riverhouse logo
STUDIO NAME: Jeff Fisher LogoMotives
CREATIVE DIRECTOR: Sue Fisher, TriAd
DESIGNER: Jeff Fisher
CLIENT: Crossings at the Riverhouse
CLIENT'S PRODUCT/SERVICE: Restaurant at a resort hotel

Jeff Fisher used the historical surroundings of the site of the restaurant for inspiration. He says, "The name 'Crossings' actually refers to the fact that the restaurant and hotel are located at the site of an old cattle crossing."

(bottom right)
NAME OF PIECE: Fog City Press logo
STUDIO NAME: DogStar
ART DIRECTORS: Diane Dempsey/Weldon Owens Publishing
DESIGNER: Rodney Davidson
ILLUSTRATOR: Rodney Davidson
CLIENT: Weldon Owens Publishing

Rodney Davidson says, "Memories of San Francisco and walking across the Golden Gate Bridge were all the inspiration I needed for this mark." The historical landmark and the black-and-white treatment together give this logo a sense of history.

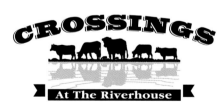

NAME OF PIECE: Turner Classic Movies calendar
STUDIO NAME: BAD Studio
ART DIRECTOR: Scott Banks
DESIGNERS: Scott Banks, Suzanna Schott, Kevin Fitzgerald
CLIENT: Turner Classic Movies
CLIENT'S PRODUCT/SERVICE: Cable TV network
SPECIAL PRODUCTION TECHNIQUES: The calendar is designed to stand up on a desk using a minimum of space. An intro page had to be added so the two visible pages would be for the same month.

One of the inspirations for this piece came from the countdown dial at the beginning of a film. According to Scott Banks, "The flashing circles that count down to the start of the movie create a great sense of anticipation."

NAME OF PIECE: Old Whiskey River packaging
STUDIO NAME: MOD/Michael Osborne Design
ART DIRECTOR: Michael Osborne
DESIGNER: Paul Kagiwada
CLIENT: Alive Spirits
CLIENT'S PRODUCT/SERVICE: Old Whiskey River bourbon

Willie Nelson's song "Whiskey River" was the inspiration for this package design, explains Art Director Michael Osborne. With a Western typeface, a bandana-like stripe down the side, and a guitar pick tied to the top of the bottle, this package definitely achieves an authentic appearance.

NAME OF PIECE: meth*od*o*lo*gy notecards
STUDIO NAME: Chen Design Associates
ART DIRECTOR: Joshua C. Chen
DESIGNERS: Joshua C. Chen, Kathryn A. Hoffman, Leon Yu, Gary E. Blum
COPYWRITERS: Joshua C. Chen, Kathryn A. Hoffman
ILLUSTRATORS: Gary E. Blum, Elizabeth Baldwin
PHOTOGRAPHERS: Joshua C. Chen, Leon Yu

"As we were brainstorming for this project," says Joshua C. Chen, "it occurred to us that people were rushing toward the new millennium with seemingly no regard for the past—as if by a flip of the calendar from 1999 to 2000 we would suddenly be in this ultramodern, futuristic environment. As designers deeply rooted in the historical context of our craft, we wanted to make a statement about the timeless elements of good design."

(right)
NAME OF PIECE: Bad Country poster
STUDIO NAME: BAD Studio
DESIGNER: Scott Banks
SPECIAL PRODUCTION TECHNIQUE: Silkscreen

"European and Asian copies of American design" were the inspirations for this design, explains Scott Banks, "It's sort of a copy of a copy." This piece uses two tones, blue and brown, to achieve a look that could be straight from an old western poster in the 1900s. The silkscreen appearance and the distressed country-western typefaces give the poster an ethereal, authentic quality.

(below)
NAME OF PIECE: Central Oregon Air Show logo
STUDIO NAME: Jeff Fisher LogoMotives
CREATIVE DIRECTOR: Sue Fisher, TriAd
DESIGNER: Jeff Fisher
CLIENT: Central Oregon Air Show
CLIENT'S SERVICE: Annual community air show

Jeff Fisher states that "the greatest representation of altitude in the central Oregon region are the snow-covered Three Sisters Mountains. Incorporating graphic images of mountains, clouds and a moving plane seemed natural. I used an airplane image not of a specific plane, but rather a generic fighter jet from a historic perspective. The use of red, white and blue—along with a state fair-like design quality—add to that sense of history."

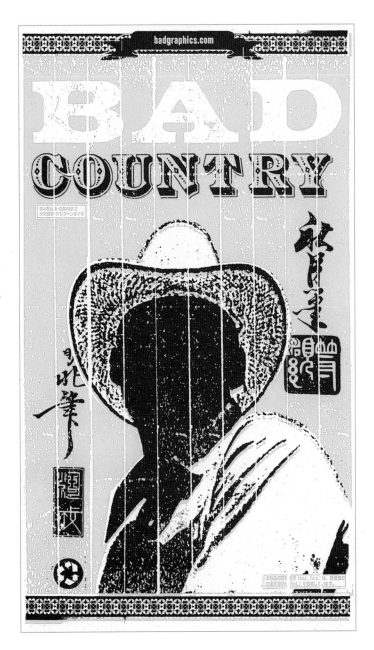

NAME OF PIECE: Interwest Partners brochure
STUDIO NAME: Cahan & Associates
ART DIRECTOR: Bill Cahan
DESIGNER: Kevin Roberson
ILLUSTRATOR: Tim Bower
CLIENT: Interwest Partners
CLIENT'S SERVICE: Venture capital
SPECIAL PRODUCTION TECHNIQUES: The entire brochure is letterpressed on French-folded paper to give it a personal, intimate feel.

Kevin Roberson explains, "Most venture capital firms are perceived as 'vulture capitalists'— only out for money. InterWest Partners, however, are known for being the nice guys of the business. Instead of bragging about their hefty capital resources or their long list of credentials, the focus of this piece is on their keen ability to create and maintain relationships. Large headlines are the objective voice of a therapist giving advice about successful relationships. Small quotes from the partners support the therapist's ideas with more specific business language. Small line art illustrations and short first-person biographical statements further differentiate our client from the slick approaches of most venture capital brochures."

NAME OF PIECE: *Leading the Way* capital campaign case statement
STUDIO NAME: Chen Design Associates
ART DIRECTOR: Joshua C. Chen
DESIGNERS: Joshua C. Chen, Kathryn A. Hoffman
PHOTOGRAPHER: Richard Wheeler
CLIENT: San Francisco Theological Seminary
SPECIAL PRODUCTION TECHNIQUES: The team used a metallic and black duotint for the historical photo. They also used a four-digit metallic ink for overprinting, which eliminates the need for dry-trapping and saves both time and money.

Joshua Chen explains, "We melded history with forward-thinking elements in numerous ways: deep, rich colors and cover stock; an antique-looking metallic ink; a timeline of seminary 'firsts' along the bottom of the piece; juxtaposition of old photos of the students with contemporary faces; an old Western typeface set in an edgy way with distressed urban touches; rich tri-tone full-bleed photography; and nontraditional cropping of photos."

Elliotts Typhoid Mary 8

ABCDEFGHIJKLMN
OPQRSTUVWXYZ
abcdefghijklmn
opqrstuvwxyz
1234567890

Elliotts Venus Dioxide

ABCDEFGH99KLMN
OPQRSTUVWXYZ
abcdefghijklmn
opqrstuvwxyz
1234567890

Face Cuts

Pike

ABCDEFGHIJKLMN
OPQRSTUVWXYZ
abcdefghijklmn
opqrstuvwxyz
1234567890

Litterbox

ABCDEFGHIJKLMN
OPQRSTUVWXYZ
abcdefghijklmn
opqrstuvwxyz
1234567890

C0 M79 Y94 K0
C0 M11 Y47 K0
C76 M0 Y47 K30

C59 M51 Y49 K58
C89 M28 Y0 K0
C0 M0 Y40 K0

C18 M0 Y100 K18
C40 M30 Y30 K100
C6 M0 Y0 K34

C0 M100 Y0 K100
C0 M0 Y20 K88
C0 M91 Y76 K6

C70 M35 Y6 K6
C0 M90 Y100 K0
C55 M0 Y6 K0

C0 M85 Y10 K0
C50 M20 Y80 K7
C10 M15 Y75 K0

C56 M0 Y47 K34
C0 M30 Y83 K0
C43 M0 Y0 K23

C100 M69 Y0 K12
C7 M7 Y94 K0
C89 M28 Y0 K0

Humorous ■☞ color

Eye-catching, intriguing and lighthearted, a humorous approach to design is extremely popular and effective in society today. If you can grab your audience's attention by making them chuckle or simply entertain them for a moment, chances are they'll remember your product or service and perhaps, if you're lucky, even tell others.

> "It is the visual sense of humor that our clients like. It adds another level to design, making it something more than just well-designed or a pretty picture."
>
> —Scott Banks

Definition ☞

humorous (adj.)
1. Full of or characterized by humor; funny
2. Employing or showing humor; witty

Questions for Client ☞

➤ Do you want the audience to feel like your business or product has a sense of humor?
➤ Do you have the latitude to stray away from a corporate image and surprise your audience?
➤ What type of humor are you trying to portray? Are you poking fun, being sarcastic, telling a joke, or pointing out irony?

(top)
NAME OF PIECE: DogStar Logo Series
STUDIO NAME: DogStar
DESIGNER: Rodney Davidson

Rodney Davidson conceived this piece to give a friendly reminder to clients who were past due on their payments. He says, "The idea behind the Paid in Full logo is merely gratitude for their prompt payment. Sometimes late payments are just an oversight so the first Past Due notice serves as a friendly reminder. The next mark I think speaks for itself. No more friendly reminders at this point. Collecting has become a serious issue. Finally, I created the last Past Due notice while trying to collect the down payment for my house. It worked!"

(bottom)
NAME OF PIECE: DataDork logo
STUDIO NAME: Jeff Fisher LogoMotives
DESIGNER: Jeff Fisher
CLIENT: DataDork
CLIENT'S PRODUCT/SERVICE: A web-based resource for self-proclaimed "computer geeks"

Jeff Fisher explains, "The term 'DataDork' is a name given to the client by his wife while he was still in college majoring in computer science. I was a little leery of focusing on the stereotypical image of a 'computer geek' in the design of the logo. However, this was exactly what the client wanted. When this version of the design was e-mailed to the client he immediately called and left a message that said, 'Stop. Don't do anything else to this design!'"

NAME OF PIECE: *Mission Stratakolour: Space Cadet's journey out of monotony*
STUDIO NAME: Q
ART DIRECTOR: Thilo von Debschitz
DESIGNER: Matthias Frey
COPYWRITER: Christoph Kohl
ILLUSTRATOR: Matthias Frey, vintage clip-art
CLIENT: Arjo Wiggins
CLIENT'S PRODUCT: Fine paper
SPECIAL PRODUCTION TECHNIQUES: Screen printing, silver, die cuts
SPECIAL FEATURE: Special binding (clips)

Matthias Frey explains, "Since Stratakolour is a rather conservative paper, we wanted to show that it also works for trendy and humorous applications, an unexpected solution. Our aim was to show the vibrant colors of Stratakolour by reducing the printed colors to silver, white and black. It is a duotone paper, hence the title 'Space Cadet's journey out of monotony.'"

(top)
NAME OF PIECE: MACtac sales kit
STUDIO NAME: Brokaw, Inc.
ART DIRECTOR: Steve McKeown
ILLUSTRATOR: Janis Emerson
CLIENT: MACtac
CLIENT'S PRODUCT: Pressure-sensitive label stock
SPECIAL PRODUCTION TECHNIQUES: Embossing, foil stamping, metallic inks and die cuts.

"In the printing industry, label stock has a bad reputation for being problematic on press, from oozing adhesive to poor ink hold-out. MACtac developed a line of innovative pressure-sensitive stock that solved many of these problems, making the printer's life a whole lot easier. With our campaign, we just took it one step further by using some pretty goofy examples to show how our product could help make people's lives easier, even in their typical office setting," explains Steve McKeown.

(bottom)
NAME OF PIECE: Popcorn
STUDIO NAME: HSR B2B
ART DIRECTOR: John G. Pattison
COPYWRITER: Paul Singer
PHOTOGRAPHER: Steve Paszt
CLIENT: Glacier Glove
CLIENT'S PRODUCT: Gloves for outdoor enthusiasts

John Pattison explains, "We wanted to illustrate the fact that there are no warmer gloves available on the market than these. Or more simply put, these are very warm gloves."

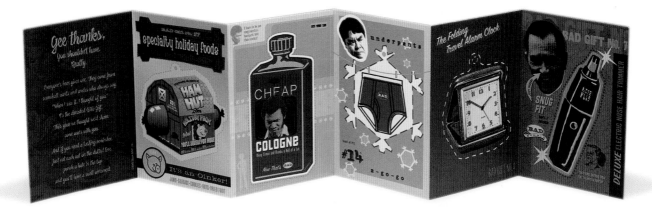

NAME OF PIECE: BAD holiday card
STUDIO NAME: BAD Studio
ART DIRECTOR: Scott Banks
DESIGNERS: Scott Banks, Lyn Albers, Mark McDevitt, Brook Haglar, Suzanna Schott
SPECIAL PRODUCTION TECHNIQUES: Lots of top-secret clip art sources
SPECIAL FOLDS/FEATURES: Accordion fold

"The inspiration for this piece was all the bad gifts people get and give around the holidays," explains Scott Banks, *"The accordion fold was a little tricky. At first we wanted a stand-alone last page, but then we would have had to kill one design or make the panels smaller because of the size of the press we were using."*

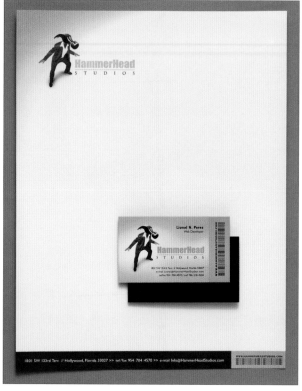

NAME OF PIECE: Gladly Remove It
STUDIO NAME: Brokaw Inc.
DESIGNER: Jody Dana
CLIENT: Jazzy Jeff's Tattoos

When asked about the inspiration for this piece, Jody Dana simply responded, "What? A tattoo parlor over a butcher shop isn't overtly inspirational?"

NAME OF PIECE: HammerHead Studios Corporate Identity
STUDIO NAME: O Design, Inc.
ART DIRECTORS: Dean Simunek, Ozzie Hernandez
DESIGNER: Dean Simunek
ILLUSTRATOR/PHOTOGRAPHER: Dean Simunek
CLIENT: HammerHead Studios, Inc.
CLIENT'S SERVICE: Internet solutions provider
SPECIAL PRODUCTION TECHNIQUES: "We opted to develop a nonstandard envelope design that opens from the side. This required the creation of a special die and production methods that required hand folding and gluing," explains Simunek.
SPECIAL FOLDS/FEATURES: A bar code was added to emphasize the functional nature of design and communicate the company's programming capabilities.

Dean Simunek describes the concept behind this logo: "Lionel Perez, a web developer, decided to change his company's name to HammerHead Studios, but didn't want to be associated with the shark of the same name. Our solution was to create a humorous icon that embodied Lionel's tenacious spirit while serving as a visual metaphor for HammerHead Studios. The result: a photo composite of the best tool available for building dynamic web sites."

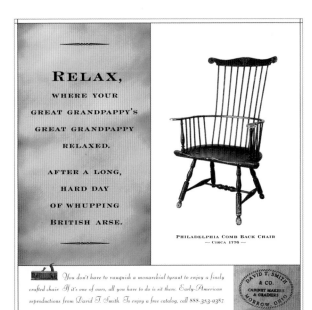

RELAX,

WHERE YOUR
GREAT GRANDPAPPY'S
GREAT GRANDPAPPY
RELAXED.

AFTER A LONG,
HARD DAY
OF WHUPPING
BRITISH ARSE.

PHILADELPHIA COMB BACK CHAIR
— CIRCA 1776 —

You don't have to vanquish a monarchial tyrant to enjoy a finely crafted chair. If it's one of ours, all you have to do is sit there. Early-American reproductions from David T. Smith. To enjoy a free catalog, call 888-353-9387.

DAVID T. SMITH
& CO.
CABINET MAKERS
& GRAINERS
MORROW, OHIO

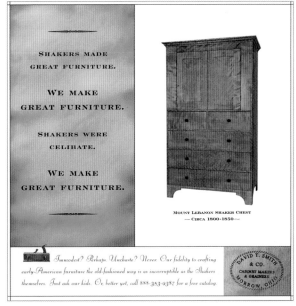

SHAKERS MADE
GREAT FURNITURE.

WE MAKE
GREAT FURNITURE.

SHAKERS WERE
CELIBATE.

WE MAKE
GREAT FURNITURE.

MOUNT LEBANON SHAKER CHEST
— CIRCA 1800-1850 —

Immodest? Perhaps. Unchaste? Never. Our fidelity to crafting early-American furniture the old-fashioned way is as incorruptible as the Shakers themselves. Just ask our kids. Or, better yet, call 888-353-9387 for a free catalog.

DAVID T. SMITH
& CO.
CABINET MAKERS
& GRAINERS
MORROW, OHIO

NAME OF PIECE: David T. Smith furniture campaign
STUDIO NAME: HSR B2B
ART DIRECTOR: John G. Pattison
COPYWRITER: Paul Singer
CLIENT: The Workshops of David T. Smith
CLIENT'S PRODUCT: Custom reproduction furniture

John Pattison remarks, "We wanted to use a very formal, dignified look to mirror the character of this beautiful handcrafted furniture. The headlines pay homage to each piece through unexpected humor. The result was a 200% increase in sales over a one-year period. David T. Smith became somewhat of a cult figure after these ads ran. Literally dozens of customers approached him at trade shows telling him how much they enjoyed the ads."

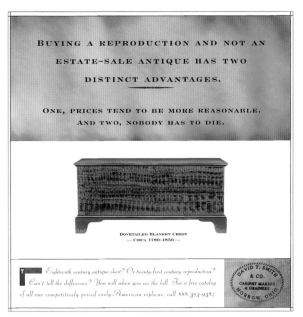

BUYING A REPRODUCTION AND NOT AN
ESTATE-SALE ANTIQUE HAS TWO
DISTINCT ADVANTAGES.

ONE, PRICES TEND TO BE MORE REASONABLE.
AND TWO, NOBODY HAS TO DIE.

DOVETAILED BLANKET CHEST
— CIRCA 1780-1850 —

Eighteenth century antique chest? Or twenty-first century reproduction? Can't tell the difference? You will when you see the bill. For a free catalog of all our competitively priced early-American replicas, call 888-353-9387.

DAVID T. SMITH
& CO.
CABINET MAKERS
& GRAINERS
MORROW, OHIO

Often, the type of font used in innovative design isn't what's important: it's how you use the characters. Look at this section's typographic treatments. Very often words are placed within an image, or are layered on top of one another. This creates a total package which is far more intriguing and captivating than the straightforward typography that is commonly seen.

Here are some typefaces that are staples for designers.

Tarzana
ABCDEFGHIJKLMN
OPQRSTUVWXYZ
abcdefghijklmn
opqrstuvwxyz
1234567890

DIN
ABCDEFGHIJKLMN
OPQRSTUVWXYZ
abcdefghijklmn
opqrstuvwxyz
1234567890

Officina Sans
ABCDEFGHIJKLMN
OPQRSTUVWXYZ
abcdefghijklmn
opqrstuvwxyz
1234567890

Futura
ABCDEFGHIJKLMN
OPQRSTUVWXYZ
abcdefghijklmn
opqrstuvwxyz
1234567890

Gill Sans
ABCDEFGHIJKLMN
OPQRSTUVWXYZ
abcdefghijklmn
opqrstuvwxyz
1234567890

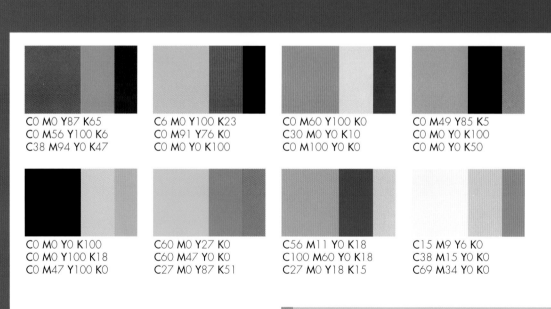

CO M0 Y87 K65
C0 M56 Y100 K6
C38 M94 Y0 K47

C6 M0 Y100 K23
C0 M91 Y76 K0
C0 M0 Y0 K100

C0 M60 Y100 K0
C30 M0 Y0 K10
C0 M100 Y0 K0

C0 M49 Y85 K5
C0 M0 Y0 K100
C0 M0 Y0 K50

C0 M0 Y0 K100
C0 M0 Y100 K18
C0 M47 Y100 K0

C60 M0 Y27 K0
C60 M47 Y0 K0
C27 M0 Y87 K51

C56 M11 Y0 K18
C100 M60 Y0 K18
C27 M0 Y18 K15

C15 M9 Y6 K0
C38 M15 Y0 K0
C69 M34 Y0 K0

INNOVATIVE | COLOR

INNOVATIVE

Innovative usually means that your design or packaging has a look that's never been done before. Innovative design is revolutionary in its typographic treatments, unusual color usage, and/or special production techniques. Many times—but not always—innovation costs, so be prepared to pay a little bit extra to show that you're on top of the times.

> "The key to successsful communication: ask a lot of questions for clarification, reiterate what the client is saying, and offer common examples or frames of reference to any potentially ambiguous words or concepts. As the relationship develops, learn the particular 'dialect,' the nuances of the client's words. Pay attention to what they mean rather than what they say."
>
> —Patrick Ho

DEFINITION |

innovative (adj.)

1. Ahead of the times
2. Being or producing something like nothing done or experienced or created before

QUESTIONS FOR CLIENT |

- ➤ Does your business set trends? How do you want to convey this in your design?
- ➤ Does your audience tend be attracted to cutting-edge products and services?
- ➤ Can you afford (both financially and professionally) to try new things?

INNOVATIVE

NAME OF PIECE: CFD self promotion
STUDIO NAME: Campbell Fisher Design (CFD)
ART DIRECTORS: Greg Fisher, Mike Campbell
DESIGNERS: Chris Bohnsack, GG Le Mere, Ken Peters

According to Greg and Mike Campbell, "We wanted to create a self promotion that would illustrate elements of our design process. In solving the different design-specific brain teasers, clients were engaged in the creative process and were ultimately driven to our Web site to find the answers." They add, "It's not something you merely look at; it's something you experience because you are asked to participate."

(right)
NAME OF PIECE: Retirement party invitation
STUDIO NAME: Erwin Zinger Graphic Design
DESIGNER: Erwin Zinger
PHOTOGRAPHER: John Welling
CLIENT: Gemeente Roden (City of Roden)
CLIENT'S PRODUCT/SERVICE: Local government
SPECIAL PRODUCTION TECHNIQUES: Foil printing
SPECIAL FOLDS/FEATURES: The fold of the envelope opens from
 the center rather than the top.

Erwin Zinger explains, "The mayor had been functioning as a
spider in his web throughout his career as a politician. That
inspired me to use the Pergamijn paper, which is often used
in photo albums and has a spider web impressed in it."

(below)
NAME OF PIECE: Vitamine per Milano
STUDIO NAME: Leftloft
CLIENT: Comitato Milly Moratti
CLIENT'S SERVICE: Promotion for a mayoral candidate in
 Milan, Italy

Vitamine was a promotional brochure that had a print run of
350,000 copies. As a piece of campaign literature, Leftloft had
to make sure that it spoke with images and "recounted the
political program using not a political language, but a language
near the people." Attention was devoted to themes, thanks to
the use of large photographs and titles.

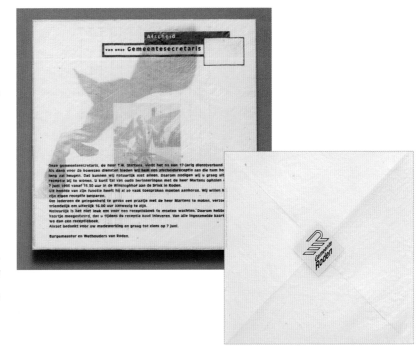

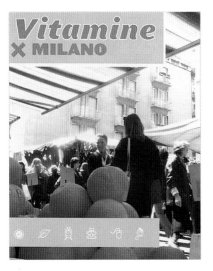

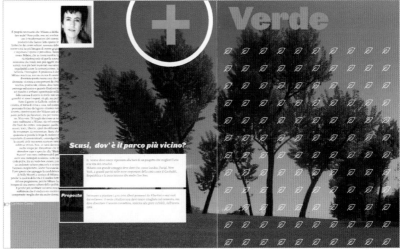

(left)
NAME OF PIECE: 3 x T
STUDIO NAME: dossiercreative inc
CREATIVE DIRECTOR: Don Chisholm
DESIGNER: Eena Kim
CLIENT: Self promotion
SPECIAL PRODUCTION TECHNIQUE: Clear thermography.
SPECIAL FOLDS/FEATURES: Embossed lexan to package the three teas together, screen printed lids and embossed tags

"For our Christmas gifts to our clients last year, we decided to give a set of three different teas. Each tea was packaged in individual tins decorated in motifs which are thematically linked to the associated regions. For example, the chai tea's package incorporates Hindi script in its design. To convey the complexity of flavor of each tea, we created a rich layered design and added the tactility of spot thermography to accentuate the sensual quality of the experience," says Patrick Ho.

(below)
NAME OF PIECE: *The Untouchables* promo
STUDIO NAME: TBS On-Air Creative Services
ART DIRECTOR: Paul Markowski
SENIOR DESIGNER: David Wilder
PRODUCER/CLIENT: Cary McNeal
OTHERS: Tobie Pate, Senior V.P. On-Air/Creative Director; Gary Holland, V.P. On-Air; Alysa Story, Art Director; Kathryn Bulmer, Graphics Producer
CLIENT'S PRODUCT: Promotional TV spots

David Wilder explains, "We wanted the mood of the era to come through in the design, so we focused on the Prohibition aspect of the movie. The idea for the fan occurred after watching the scene in which Eliot Ness raids a warehouse that supposedly houses several crates of whiskey. We wanted to give it that warehouse/art deco feeling without overstating it, so we chose to focus on an aspect of the warehouse—the fans."

(top)
NAME OF PIECE: Bioform logo and package
STUDIO NAME: Lewis Moberly
ART DIRECTOR: Mary Lewis
DESIGNERS: Mary Lewis, Ann Marshall, Isabelle Wolf
ILLUSTRATOR: Ian Rippington
CLIENT: Charnos
CLIENT'S PRODUCT: Lingerie and hosiery
SPECIAL FOLDS/FEATURES: The box is made from translucent polypropylene, printed front and back but left clear at the sides, allowing women to see through to verify the style and color of the bra inside. An "easy open" side panel encourages women to open the box and look at the product in more detail before making a decision to purchase.

This brand concept was innovation-led from start to finish. Mary Lewis explains: "For the product, brand, and packaging development, the brief was to rewrite the rules of bra marketing and create a unique brand proposition for parent company Charnos. The branding needed to be revolutionary, making the product stand apart within the category. The logo echoes the shape, locking both together to create powerful branding."

(bottom)
NAME OF PIECE: *Voices in the Moonlight*, a promotional campaign
STUDIO NAME: Vangool Design & Typography
NAME OF PIECE: Voices in the Moonlight
CREATIVE DIRECTOR: Helen Moore-Parkhouse
DESIGNER: Janine Vangool
PUPPET DESIGN AND CONSTRUCTION: Noreen Young Productions
MOON DESIGN AND CONSTRUCTION: Tom McCarthy
COVER PHOTOGRAPHY: Trudie Lee Photography
CLIENT: Calgary Opera
SPECIAL FEATURES: Die cut window and turning wheel

Janine Vangool explains that "the moonlight theme is meant to evoke the feeling of romance, of the enchantment of evening when our senses and emotions tend to be heightened and when there is magic in the air. It is through the instrument of the voice that the emotional impact of the opera is communicated, thus 'Voices in the Moonlight.'"

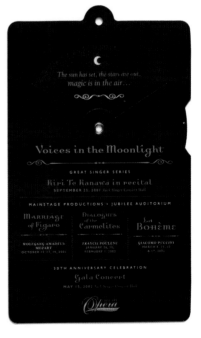

(left)
NAME OF PIECE: Agents
STUDIO NAME: Prejean LoBue
ART DIRECTOR: Kevin Prejean
DESIGNERS: Kevin Prejean, Gary LoBue, Jr.
ILLUSTRATOR: Kevin Prejean
CLIENT: Hallie Roberts Realty
SPECIAL PRODUCTION TECHNIQUES: In order to mimic multiple
 spot colors in a cost-effective way, the two designers
 utilized extremely fine line screens (200 lpi) with CMYK
 screen tints.
SPECIAL FOLDS/FEATURES: The back panel of the announce-
 ment was die cut to accept the client's standard-size
 business cards.

The designers at Prejean LoBue wanted to play on the word "agent" for this piece.

(below)
NAME OF PIECE: 500 Watts business card
STUDIO NAME: 500 Watts
DESIGNER: Bob Slote
CLIENT'S SERVICE: Design studio

Bob Slote explains that this innovative approach to business card design was inspired by European cigarette packages, coupled with a unique logo.

You'll find them in the oddest places. Behind the drapes. Or at the races.

In Zanzibar. A Paris flat. Or Vegas playing Baccarat.

Secret Agent

With grace and style they combat evil and keep the free world from upheaval.

And when their quarry's been deterred, a dry Martini, "shaken, not stirred."

Faster cars. Gleaming teeth. Brighter whites. And pain relief.

Give them ants a foggy death. Cure poor Fido's doggy breath.

Chemical Agent

Whisk away that scummy grime. Do your chores in half the time.

Everywhere and everyday, science helps us in some way.

NAME OF PIECE: *Powerful Page Design*
STUDIO NAME: F&W Publications
DESIGNER: Lisa Buchanan
SPECIAL FEATURES: Silver printed cover with red gel die cut.

Lisa Buchanan states, "The inspiration for this book was the layering designers use every day in page layout programs like QuarkXPress, specifically the grid system. Looking at page design, one wouldn't necessarily notice the grid that lies beneath, but this is what holds everything together. The entire concept of the book was based on a theme of 'revealing,' from the cover to the endpapers. The red transparency on the cover hides the entire title so that when you first see it, it reads, 'To design your vision.' But once you open the cover, you see colors that were hidden and the subtitle becomes: 'Top designers lay out their concepts to reveal their inspirations.' There is also a surprise encoded message on the back endpaper of the book."

Girls are Weird
ABCDEFGHIJKLMNOPQRSTUVWXYZ
abcdefghijklmnopqrstuvwxyz
1234567890

Improv
ABCDEFGHIJKLMN
OPQRSTUVWXYZ
abcdefghijklmn
opqrstuvwxyz
1234567890

Kid Type-Crayon
ABCDEFGHIJKLMN
OPQRSTUVWXYZ
abcdefghijklmn
opqrstuvwxyz
1234567890

Schmelvetica
ABCDEFGHIJKLMN
OPQRSTUVWXYZ
abcdefghijklmn
opqrstuvwxyz
1234567890

Party
ABCDEFGHIJKLM
NOPQRSTUVWXYZ
abcdefghijklmnopqrstuvwxyz
1234567890

Kid Type Marker
ABCDEFGHIJKLMN
OPQRSTUVWXYZ
abcdef ghijklmn
opqrstuvwxyz
1234567890

C58 M0 Y22 K0
C0 M53 Y15 K0
C0 M5 Y61 K0

C56 M0 Y100 K0
C0 M6 Y72 K0
C0 M0 Y0 K100

C0 M100 Y30 K0
C100 M0 Y65 K0
C6 M0 Y76 K0

C100 M43 Y0 K0
C0 M91 Y76 K0
C65 M0 Y100 K0

C11 M0 Y79 K0
C100 M9 Y0 K6
C94 M91 Y0 K0

C0 M43 Y87 K0
C100 M0 Y6 K18
C0 M72 Y6 K0

C25 M5 Y100 K0
C100 M47 Y0 K0
C18 M94 Y0 K0

C100 M94 Y0 K6
C0 M0 Y100 K0
C100 M6 Y0 K34

Juvenile

This section's designs are targeted toward kids, and they often use bright colors and bold lines to attract attention. In order to best understand this market, gather up a niece or nephew, borrow a neighbor, or offer to babysit for a friend. Remember, boys and girls at younger ages have widely different interests, and their interests may change drastically from year to year, so it is in your best interest get as many specifics as possible.

"Sometimes a quick thumbnail is sketched to show a particular direction at the initial meeting. Other times we go back and have a brainstorm meeting on the objectives and let ideas fly, often coming up with something really wacky and hilarious. Then we usually tone it down to what we feel the public would like and present it to the client."

—Darren Wilson

DEFINITION ➤

juvenile (adj.)
1. Not fully grown or developed; young
2. Of, relating to, characteristic of, intended for, or appropriate for children or young people
3. Marked by immaturity; childish

QUESTIONS FOR CLIENT ➤

➤ What is the age of your target audience? Be very specific. Sometimes even a year or two makes a big difference.
➤ Is your audience mainly girls or boys, or both?
➤ What sort of atmosphere do you want to portray? Think about kids' typical surroundings and try to see things from their point of view.

(left)
NAME OF PIECE: The Learning Company's *Play & Learn Games* packaging
STUDIO NAME: MOD/Michael Osborne Design
ART DIRECTOR: Michael Osborne
DESIGNER: Nicole Lembi
CLIENT: The Learning Company
CLIENT'S PRODUCT: Educational software

These playful packages marketed to children use bright colors and active figures to intrigue and captivate the audience. Designed to educate, almost every licensed character is holding a book or visually referring to the learning process.

(bottom left)
NAME OF PIECE: Festival of the Lion King logo
STUDIO NAME: Disney Design Group
DESIGNER: Natalie L. Bert
CLIENT: Disney's Animal Kingdom®

The fun and festive characters intertwine to form a circle around the title of the show. The bold lines and appealing colors give this logo an engaging quality that speaks to to kids everywhere. Image © Disney.

(bottom right)
NAME OF PIECE: "What's the Evidence" logo
STUDIO NAME: Emma Wilson Design Company
ART DIRECTORS: Emma Wilson, Vicki Tripp
DESIGNER/ILLUSTRATOR: Emma Wilson
CLIENT: The Wright Group/McGraw-Hill
CLIENT'S PRODUCT OR SERVICE: Literacy products for children

The concept behind the creation of this logo was "to create a compelling visual landmark within a textbook to guide teachers to informative research," explains designer Emma Wilson. Simply rendered with a basic serif typeface, this logo points the way to additional information by using the universal symbol for sleuths, the thumbprint.

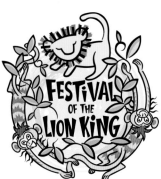

what's the evidence?

NAME OF PIECE: Nickelodeon identity manual
STUDIO NAME: AdamsMorioka, Inc.
ART DIRECTORS: Sean Adams, Russell Hicks, Lisa Judson, Noreen Morioka, Fred Seibert
DESIGNERS: Sean Adams, Volker Dürre
ILLUSTRATORS: Sean Adams, Jennifer Hopkins, Michael Mabry, Chip Wass
CLIENT: Nickelodeon
SPECIAL PRODUCTION TECHNIQUES: UV inks, varnishes, interactive CD
SPECIAL FOLDS/FEATURES: Wire-o binding, gatefolds, and half pages

According to Sean Adams, this identity manual reflects the same bright colors, fun shapes and unique characters found in Nickelodeon's programming to communicate with its audience.

(left)
NAME OF PIECE: Nabisco's *The Roll* package and display design
STUDIO NAME: Smith Design Associates
ART DIRECTOR: James C. Smith
DESIGNER: Carol Konkowski
ILLUSTRATOR: Jim Olsen
CLIENT: Nabisco/Kraft Foods

The objective for this project was to re-brand under the Nabisco umbrella, in order to create a bit more "attitude" for a 'tween [between child and teen, generally ages nine to thirteen] convenience store target. "We decided to bring the strawberry to life, tying the tongue to the product form, a 'roll,'" says James C. Smith.

(below)
NAME OF PIECE: The Ritter's Critter's Kids Club logo
STUDIO NAME: Born to Design
DESIGNER: Todd Adkins
CLIENT: Ritter's Frozen Custard

"The concept here was to make the image look like it was originally created for an ice cream or custard shop from the 1950s. The business model of the company plays heavily on old-fashioned values and on conveying a return to a simpler time when going out for ice cream was a fun family event, and the symbol needed to reflect these ideals," explains Todd Adkins.

NAME OF PIECE: Gymboree branding system
STUDIO NAME: MOD/Michael Osborne Design
ART DIRECTOR: Michael Osborne
DESIGNER: Paul Kagiwada
CLIENT: Gymboree
CLIENT'S PRODUCT: Children's clothing

Gymboree is in the children's fashion business and "requires a branding system and color scheme that is flexible, fun, and easy to apply across a wide array of materials," says Michael Osborne.

(below)
NAME OF PIECE: Genesis Productions logo
STUDIO NAME: Born to Design (for Flack Design)
DESIGNER: Todd Adkins
CLIENT: Genesis Productions
CLIENT'S PRODUCT/SERVICE: Christian theatrical productions

Designer Todd Adkins says, "The objective for this project was to create a logo that would convey heavenly celebration and praise to Christian viewers, but be easily accessible and not heavy-handed to a non-Christian as well. A rising sun composed of the initial G shines brightly to relate newness, rebirth and a light too bright to be contained, even within the boundaries of the blue morning sky."

To achieve a kinetic look, the choice of typeface isn't particularly important; it's how the audience reads the piece. Is it quickly read? Do the lines of type move your eye around the page? Is the type animated or dynamic in the way it's placed on the page or package? Sometimes unusual juxtapositions can make type seem to move. For example, placing a heavy, bold sans serif font before an italic font lends the feeling that the italic word is running away from the heavy word.

C100 M95 Y0 K0
C65 M100 Y0 K15
C0 M0 Y0 K0

C100 M0 Y50 K60
C35 M0 Y100 K60
C85 M95 Y0 K45

C35 M95 Y0 K0
C80 M70 Y0 K0
C100 M45 Y0 K0

C55 M60 Y0 K0
C45 M0 Y100 K25
C0 M45 Y70 K0

C0 M0 Y100 K30
C75 M40 Y0 K0
C0 M100 Y35 K10

C0 M100 Y65 K35
C50 M65 Y0 K0
C75 M40 Y0 K0

C72 M0 Y10 K0
C85 M0 Y55 K55
C100 M75 Y0 K10

C0 M0 Y95 K10
C0 M30 Y85 K0
C100 M80 Y0 K25

KINETIC≣ *color*

Kinetic

Motion, action, and excitement are the power players behind a kinetic design, either through the total package or through the images and colors displayed. Be sure to completely understand the message you are trying to communicate before beginning your project. Creating the perfect rhythm is the key to success in this dynamic style.

> "Before entering the specifics of the work to be carried out, I start obtaining information through an informal conversation about what the client likes, mainly by finding out what he or she does not like. I also observe the client's work environment, the kind of building the company has established, its location, its office, its decorations, etc."
> —Fabiana Prado

DEFINITION ≣

kinetic (adj.)
1. Relating to the motion of material bodies and the forces associated therewith
2. Characterized by motion
3. Supplying motive force

QUESTIONS FOR CLIENT ≣
➤ Do you want the audience to feel a rhythm that is fast-paced and powerful, or steady and methodical?
➤ Does your audience tend to be drawn to the exciting or dynamic?
➤ Do you want your audience to know that your product or service is moving forward with the times?

(top left)
NAME OF PIECE: AMP logo
STUDIO NAME: Jeff Fisher LogoMotives
ART DIRECTOR: Sara Perrin
DESIGNER: Jeff Fisher
CLIENT: AMP/Anne-Marie Petrie
CLIENT'S SERVICE: Business consultation and interior design services
SPECIAL PRODUCTION TECHNIQUES: The *A* in the logo was altered by digitally removing the cross bar and replacing it with a bolt of lightning.

Jeff Fisher explains that "with the client's initials being AMP, the use of electrical related imagery seemed a natural. After I met the high-energy client in person, the concept was confirmed."

(top right)
NAME OF PIECE: Black Warrior–Cahaba Rivers Land Trust logo
STUDIO NAME: DogStar
DESIGNER: Rodney Davidson
ILLUSTRATOR: Rodney Davidson
CLIENT: Black Warrior–Cahaba Rivers Land Trust
CLIENT'S SERVICE: Conservation

Rodney Davidson wanted to created a "fluid, integrated mark in which each element defines and gives balance to the design."

(bottom)
NAME OF PIECE: Disneyland Resort logo
STUDIO NAME: Disney Design Group
DESIGNER: Darren Wilson
CLIENT: Disneyland Resort

Darren Wilson explains, "The goal was to create one cohesive destination mark for both parks as well as Downtown Disney. I had the idea to use the castle and Grizzly Peak as equals and fuse them together with the monorail. The swoosh around the icons reins the mark in tight and stabilizes the type."

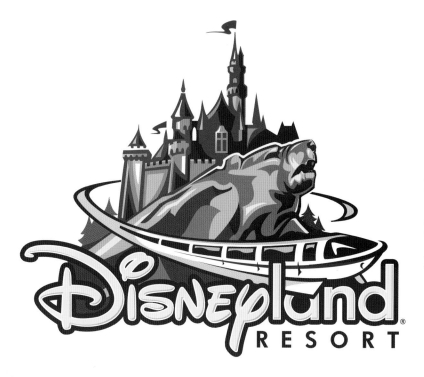

NAME OF PIECE: Mediterranean Games "Impression" logo
STUDIO NAME: STUDIO INTERNATIONAL
DESIGNER: Boris Ljubicic
CLIENT: International Committee of the Mediterranean Games

Boris Ljubicic explains the evolution of this design: "The five rings representing five continents (the Olympic logo) had been transformed into three rings (blue, yellow and black, representing Europe, Asia and Africa) as the logo for the Mediterranean Games. It is on this concept that I designed the logo for the Split 1979 Mediterranean Games. Its color is the blue of the Mediterranean, its rings one-third immersed in the sea. The logo is striking for its curved lines."

NAME OF PIECE: Providian Financial 1999 annual report
STUDIO NAME: Cahan & Associates
ART DIRECTOR: Bill Cahan
DESIGNER: Bob Dinetz
CLIENT: Providian Financial
CLIENT'S SERVICE: Financial services

"Providian Financial provides credit to individuals needing help to reach their financial goals and improve their lives. Through a layout that is intended to be conversational and easy to read, real letters from customers are featured for each area of business. Sentences are broken apart according to how a person would group their words into natural, logical phrases," says Bill Cahan.

NAME OF PIECE: Onerail corporate communications brochure
STUDIO NAME: Creative House
CREATIVE DIRECTORS: Julie Cochrane, Richard Carmichael
DESIGNER: Paul Edward Fleming
CLIENT: Onerail
CLIENT'S PRODUCT/SERVICE: Global rail reservations distribution
SPECIAL PRODUCTION TECHNIQUES: OPP matte laminate on the cover, overall varnish throughout the inside, metallic inks
SPECIAL FOLDS/FEATURES: Custom die cuts and rounded corners

Paul Edward Fleming describes the process he went through to create this piece. He says, "Since the literature revolved around an online application, I decided to work with a digital theme. The initial design element I created was an outlined keyboard effect over the photos, using round corner boxes stroked with a 0.5-point white line. The second inspiration came from the trains themselves. I wanted to capture the tremendous power of high speed trains that fly by in a blur. To accomplish this, I used blurs to add the feeling of motion and speed. Also, in the type I used a mixture of regular and italic faces to create the feeling the reader was traveling from page to page as from station to station."

NAME OF PIECE: Nike Seasons Greetings
STUDIO NAME: Karl Design/Brunnader & Kahl
ART DIRECTORS: Andreas Karl, Stefan Kahl, Jasmine Brunnader
DESIGNER/ILLUSTRATOR: Andreas Karl
CLIENT: Brunnader & Kahl/Nike Germany

Andreas Karl explains, "When I did this card for Nike, the company still used the name-plus-swoosh combination as its logo. I can't help it; for me, the swoosh always looks like the blade of a skate."

NAME OF PIECE: Love Square and Circle poster
STUDIO NAME: STUDIO INTERNATIONAL
DESIGNER: Boris Ljubicic
CLIENT: MDC, Museum Documentation Centre, Croatia

According to Boris Ljubicic, "The sheer simplicity and utilitarianism of the poster for International Museum Day was inspired by basic geometrical forms: the square and the circle. The poster, a three-dimensional object that is mounted on a wall, offers several dynamic images that change constantly, depending on the angle from which it is observed. The circle represents the culture of the East, while the square symbolizes the culture of the West. The light and sinewy quality of paper helps show that the object is not rigid and permanent; rather it is elastic, changeable and inspiring."

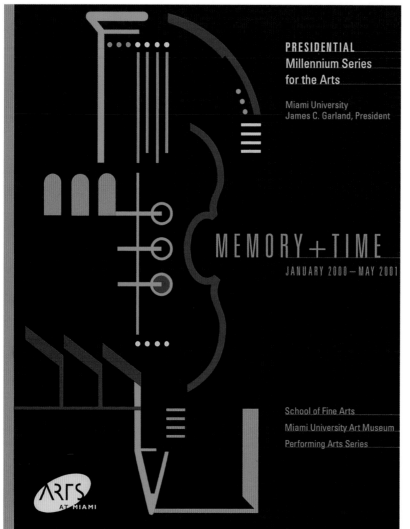

PRESIDENTIAL
Millennium Series
for the Arts

Miami University
James C. Garland, President

MEMORY + TIME

JANUARY 2000 — MAY 2001

School of Fine Arts
Miami University Art Museum
Performing Arts Series

ARTS
AT MIAMI

(left)
NAME OF PIECE: Memory + Time poster
STUDIO NAME: Peg Faimon Design
DESIGNER: Peg Faimon
CLIENT: Miami University School of Fine Arts

"Representative elements from art, music, architecture, and theater are deconstructed and reconstructed to create a new, more holistic vision. The concepts of memory and time are integral to the pacing and placement of the elements," explains Peg Faimon.

(below)
NAME OF PIECE: Heavy Talent logo
STUDIO NAME: DogStar
DESIGNER: Rodney Davidson
CLIENT: Heavy Talent
CLIENT'S SERVICE: Artist representative

Rodney Davidson explains, "The artists represented in this group all happen to be of rather large stature as well as being creative heavyweights." The implied motion of the portfolio as well as the italicized type next to a heavy sans serif font gives this logo a feeling of motion.

HEAVY *talent*

(right)
NAME OF PIECE: Fiction First Aid
STUDIO NAME: F&W Publications
DESIGNER: Lisa Buchanan

The concept for this book comes from its title, *Fiction First Aid*. Lisa Buchanan says, "My mind conjured up many images relating to the medical field. Because I didn't want to be overbearing, I decided to use lots of white space and two power colors: red and blue. The motion of the heart monitor line leads your eye directly to the title, successfully capturing the audience's attention."

(below)
NAME OF PIECE: Cooper & Associates logo
STUDIO NAME: Jeff Fisher LogoMotives
DESIGNER: Jeff Fisher
CLIENT: Cooper & Associates
CLIENT'S SERVICE: Motivational speaker

Jeff Fisher says, "Previously Cooper had used an exclamation point as part of his business identity. A microphone seemed like the logical design element to convey the fact that the client was a speaker. Combining the two elements created a strong center graphic for the logo. Slanting the graphic allowed for the "dot" of the exclamation point to become the o in the word Associates, and the entire image projected more energy as a result."

FICTION
first aid

Instant Remedies
for Novels and Stories

 Raymond Obstfeld

AG Old Face
ABCDEFGHIJKLMN
OPQRSTUVWXYZ
abcdefghijklmn
opqrstuvwxyz
1234567890

Giza
ABCDEFGHIJKLMN
OPQRSTUVWXYZ
abcdefghijklmn
opqrstuvwxyz
1234567890

Berthold City
ABCDEFGHIJKLMN
OPQRSTUVWXYZ
abcdefghijklmn
opqrstuvwxyz
1234567890

Courier
ABCDEFGHIJKLMN
OPQRSTUVWXYZ
abcdefghijklmn
opqrstuvwxyz
1234567890

Blackoak
ABCDEFGHIJKLMN
OPQRSTUVWXYZ
abcdefghijklmn
opqrstuvwxyz
1234567890

Madrone
ABCDEFGHIJKLMN
OPQRSTUVWXYZ
abcdefghijklmn
opqrstuvwxyz
1234567890

CO M100 Y100 KO
C100 M34 YO KO
CO M35 Y100 KO

CO M15 Y94 KO
CO M51 Y100 KO
CO M100 Y91 KO

CO M6 Y6 K11
CO M100 Y91 KO
CO M27 Y100 KO

CO M80 Y10 K5
CO M10 Y100 KO
C80 M0 Y60 KO

CO M40 Y80 KO
CO MO YO K100
CO MO YO KO

CO M100 Y34 K9
CO M79 Y91 KO
C79 M100 YO K9

C91 M43 YO KO
C11 MO Y94 KO
C100 MO Y30 K23

C76 MO Y100 K11
CO MO Y100 K18
CO MO Y100 KO

(((**LOUD**))) COLOR

((LOUD))

You want your message OUT THERE, and a loud style will certainly achieve that goal. By noisily attracting attention, this type of design is urgent and intense, and needs to have an equally strong, powerful message. A loud design will clearly elicit the desired effect from your audience.

"Graphic design is all about communication. If the client feels comfortable that you understand their company, service or product, then selling an idea becomes that much easier (most of the time). The key is to clearly define the project needed and keep the client focused."

—Jill Howry

((DEFINITION))

loud (adj.)

1. Having, making, or being a strong or great sound; noisy
2. Clamorous; boisterous
3. Emphatic; impressive; urgent
4. Ostentatious; likely to attract attention

((QUESTIONS FOR CLIENT))

➤ Do you have a strong message?
➤ What response or call to action are you expecting?
➤ Who or what is your competition in the market? Do you need to associate with them or strongly oppose them?

ST. LOUIS SCIENCE CENTER 1998 ANNUAL REPORT

INTEREST ⊕
UNDERSTANDING

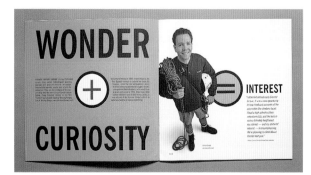

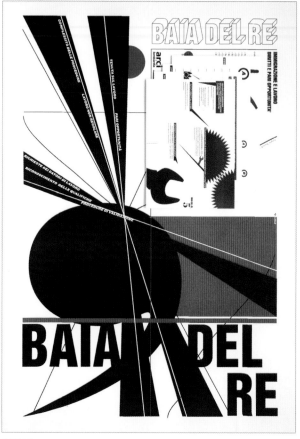

NAME OF PIECE: St. Louis Science Center 1998 annual report
STUDIO NAME: ProWolfe Partners, Inc.
ART DIRECTORS: Bob Prow, Tiffany Larson
DESIGNER: Tiffany Larson
CLIENT: St. Louis Science Center

Tiffany Larson says, "The goal of this piece was to emphasize the St. Louis Science Center's mission to create interest and understanding of science and technology within the community. The SLSC wants to be recognized for its role in educating people of all ages in the community, through its affiliations with public schools, special programs, demonstrations and exhibitions."

NAME OF PIECE: Baia del re poster
STUDIO NAME: Leftloft
CLIENT: Arci Milano
CLIENT'S SERVICE: Nonprofit cultural and social services for immigrants
SPECIAL FOLDS/FEATURES: The folded poster acts as an envelope to hold the schedules.

"Playing with constructivism, we represented the work and its problems" explain the designers from Leftloft. This piece is a large folded poster that sends its message loudly. As it unfolds, papers contained inside it are revealed. They define the schedules for the event.

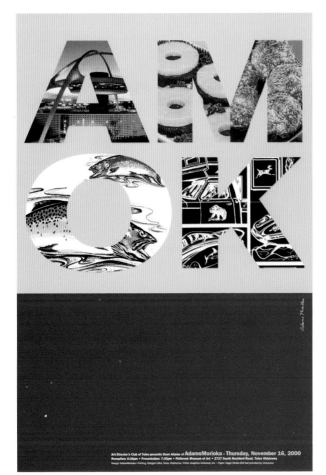

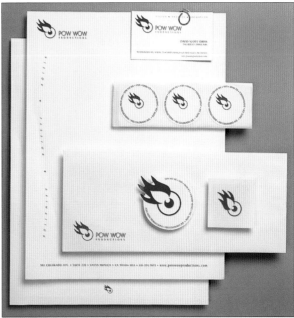

NAME OF PIECE: Pow Wow Productions Identity
STUDIO NAME: Westlake Advertising Agency
ART DIRECTOR: David Scott Smith
DESIGNERS: David Scott Smith, Robert Perry
ILLUSTRATOR: Robert Perry
CLIENT: Pow Wow Productions LLC
CLIENT'S PRODUCT/SERVICE: Animation and live action film design

"My drive was to capture two concepts: Vision (represented by an eye) and Passion (represented by fire). Simple, clean, direct. I wanted to identify our group as a gathering of creative spirits, represented in the circle motif. I personally felt compelled to dismiss any North American Indian cliché," explains David Scott Smith. *"The words Pow and Wow also suggested a little Lichtenstein and a bit of Batman."*

NAME OF PIECE: AdamsMorioka Oklahoma poster
STUDIO NAME: AdamsMorioka, Inc.
DESIGNER: Sean Adams
CLIENT: Art Director's Club of Tulsa

"The theme song from Rodgers & Hammerstein's 'Oklahoma!,' Los Angeles landmarks, fluorescent snowball snacks, and camper decals," are all inspirations for this Art Director's Club poster from AdamsMorioka, reports Sean Adams. These influences are visually contained within the type AMOK (for AdamsMorioka, OKlahoma).

MAYBE GOOD DESIGN
ISN'T PRETTY

some things are beyond words.

NAME OF PIECE: GVO brochure series
STUDIO NAME: Cahan & Associates
ART DIRECTOR: Bill Cahan
DESIGNERS: *What's Love Got To Do With It?*, Kevin Roberson; *Maybe Good Design Isn't Pretty*, Bob Dinetz; *Some Things Are Beyond Words*, Kevin Roberson
ILLUSTRATORS: Nick Dewar, Bob Dinetz
CLIENT: GVO Inc.
CLIENT'S SERVICE: Industrial design

Bill Cahan explains, "By highlighting the incorrect approach to product design, we wanted to make it clear in Maybe What's Love Got To Do With It? *that great products are what the customer really wants, not what the designer wants. In* Maybe Good Design Isn't Pretty, *our intention was to convey the idea that good design may not be what you think it is. In* Some Things Are Beyond Words, *our intention was to demonstrate that research is more than filling out questionnaires; it is about getting close to people and reading between the lines."*

NAME OF PIECE: Cinequest poster
STUDIO NAME: Tharp Did It
DESIGNERS: Rick Tharp, Jill Prestigiacomo
CLIENT: Cinequest
CLIENT'S SERVICE: Film festival

This poster for Cinequest was based on one simple image: Rick Tharp's eye. Posterized and enlarged to show the dots that form this shape, this design is sure to catch the attention of passers-by.

NAME OF PIECE: Mike's Hard Lemonade
STUDIO NAME: dossiercreative inc
CREATIVE DIRECTOR: Don Chisholm
DESIGNER: Peter Woods
CLIENT: Mark Anthony Brands

According to Patrick Ho, "The brand was developed as the product of a guy-next-door character to establish rapport with the advertising-savvy 19 to 26 age group. Our team created an anti-slick, anti-image branding strategy that steered clear of traditional refreshment motifs. The lack of these motifs meant that we had to rely more on the printed story, especially to convey the character of the brand. And—somewhat surprisingly in this supposedly visual age—many people did take the time to read the story."

FF Just Left Hand
ABCDEFGHIJKLMNOPQRSTUVWXYZ
abcdefghijklmnopqrstuvwxyz
1234567890

Trixie
ABCDEFGHIJKLMNOPQRSTUVWXYZ
abcdefghijklmnopqrstuvwxyz
1234567890

Gen X Crumble
ABCDEFGHIJKLMN
OPQRSTUVWXYZ
abcdefghijklmn
opqrstuvwxyz
1234567890

Metamorph
ABCDEFGHIJKLMN
OPQRSTUVWXYZ
abcdefghijklmn
opqrstuvwxyz
1234567890

Basketcase
ABCDEFGHIJKLMN
OPQRSTUVWXYZ
abcdefghijklmn
opqrstuvwxyz
1234567890

Your own handwriting...

CO M30 Y85 K0
C30 M45 Y100 K0
C30 M75 Y75 K35

C15 M10 Y25 K0
C43 M23 Y60 K0
C60 M66 Y100 K0

CO M0 Y0 K40
CO M0 Y0 K70
C35 M27 Y50 K0

C70 M38 Y0 K0
C45 M0 Y100 K60
C65 M65 Y50 K0

C10 M0 Y5 K47
CO M0 Y87 K60
C70 M38 Y0 K0

C75 M85 Y55 K0
CO M38 Y95 K20
CO M0 Y95 K70

C30 M75 Y75 K35
C70 M30 Y100 K5
C40 M80 Y20 K0

C30 M20 Y75 K10
C60 M15 Y85 K0
C30 M45 Y100 K0

MESSY/ color

In messy design, ordering your information in a hierarchy is extremely important. If you have a weak message, or one that is not clearly defined and organized, the meaning quickly becomes clouded and unclear within the designed chaos. With purposeful disorder, this design style can simulate grim reality or anarchy, depending on the treatment.

"Try really hard to confirm, both in conversation and in a written brief, exactly what was discussed and decided upon during this meeting. Something visual for reference in most cases is much better than words and will save you a lot of time and frustration during the design process."

—Kelly D. Lawrence

DEFINITION/
messy (adj.)
1. Disorderly and dirty
2. Exhibiting or demonstrating carelessness
3. Unpleasantly difficult to settle or resolve

QUESTIONS FOR CLIENT/
➤ Do you want to portray the feeling that the project is off-the-cuff, simulating real life, or bending the rules?
➤ Exactly how messy can the finished piece be? Is readability an issue with your audience?
➤ Will your message be enhanced by using a messy design?

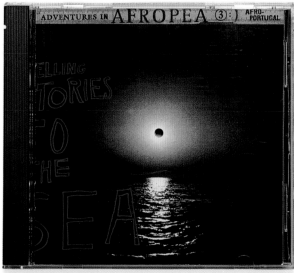

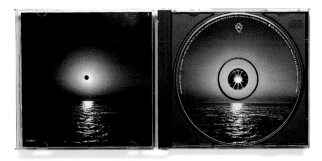

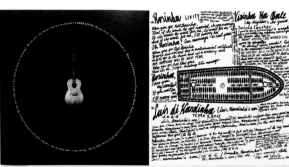

NAME OF PIECE: *Telling Stories*
STUDIO NAME: Sagmeister Inc.
ART DIRECTOR: Stefan Sagmeister
DESIGNERS: Stefan Sagmeister, Veronica Oh
ILLUSTRATOR: Indigo Arts
PHOTOGRAPHY: Tom Schierlitz
CLIENT: Warner Bros. Music Inc.
SPECIAL PRODUCTION TECHNIQUE: Die-cut hole

Stefan Sagmeister explains, "The music from this CD is a compilation of Portuguese-influenced music from the African Islands of Cape Verde and São Tome. We unified the wide range of different lyrics and artists with a hole that is die cut through the entire booklet. A friend (who reads more Taoists than I do) suggested the central theme of the cover is 'Nothingness.'"

(top left)
NAME OF PIECE: Redneck poster
STUDIO NAME: BAD Studio

For inspiration, Scott Banks needed to look no further than hand-lettered road signs in the South. The hand-illustrated and hand-written poster shows a slightly balding man with a five o'clock shadow and yellow teeth. He is yelling out an invitation for people to come to a poster show as flies buzz around him.

(right and bottom left)
NAME OF PIECE: BAD Studio poster show invite
STUDIO NAME: BAD Studio
ART DIRECTOR: Scott Banks
DESIGNER: Kevin Fitzgerald

BAD Studio had a certain requirement for this project: "Every piece for this event had to have a pair of 'Groucho' glasses in it. The challenge for each designer was the decision whether to exploit it, as in the Warhol-style poster, or push it as something more subliminal."

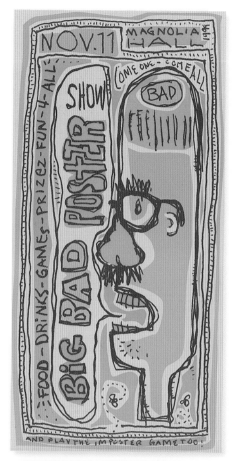

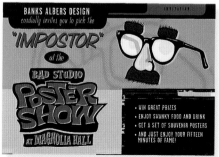

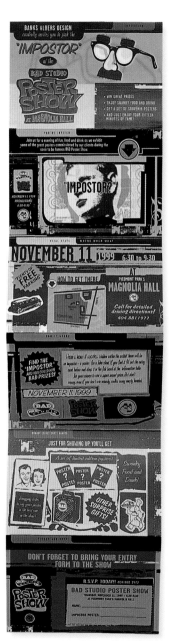

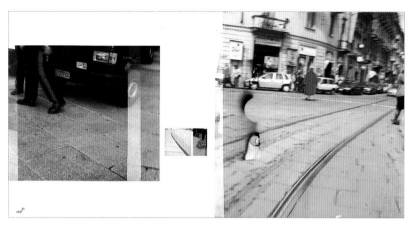

NAME OF PIECE: 520/01
STUDIO NAME: Matite Giovanotte
ART DIRECTORS: Barbara Longiardi, Antonella Bandoli, Sabrina Poli
DESIGNERS: Barbara Longiardi, Gianluca Rondoni
CLIENT: Yien Group
CLIENT'S PRODUCT: Magazine
SPECIAL FEATURE: Vacuum packaging

Art Director Barbara Longiardi worked with the color gray—
and its various shades and meanings—to create this piece.
In doing so, she highlights two different ways of portraying
"messy." In the first spread, photographs were taken with
quick movements and an unfocused lens, giving the piece a
rather chaotic appearance. In the second spread, the type
treatment displays a distressed quality, communicating its
raw nature.

NAME OF PIECE: *The Observer Life* magazine, "Virtual Reality"
STUDIO NAME: *The Observer*
DESIGNER: Wayne Ford
CLIENT: Self promotion
CLIENT'S SERVICE: Newspaper publishing

Wayne Ford explains that this is "a feature [article] on the new wave of fashion photography, and its use of computer technology." He used the work of Nick Knight, a photographer who is a key proponent of the style.

CHANCES THAT THERE IS LIFE ON ANOTHER PLANET: 1 IN 1,000,000,000

NAME OF PIECE: GVO brochure
STUDIO NAME: Cahan & Associates
ART DIRECTOR: Bill Cahan
DESIGNER: Bob Dinetz
ILLUSTRATORS: Bob Dinetz, Gary Baseman
CLIENT: GVO Inc.
CLIENT'S SERVICE: Industrial design

This particular brochure, Chances That There Is Life on Another Planet, *tries to convey the idea that even if the odds are against you, developing a new product does not have to be a gamble.*

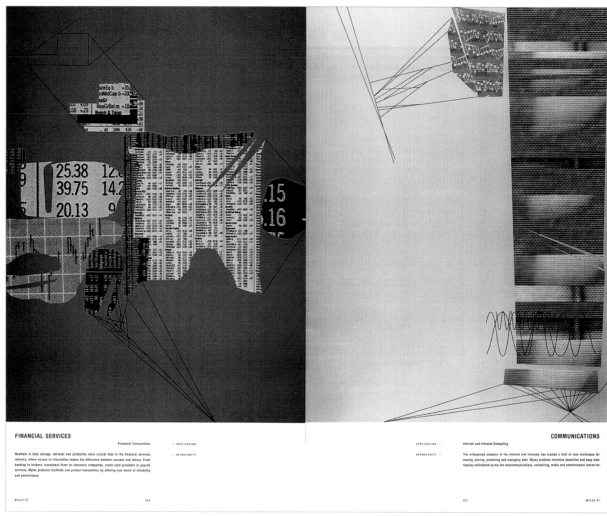

FINANCIAL SERVICES

Financial Transactions

- APPLICATION
- OPPORTUNITY

Nowhere is data storage, retrieval and protection more crucial than in the financial services industry, where access to information makes the difference between success and failure. From banking to brokers, investment firms to insurance companies, credit card providers to payroll services, Mylex products facilitate and protect transactions by offering new levels of reliability and performance.

APPLICATION - Internet and Intranet Computing

OPPORTUNITY -

The widespread adoption of the Internet and intranets has created a host of new challenges for moving, storing, protecting and managing data. Mylex products minimize downtime and keep data flowing unhindered across the telecommunications, networking, media and entertainment industries.

COMMUNICATIONS

NAME OF PIECE: Mylex 1997 annual report
STUDIO NAME: Cahan & Associates
ART DIRECTOR: Bill Cahan
DESIGNER: Bob Dinetz
ILLUSTRATOR: Bob Dinetz
CLIENT: Mylex Corporation
CLIENT'S PRODUCT: High-tech software

According to the designers at Cahan & Associates, "The purpose of the book was to quickly and boldly answer the three most important questions shareholders would ask after a disappointing year. In addition to the cost-effective one-color section, a full-color chapter is inserted in the middle of the annual to illustrate the areas in which Mylex's products have the most potential."

(top)
NAME OF PIECE: BAD Jazz limited edition poster
STUDIO NAME: BAD Studio
DESIGNER: Mark McDevitt
ILLUSTRATOR: Mark McDevitt

The inspirations for this piece were 1940s and 1950s jazz album covers, according to designer Mark McDevitt. This unique interpretation gives an unusually rough, raw perspective of this era.

(bottom)
NAME OF PIECE: School of Visual Concepts fall schedule
STUDIO NAME: Emma Wilson Design Company
ART DIRECTORS: Emma Wilson and Larry Asher
DESIGNER: Emma Wilson
CLIENT: School of Visual Concepts

Emma Wilson says, "This school caters to creative professionals who want to improve their skill set to get a more fulfilling job. Very often they have studied graphic design and advertising in college or have a career as a corporate creative but have found that their portfolio isn't compelling enough to get them the 'big firm' job."

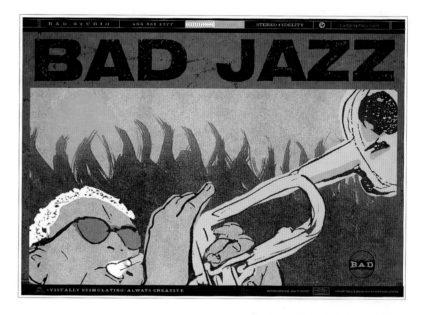

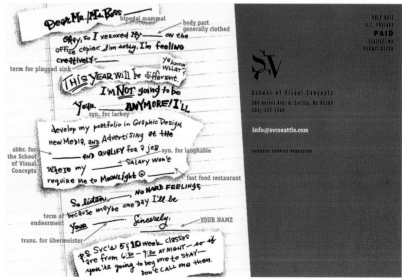

Base 9
ABCDEFGHIJKLMNOPQRSTUVWXYZ
abcdefghijklmnopqrstuvwxyz
1234567890

Univers Condensed
ABCDEFGHIJKLMNOPQRSTUVWXYZ
abcdefghijklmnopqrstuvwxyz
1234567890

Rotis Semi Sans
ABCDEFGHIJKLMNOPQRSTUVWXYZ
abcdefghijklmnopqrstuvwxyz
1234567890

Bell Centennial
ABCDEFGHIJKLMNOPQRSTUVWXYZ
abcdefghijklmnopqrstuvwxyz
1234567890

Bell Gothic
ABCDEFGHIJKLMNOPQRSTUVWXYZ
abcdefghijklmnopqrstuvwxyz
1234567890

Frutiger
ABCDEFGHIJKLMNOPQRSTUVWXYZ
abcdefghijklmnopqrstuvwxyz
1234567890

C89 M16 Y18 K5
C75 M62 Y0 K0
C15 M45 Y95 K5

C20 M100 Y70 K0
C0 M0 Y0 K100
C30 M21 Y21 K0

C0 M100 Y100 K0
C0 M12 Y100 K0
C100 M10 Y0 K0

C0 M0 Y0 K100
C0 M0 Y100 K0
C0 M0 Y0 K0

C0 M40 Y95 K0
C0 M0 Y0 K0
C0 M0 Y0 K100

C70 M35 Y65 K25
C30 M5 Y15 K0
C25 M20 Y25 K0

C80 M55 Y0 K0
C70 M75 Y10 K15
C50 M30 Y0 K0

C0 M10 Y20 K15
C0 M0 Y0 K50
C0 M40 Y40 K70

minimal color

minimal

This type of design is pared down to basic elements:
Less is more,
and
KISS (keep it simple, stupid).

> *"I try to bring back the information the client gives me to simple one-word items, words like confidence, innovative, business, etc. I use the words that I distill from the briefing constantly as a program of demands during the designing process. This is what the design should contain, [graphically] speaking."*
> —*Erwin Zinger*

definition

minimal (adj.)

1. Small in amount or degree
2. Only barely adequate

questions for client

➤ Do you want your design to look modern and clean?

➤ Does your audience tend to be attracted to simple, classic looks?

➤ Is most of your audience high-tech, trend-setting and modern?

➤ Can you express your message with a simple statement or image, or does it need to be more defined?

DISNEY
DESIGN
GROUP

(top and bottom left)
NAME OF PIECE: 505 Union Station branding program
STUDIO NAME: Michael Courtney Design
ART DIRECTOR: Michael Courtney
DESIGNERS: Michael Courtney, Scott Scouchuck
CLIENT: Vulcan NW
CLIENT'S SERVICE: Real estate development

"505 Union Station is an architecturally unique, technologically advanced building, placed at the center of a 'Silicon Campus' setting atop a new transportation complex. We wanted to showcase those features, so we used a brochure cover with an arc die cut (as on the building) and metallic colors," explains Michael Courtney.

(bottom middle)
NAME OF PIECE: Brokaw New Media logo
STUDIO NAME: Brokaw Inc.
DESIGNER: John Naegele
CLIENT'S SERVICE: Internet, multimedia development

"The circle was chosen to represent an all-encompassing background. Rounded corners of type soften the edges and make the logo feel personable. Unfinished letterforms are futuristic, suggesting what is to come. The characters represent an emergence, breaking away from conventional thought and the expected. They also reflect our belief that people are intelligent and don't need everything spelled out for them. Further, they embody simplicity, suggesting that communication is best when it is stripped down to its most basic idea," says John Naegele.

(bottom right)
NAME OF PIECE: Disney Design Group proposed logo
STUDIO NAME: Disney Design Group
ART DIRECTOR: Renee Schneider
DESIGNER: Joe Andrews
CLIENT: Self promotion

Joe Andrews explains, "When I began working on this logo I wanted to create one design that could be seen in two different ways. At first, I tried combining different poses of Mickey Mouse with the words Disney Design Group or the initials DDG but neither combination gave me what I was looking for. Then I noticed a front-view pie-eyed Mickey and realized that Mickey's eyes and nose were perfect for manipulating into the initials of our design firm. The resulting logo shows just enough of Mickey to be recognizable as Mickey/Disney and can also be read as DDG." Image © Disney.

(top)
NAME OF PIECE: SFMOMA millennium merchandise
and packaging
STUDIO NAME: MOD/Michael Osborne Design
ART DIRECTOR: Michael Osborne
DESIGNER/ILLUSTRATOR: Michelle Regenbogen
CLIENT: San Francisco Museum of Modern Art

*"The linear, modern architecture of the museum" was the
inspiration for these pieces, explains art director Michael
Osborne. The simple shapes and colors against a primarily
black background bring design back to its basics.*

(bottom)
NAME OF PIECE: Avery Flory Design identity
STUDIO NAME: Miaso Design
DESIGNER: Kristin Miaso
CLIENT: Avery Flory Design
CLIENT'S SERVICE: Architecture and interior design

*Kristin Miaso says, "I wanted to give Avery Flory a
contemporary yet conservative look for their identity.
The [2] represents the two partners, who are married."*

XO
MA
01
02
03
04
05
06
07
08
09
99
AR

NAME OF PIECE: XOMA 1999 annual report
STUDIO NAME: Howry Design Associates
ART DIRECTOR: Jill Howry
DESIGNER: Todd Richards
CLIENT: XOMA (US) LLC
CLIENT'S PRODUCT: Biopharmaceuticals developer

Todd Richards explains, "XOMA develops biopharmaceuticals with medical targets that include infectious diseases, immunological and inflammatory disorders, and cancer. Our task was first and foremost to position XOMA as a multiple drug/multiple indication company. The annual report served as an 'index' of diseases—what they look like, what drug candidates are being developed and at what stage of clinical trial development each candidate is." The simple cover conveys the essence of this concept.

NAME OF PIECE: meth*od*o*lo*gy notecards
STUDIO NAME: Chen Design Associates
ART DIRECTOR: Joshua C. Chen
DESIGNERS: Joshua C. Chen, Kathryn A. Hoffman, Leon Yu, Gary E. Blum
COPYWRITERS: Joshua C. Chen, Kathryn A. Hoffman
ILLUSTRATORS: Gary E. Blum, Elizabeth Baldwin
PHOTOGRAPHERS: Joshua C. Chen, Leon Yu

This design is part of a notecard set which was created to communicate two thoughts. One, there is a very deliberate system of principles, procedures and practices applied to the field of graphic design. And two, regardless of style and aesthetics, effective graphic design is rooted in the same basic principles.

Designer Christopher Gorz explains, "The concept of this piece was to highlight Abbott International's diverse HIV/AIDS research in a unifying way. To achieve this, the brochure was designed with each spread building upon the next. A die-cut graphic of an HIV molecule was the common element used throughout to accomplish this effect. When the page is turned, the hole reveals a word that makes up the statement above it."

Rodney Davidson explains, "In the early stages of concepting, I considered using the Christian fish symbol in some way but abandoned it to pursue other directions. I wanted the logo to get across the idea, 'Be ye fishers of men.' Eventually, I reconsidered the fish symbol and discovered a way to combine the fish with a human figure."

This logo is made up of only five basic rectangles. It clearly communicates both the name and purpose of this company by visually representing both a hand and a city skyline.

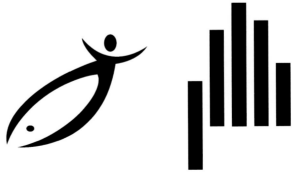

1120 North Ashland Avenue Chicago Illinois 60622 312 387 6947 786 ZLC

1120 North Ashland Avenue Chicago Illinois 60622
An Beckman J986 J86 J2C

NAME OF PIECE: Avant Gardeners identity system
STUDIO NAME: Rahmin Eslami Design
DESIGNER: Rahmin Eslami
PHOTOGRAPHER: Brian Steege, Guildhaus Photographics
CLIENT: Avant Gardeners
SPECIAL TECHNIQUES: cross-processed photography

*"I created the logo using two lowercase letter A's with one inverted to form a lowercase G,"
explains designer Rahmin Eslami "After all, part of being avant-garde is to flip the world upside
down and to look at it in another way. I also wanted the logo to be simple enough that it could
be iconic. To further this concept, I inverted all supporting text, including phone numbers and
song titles, causing the copy to meet in an avant-garde fashion. You can be reading in one
direction and then suddenly all the characters are upside down. For the image, I had been
working with the photographer on another project that required a cross-processed photography
shoot at the local airport. Toward the end of the shoot, he wanted to experiment even more."
The result: a distinctly unique shot with a new spin on reality.*

NAME OF PIECE: Center for Nonprofit Management 1999
annual report
STUDIO NAME: Prejean LoBue
ART DIRECTOR: Gary LoBue, Jr.
DESIGNERS: Gary LoBue, Jr., Kevin Prejean
ILLUSTRATOR: Gary LoBue, Jr.
CLIENT: Center for Nonprofit Management, Dallas
CLIENT'S SERVICE: Management training for nonprofit
organizations

*Gary LoBue, Jr., says, "With a new identity, a new positioning
statement and new attitude in place, it made perfect strategic
sense to utilize the narrative section of the report to promote
these new ideals to the organization's membership. The
positioning statement for the Center is 'Common Goals.
Uncommon Solutions.' With a declaration of that nature we
found that a theme based on seemingly impossible goals and
their subsequent solutions would make for an interesting
print communications vehicle. This also communicates the
willingness of the Center to go 'above and beyond.'"*

**Scaling Mount Everest, Landing on
the Moon, Running a Four-Minute
Mile, Reaching the North and South
Poles, Splitting the Atom, Finding a
Cure for Polio, Breaking the Sound
Barrier, Erecting the Empire State
Building, Flying Across the Atlantic
Ocean, Traveling Throughout Time.
Wait just a minute, we haven't made
time travel possible yet- have we?**

Center for Nonprofit Management 1999 Annual Report

Calfisch Script
ABCDEFGHIJKLMNOPQRSTUVWXYZ
abcdefghijklmnopqrstuvwxyz
1234567890

Professor
ABCDEFGHIJKLMNOPQRSTUVWXYZ
abcdefghijklmnopqrstuvwxyz
1234567890

Petras

ABCDEFGHIJKLMN
OPQRSTUVWXYZ
abcdefghijklmnopqrstuvwxyz
1234567890

DF Incidentals

Aquiline
ABCDEFGH
IJKLMNOPQR
STUVWXYZ
abcdefghijklmnopqrstu
vuxyz 1234567890

CO M91 Y100 K23
C43 M31 Y78 K15
C60 M0 Y51 K51

C0 M30 Y50 K0
C24 M14 Y37 K0
C36 M13 Y11 K0

C6 M0 Y50 K0
C45 M0 Y0 K0
C38 M0 Y51 K0

C0 M0 Y0 K0
C45 M48 Y0 K0
C0 M20 Y70 K0

C0 M56 Y100 K30
C0 M0 Y15 K6
C0 M65 Y100 K0

C100 M72 Y0 K6
C56 M0 Y91 K38
C0 M18 Y100 K43

C79 M94 Y11 K0
C0 M91 Y72 K23
C65 M0 Y23 K34

C55 M33 Y77 K0
C40 M35 Y30 K0
C52 M30 Y52 K0

Natural

Designs done in a natural style often use raw outdoor colors. Earthy pigments like olive, burgundy, and deep blue are very popular. Decide on the outdoor landscape that you want to use as your palette. Natural colors that are found in a deep woodland forest are obviously different from those found in a desert. The client should also be aware that this style can take on a somewhat unpolished look.

"I always ask clients who I feel may be on a different wavelength to bring a collection of interesting things to the first meeting. These can be anything from a competitor's brochure to a favorite movie; all of this helps build up a visual picture of my client."
—Wayne Ford

Definition 🍃

natural (adj.)
1. In accordance with or determined by nature or natural laws
2. Existing in or in conformity with nature or the observable world
3. Relating to or concerning nature
4. Not by design or artifice; unforced and impromptu

Questions for Client 🍁

➤ Do you want to emphasize the fact that your business is aware of the environment?
➤ What environment and location are you suggesting? What colors are associated with this landscape?
➤ How is your service or product connected to the outdoors?

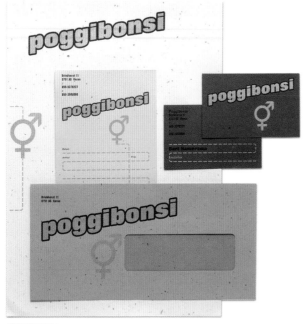

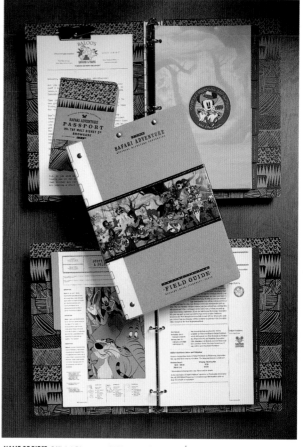

NAME OF PIECE: Poggibonsi stationery
STUDIO NAME: Erwin Zinger Graphic Design
DESIGNER: Erwin Zinger
CLIENT: Poggibonsi
CLIENT'S SERVICE: Fashion retailer

Erwin Zinger explains that the store sells "clothes which are useful for business and casual wear, so I tried to give [the design] the same touch." He combined the symbols for male and female to show that the store caters to both women and men.

NAME OF PIECE: Official Disneyana 2000 convention catalog
STUDIO NAME: Disney Design Group
DESIGNER: Michael Cole
ILLUSTRATOR: Randy Noble
CLIENT: Disney's Specialty Merchandising

The inspiration for this piece is "It's a Small World," explains designer Michael Cole. The safari atmosphere and native patterns lend a feeling of adventure and intrigue. Image © Disney.

NAME OF PIECE: Living Homes: Sustainable Architecture
and Design
STUDIO NAME: Chen Design Associates
ART DIRECTOR: Joshua C. Chen
DESIGNERS: Joshua C. Chen, Max Spector
PHOTOGRAPHER: Terrence Moore
CLIENT: Chronicle Books

Joshua Chen wanted "to showcase sophisticated, modern, high-quality examples of homes that have been built with sustainable materials, to take it out of your typical 'granola-earthy' preconceived ideas of what sustainable architecture is." He succeeds in showing that these buildings can be beautiful and earth-conscious at the same time. Large photos and lots of white space in the layout combine to create the impression of an open, expansive lifestyle.

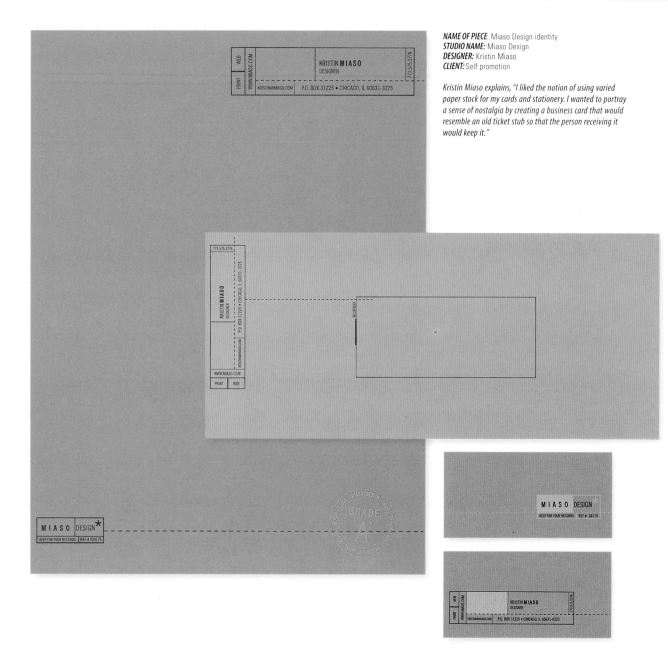

NAME OF PIECE: Miaso Design identity
STUDIO NAME: Miaso Design
DESIGNER: Kristin Miaso
CLIENT: Self promotion

Kristin Miaso explains, "I liked the notion of using varied paper stock for my cards and stationery. I wanted to portray a sense of nostalgia by creating a business card that would resemble an old ticket stub so that the person receiving it would keep it."

(top)
NAME OF PIECE: Backbone
STUDIO NAME: Howry Design Associates
ART DIRECTOR: Jill Howry
DESIGNER: Todd Richards
SPECIAL PRODUCTION TECHNIQUES: Foil, perfect binding
SPECIAL FEATURES: French folds, gate-folds

The color scheme is the primary reason this piece is natural in style. Its use of beige, off-white, gray and black indicates a raw form and natural state. It's textured, toothy paper is reminiscent of a soft leaf or handmade paper.

(bottom)
NAME OF PIECE: Atmosphere Furniture identity
STUDIO NAME: Fabian Geyrhalter Design
DESIGNER: Fabian Geyrhalter
CLIENT: Atmosphere Furniture, San Francisco

Designer Fabian Geyrhalter says, "Labeled as the first real designer furniture shop in San Francisco, the logo for this store needed to convey 'up-scale' as well as evoke the natural design and high-quality craftsmanship of the mostly wood furniture collection. The mark shows an atmospheric circle that mimics the construction and feel of the furniture pieces." The typeface is playful yet classic, and allows the mark to be used as a stand-alone creative element, while maintaining a recognizable brand identity.

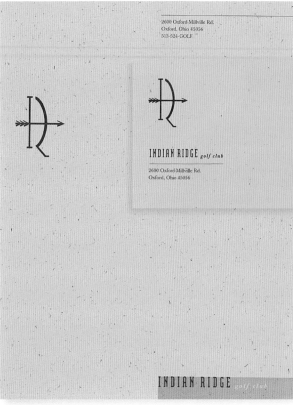

NAME OF PIECE: Indian Ridge identity
STUDIO NAME: Peg Faimon Design
DESIGNER: Peg Faimon
CLIENT: Indian Ridge Golf Club

"The I and R of the logo combine to form an Indian's bow and arrow," explains designer Peg Faimon of the inspiration for this identity system. The paper choice and color scheme capture the primitive look this design was aiming for.

NAME OF PIECE: Yosemite Wild Bear Project poster
STUDIO NAME: MOD/Michael Osborne Design
ART DIRECTOR: Michael Osborne
DESIGNER: Michelle Regenbogen
ILLUSTRATORS: David Danz, Michelle Regenbogen, Paul Kagiwada
CLIENT: Yosemite Association

Michelle Regenbogen explains, "The goal was to produce an eye-catching yet sophisticated design to help make the public aware of the problems associated with feeding the bears in their natural habitat."

NAME OF PIECE: Maxygen 2000 annual report
STUDIO NAME: Cahan & Associates
ART DIRECTOR: Bill Cahan
DESIGNER: Gary Williams
ILLUSTRATOR: Jason Holley
CLIENT: Maxygen
CLIENT'S PRODUCT/SERVICE: Biotechnology and molecular breeding

For this year's annual report, Maxygen wanted to focus on their products. Bill Cahan remarks, "My first thought was to create a book or journal that felt like something from the nineteenth century. A scientific journal of a sort. Visually, the theme of the book rested on the idea of nature as a metaphor. The size and scope of the book emphasized the credibility of Maxygen as the leader in their industry."

110 111
117 116 112 106 105 100 99 96 95 92 87 86 83 79 82 78
107 101 102 91 76 72 68 67 65 62
120 119 114 98 97 89 90 85 84 80 81 71 64
115 109 108 104 103 94 93 77 75 74 69 66 63
118 113 88 70 73

OBSCURE {type}

Dead History
ABCDEFGHIJKLMN
OPQRSTUVWXYZ
abcdefghijklmn
opqrstuvwxyz
1234567890

erasure
abcdefghijklmn
opqrstuvwxyz
1234567890

Hack
ABCDEFGHIJKLMN
OPQRSTUVWXYZ
abcdefghijklmn
opqrstuvwxyz
1234567899

Magda
ABCDEFGHIJKLM
NOPQRSTUVWXYZ
abcdefghijklm
nopqrstuvwxyz
1234567890

Elliotts Blue Eye Shadow
ABCDEFGHIJKLM NOPQRSTUVWXYZ
abcdefghijklMNopqrstuvwxyz
1234567890

Eviscerate
ABCDEFGHIJKLMN
OPQRSTUVWXYZ
abcdefghijklmn
opqrstuvwxyz
1234567890

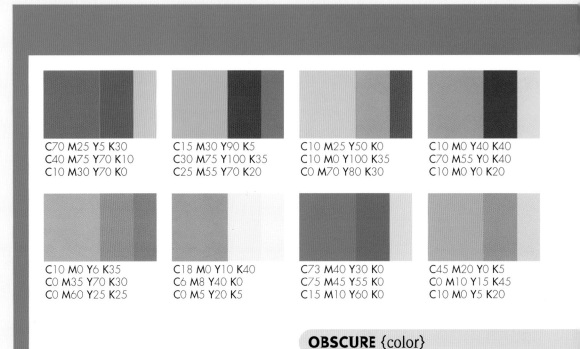

C70 M25 Y5 K30
C40 M75 Y70 K10
C10 M30 Y70 K0

C15 M30 Y90 K5
C30 M75 Y100 K35
C25 M55 Y70 K20

C10 M25 Y50 K0
C10 M0 Y100 K35
C0 M70 Y80 K30

C10 M0 Y40 K40
C70 M55 Y0 K40
C10 M0 Y0 K20

C10 M0 Y6 K35
C0 M35 Y70 K30
C0 M60 Y25 K25

C18 M0 Y10 K40
C6 M8 Y40 K0
C0 M5 Y20 K5

C73 M40 Y30 K0
C75 M45 Y55 K0
C15 M10 Y60 K0

C45 M20 Y0 K5
C0 M10 Y15 K45
C10 M0 Y5 K20

OBSCURE {color}

A hidden meaning...

In obscure design, the message reveals itself slowly, one card at a time, like a card player that knows he has the winning hand. Obscure designs are concept-driven and often have ambiguous or partially hidden elements which are slowly revealed, providing clarity for the viewer. By playing with innuendo or double meanings, an obscure design's main focus is to draw the audience in for a closer look at ingenuity.

> "It is absolutely essential that the purpose of the piece is clear to both designer and client, because it is the foundation of any successful design. I also ask a lot of questions about what the client does not want, because those answers are often more definitive than what they say they do want."
> —Lea Ann Hutter

DEFINITION

obscure (adj.)

1. Out of sight; hidden
2. Not readily noticed or seen; inconspicuous
3. Not clearly understood or expressed; ambiguous or vague

QUESTIONS FOR CLIENT

➤ How do you want your content to be revealed? What is the order of information?

➤ Do you want the audience to feel the solution is innovative or humorous? Why?

➤ Are there any hidden surprises/games/ double meanings that could be utilized for your project?

OBSCURE

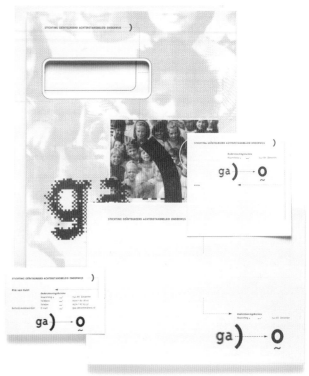

NAME OF PIECE: CDA Holiday Card 2000
STUDIO NAME: Chen Design Associates
ART DIRECTOR: Joshua C. Chen
DESIGNER/ILLUSTRATOR: Leon Yu
CLIENT: Self promotion

"We all have so much to be grateful for, and live in such prosperity. Instead of sending gifts to our clients, we sent this holiday card with a vellum sheet indicating that a donation had been made to a local nonprofit organization of CDA's choice in honor of our clients. We received many positive responses to this gesture," says Joshua Chen.

NAME OF PIECE: GAO stationery
STUDIO NAME: Erwin Zinger Graphic Design
DESIGNER: Erwin Zinger
CLIENT: GAO (Geïntegreerd Achterstandbeleid Onderwijs)
CLIENT'S SERVICE: Educational institute
SPECIAL FEATURE: When the letter is folded, the address frame appears in the address zone of the envelope.

"Because the institute has a broad target group (children), I used a different color for each item, but avoided bright colors to keep it sober, like other government designs," explains Erwin Zinger. "Another problem was that the abbreviation GAO tends to de-emphasize the O for Onderwijs (Dutch for education), so the design separates the O from the other letters to stress the educational aspect. The bow and arrow suggest forward movement, a goal of the institute's educational programs."

Vukovar is a thousand years old Croatian city on the Danube, and majority of its citizens are Croatian.

Vukovar was razed and occupied on 18 November 1991 by the forces of Greater Serbia in their aggression on the Republic of Croatia. Before the very eyes of the whole world more than 700 of its defenders and 1600 civilians were killed, and 2600 of its inhabitants dissapeared without trace.

Vukovar was deprived of its homes, churches, factories and museums, even of its trees and birds, and life itself came to a standstil.

Croatia will be free only when Vukovar is liberated and when the banished Vukovarians return to their homes. On the third anniversary of the occupation of Vukovar, 18 November 1994, Council of the City of Vukovar in Exile, Zagreb, Croatia.

NAME OF PIECE: Read Between the Lines poster
STUDIO NAME: STUDIO INTERNATIONAL
DESIGNER: Boris Ljubicic
CLIENT: STUDIO INTERNATIONAL/City of Vukovar

"The suffering inflicted on the city of Vukovar during Serbian armed aggression against the Republic of Croatia," was the inspiration for this piece, according to Boris Ljubicic. "This concept differs from the usual poster design, which seeks to be understandable from a distance, in that this one beckons you to come closer to learn the truth. The text between the lines was written by the people of Vukovar, and my task was to communicate it to a wider public. Modest, quiet and with limited color, this work presents the truth without pathetic, patriotic, rhetorical or political effects. I conceived, designed and printed it on my own initiative since it was not in the spirit of official policy. Nevertheless, it was greatly appreciated by the people and was reprinted in several editions."

NAME OF PIECE: Hidden Information
STUDIO NAME: Q
ART DIRECTOR: Laurenz Nielbock
DESIGNER: Stephan Heidenreich
CLIENT: Arjo Wiggins
CLIENT'S PRODUCT/SERVICE: Fine papers
SPECIAL PRODUCTION TECHNIQUES: Embossing, two-color scratch panel

Laurenz Nielbock emphasizes, "A picture and a big-lettered word do not tell the whole story! Most people are curious about reading tiny typography, so we put hidden information on every spread providing content that was almost unbeliev-able. That made people come very close to the paper to read; consequently they notice the quality of the material."

(below)
NAME OF PIECE: Jimmie Hale Mission logo
STUDIO NAME: DogStar
ART DIRECTOR: Ralph Watson
DESIGNER/ILLUSTRATOR: Rodney Davidson
CLIENT: The Jimmie Hale Mission
CLIENT'S SERVICE: Shelter for the homeless

Rodney Davidson explains the concept for the piece: "Jimmie Hale, a preacher and reformed alcoholic, established the mis-sion over fifty years ago. Shelter and food are provided for the homeless who are willing to attend weekly worship services." This logo truly communicates without words. Essentially, the viewer sees a bed, and without a second glance that might be it. Upon closer inspection, however, much more is revealed. The bed frame is composed of utensils, adding another layer of meaning without the need for additional explanation.

A butterfly's sense of taste is in it's...

NAME OF PIECE: Molecular Biosystems annual report
STUDIO NAME: Cahan & Associates
ART DIRECTOR: Bill Cahan
DESIGNER: Kevin Roberson
CLIENT: Molecular Biosystems Inc.
CLIENT'S PRODUCT: Ultrasound contrast agents

Kevin Roberson explains, "Molecular Biosystems has created an agent which dramatically increases readability and clarity of ultrasound images. In order to capture the importance of this significant development, a series of murky photographs are presented, with questions asking the reader to identify and 'diagnose' each picture's content. Obviously, these questions are very difficult to answer. This quiz-like exercise is analogous to the cardiologist's predicament of making accurate diagnoses without clear images."

NAME OF PIECE: SLANT Visual Noise, newsletter
STUDIO NAME: Savage Design Group
CREATIVE DIRECTOR: Paula Savage
DESIGN DIRECTOR: Bo Bothe
DESIGNERS: Bo Bothe, Eric Hines
PHOTOGRAPHER: Jack Thompson
CLIENT: Art Directors Club of Houston
SPECIAL PRODUCTION TECHNIQUE: Dry trap varnishes

According to Bo Bothe, "At the height of the dot-com craze, business was booming, clients were wanting things faster and better. Most design, it seemed, was being cranked out before the story or message was truly crafted. As designers, we tell stories. Those stories are important. The goal of this piece was to have creatives look at what they were communicating for their clients and let them know that our families and clients were just as overwhelmed by 'visual noise' as we were. Good design and good communication can help to cut through the noise."

Arabesque Ornaments

Rococo Ornaments

Ondine
ABCDEFGHIJKLMN
OPQRSTUVWXYZ
abcdefghijklmn
opqrstuvwxyz
1234567890

Clairvaux
ABCDEFGHIJKLMN
OPQRSTUVWXYZ
abcdefghijklmn
opqrstuvwxyz
1234567890

Tiepolo
ABCDEFGHIJKLMN
OPQRSTUVWXYZ
abcdefghijklmn
opqrstuvwxyz
1234567890

Young Baroque
ABCDEFGHIJKLMN
OPQRSTUVWXYZ
abcdefghijklmnopqrstuvwxyz
1234567890

C0 M100 Y91 K0
C11 M0 Y72 K0
C30 M0 Y94 K0

C0 M0 Y0 K100
C0 M10 Y55 K0
C0 M50 Y100 K0

C65 M10 Y90 K25
C15 M15 Y70 K5
C0 M45 Y15 K0

SILVER
C100 M45 Y0 K0
C0 M25 Y75 K0

C100 M40 Y20 K0
C0 M75 Y75 K10
C0 M40 Y40 K10

C0 M35 Y100 K0
C0 M75 Y80 K0
C80 M50 Y0 K30

C100 M60 Y40 K30
C65 M10 Y90 K25
C50 M55 Y80 K20

C30 M30 Y100 K0
C30 M70 Y100 K0
C0 M0 Y0 K100

ORNATE ✷ color

Tip: Add silver or gold to your color scheme. This embellishment will often bump up the cost, however if it can be worked into the budget, it will leave a lasting impression.

Ornate

Ornate design is the opposite of minimal design. The motto for ornate is; if there is an empty space, decorate and embellish! Warning: Be aware of balance in your design. Too much embellishment will tip the scales, and your design may become too cluttered, gaudy or ostentatious.

> *"How far can we think for you and how much money are you willing to spend for these thoughts?"*
> —Andreas Karl

DEFINITION ❋

ornate (adj.)
1. Rich in decorative detail
2. Marked by elaborate rhetoric and elaborate with decorative details

QUESTIONS FOR CLIENT ❋

➤ Is there a cultural or historical significance to this project?
➤ Are you interested in using Baroque or Rococo art (known for their ornate qualities) as influences for the design?
➤ Remember, it's all in the details. What are some details that can be embellished?

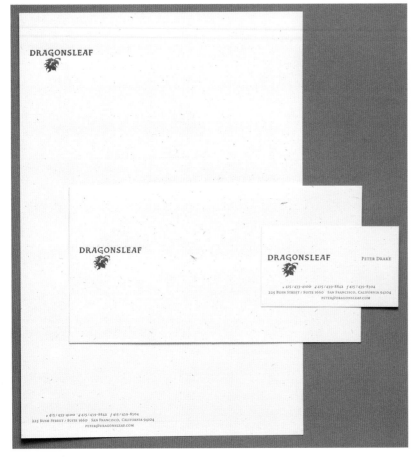

NAME OF PIECE: Dragonsleaf logo and identity system
STUDIO NAME: Chen Design Associates
ART DIRECTOR: Joshua C. Chen
DESIGNER: Leon Yu
CLIENT: Dragonsleaf LLC
CLIENT'S SERVICE: Vineyard development

Joshua Chen explains, "The company name Dragonsleaf provided many visually rich concepts. The name draws upon the Latin root of the proprietor's last name (Drake is Drago in Latin). We combined the Latin root with a leaf to connect with the lush, wooded property that this vineyard sits on. The logo and typography draws upon the influences of history, family, English heraldry, antique botanical drawings and Celtic iconography."

NAME OF PIECE: *Live* CD
STUDIO NAME: Sagmeister Inc.
ART DIRECTOR: Stefan Sagmeister
DESIGNER/ILLUSTRATOR: Motoko Hada
PHOTOGRAPHY: Dan Winters, Danny Clinch
CLIENT: Radioactive Records

Stefan Sagmeister explains, "We designed a contemporary version of a Hindu mandala on the cover of the album and two singles. This reflects the Eastern influences on the lyrics of Live's music."

NAME OF PIECE: MOD Holiday Haiku Book
STUDIO NAME: MOD/Michael Osborne Design
ART DIRECTOR: Michael Osborne
DESIGNER: Paul Kagiwada
CALLIGRAPHY: Yuki Tudisco
CLIENT: Self promotion
SPECIAL FEATURES: French folds, hand-stitched binding, rubber
stamp on cover

*"Haiku poems written by the MOD staff" were the inspiration
for this piece, explains art director Michael Osborne. The
hand-stitched binding and oriental block cut on the cover,
as well as the use of hand-made paper, combine to give this
package a uniquely ornate feel.*

nen matsu haiku

(top)
NAME OF PIECE: *Chinese Brush Painting, Step by Step*
STUDIO NAME: F&W Publications
ART DIRECTOR/DESIGNER: Lisa Buchanan

"The simple, beautiful brushstrokes taught in this book were the inspirations for the cover. I wanted the package to feel authentic as well as show off the author's amazing ability to paint using color and texture," says Lisa Buchanan.

(bottom)
NAME OF PIECE: Blossoms and Bamboo invitation
STUDIO NAME: Vangool Design & Typography
DESIGNERS: Janine Vangool
CLIENT: Calgary Opera

This invitation was created for Calgary Opera's annual fundraising evening in which patrons can enjoy dinner on the stage set of the Madame Butterfly opera production. The elegant typography and Japanese-inspired colors and motifs reflect the unique experience of dining on an opera stage set.

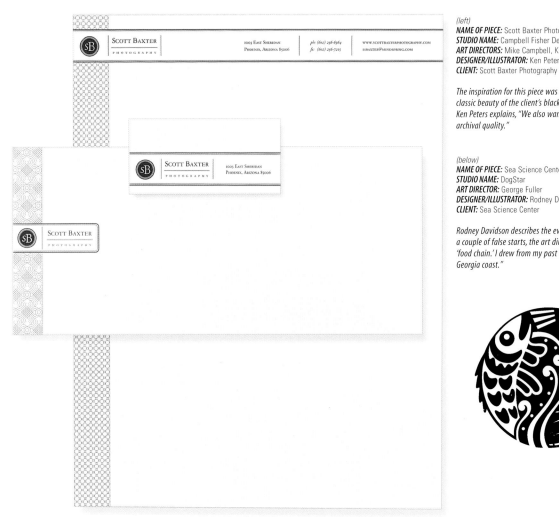

(left)
NAME OF PIECE: Scott Baxter Photography stationery system
STUDIO NAME: Campbell Fisher Design (CFD)
ART DIRECTORS: Mike Campbell, Ken Peters
DESIGNER/ILLUSTRATOR: Ken Peters
CLIENT: Scott Baxter Photography

The inspiration for this piece was derived from the timeless, classic beauty of the client's black-and-white photography. Ken Peters explains, "We also wanted to convey the feeling of archival quality."

(below)
NAME OF PIECE: Sea Science Center logo
STUDIO NAME: DogStar
ART DIRECTOR: George Fuller
DESIGNER/ILLUSTRATOR: Rodney Davidson
CLIENT: Sea Science Center

Rodney Davidson describes the evolution of this design: "After a couple of false starts, the art director suggested that I think 'food chain.' I drew from my past experiences fishing off the Georgia coast."

NAME OF PIECE: *Bridges to Babylon* CD
STUDIO NAME: Sagmeister Inc.
ART DIRECTOR: Stefan Sagmeister
DESIGNERS: Stefan Sagmeister, Hjalti Karlsson
ILLUSTRATORS: Kevin Murphy, Gerard Howland (Floating
 Company), Alan Ayers
CLIENT: Promotone, B.V.
CLIENT'S SERVICE: Music management

Stefan Sagmeister tells the story behind this design: *"After
settling on the title* Bridges to Babylon, *Mick Jagger sent me
to the British Museum in London to check out the Babylonian
collection. After coming back with lots of photos we all agreed
that an Assyrian lion would make a good symbol for the CD
cover as well as for the tour and various merchandise. Having
seen a mock-up of the stage design, which featured a stylistic
time trip with Roman columns, Babylonian patterns and
futuristic sculptures, we felt free to mix it up as well. We put
the Assyrian lion into a sixteenth-century heraldic pose, had
him illustrated in a 1970s sci-fi style and placed him into a
specially manufactured filigree slip case featuring everything
from German medieval to contemporary Japanese patterns."*

Akzidenz Grotesk
ABCDEFGHIJKLMN
OPQRSTUVWXYZ
abcdefghijklmn
opqrstuvwxyz
1234567890

Meta
ABCDEFGHIJKLMN
OPQRSTUVWXYZ
abcdefghijklmn
opqrstuvwxyz
1234567890

Compacta
ABCDEFGHIJKLMNOPQRSTUVWXYZ
abcdefghijklmnopqrstuvwxyz
1234567890

Rockwell
ABCDEFGHIJKLMNOPQRSTUVWXYZ
abcdefghijklmnopqrstuvwxyz
1234567890

MACHINE
ABCDEFGHIJKLMN
OPQRSTUVWXYZ
1234567890

RUBBER STAMP
ABCDEFGHIJKLMN
OPQRSTUVWXYZ
1234567890

CO M91 Y76 K0
C96 M69 Y0 K0
CO M0 Y0 K0

C70 M0 Y0 K100
CO M100 Y100 K0
CO M0 Y0 K70

CO M75 Y75 K60
C100 M0 Y55 K70
CO M0 Y100 K45

CO M5 Y10 K30
C100 M80 Y0 K55
CO M95 Y95 K5

C100 M60 Y70 K0
C35 M0 Y100 K60
C95 M95 Y40 K0

C95 M100 Y55 K0
CO M20 Y100 K55
C10 M0 Y35 K0

CO M50 Y100 K10
C10 M0 Y100 K45
C75 M0 Y15 K15

C30 M40 Y85 K15
C100 M100 Y10 K30
C100 M5 Y35 K35

POWERFUL ↙ color

POWERFUL

Powerful design comes in two classes: gut-punching, knockout design, or quietly authoritative design. The message is the most important item. If you are not a wizard with words, hire a great copywriter and don't embellish too much. A well-designed piece with the best copy available will be enough to send the message compellingly.

> "We constantly ask questions. If a strange acronym pops up, we ask what it means. Our clients understand from the beginning that we are new to their environment, but in a short amount of time we will speak, talk and respond the same way they do. When we do that, they are typically more interested in understanding us."
>
> —Bo Bothe

DEFINITION ✒

powerful (adj.)
1. Having great power, force, potency or effect
2. Strong enough to knock down or overwhelm
3. Having the power to influence or convince

QUESTIONS FOR CLIENT ✒

➤ In one sentence or just a few words, what's your message?
➤ What is the mood you want to set with this message?
➤ What action do you want your audience to take? How should the design call them to action?

NAME OF PIECE: *Cliffhanger* promotion, 2001
STUDIO NAME: TBS On-Air Creative Services
ART DIRECTOR: Paul Markowski
SENIOR DESIGNER: David Wilder
3D ANIMATOR: Chris Higgins
PRODUCER/CLIENT: Jennifer Johnson
OTHERS: Tobie Pate, Senior V.P. On-Air and Creative Director; Gary Holland, V.P. On-Air; Alysa Story, Art Director; Kathryn Bulmer, Graphics Producer
CLIENT'S PRODUCT: Promotional TV spots
SPECIAL TECHNIQUES: David Wilder explains, "Chris created the type pieces in Maya and then transformed each piece into snow particles blown away by the wind. Chris and I went back and forth, experimenting with different ways of blowing away the text, creating a test composite, and tweaking timings. We then took each of the finished Maya pieces and composited them together using Adobe After Effects. Going the extra mile, Chris created three different layers of blizzard snow so that when we were compositing the type animation, it could 'move' through the different layers to help sell the effect of a snow storm."

For this piece, the designers analyzed several current movies that depicted cold and borrowed several elements. They wanted to create a very current promotion for an eight-year-old movie.

(top)
NAME OF PIECE: Disney's Typhoon Lagoon® logo
STUDIO NAME: Disney Design Group
DESIGNER: Eric Caszatt
CLIENT: Disney's Park and Resort Merchandise

Researching the surf trend and visiting Disney's Typhoon Lagoon park inspired designer Eric Caszatt. Together, the swirling motion of a hurricane and the monochromatic color scheme make a powerful impact. Image © Disney.

(middle)
NAME OF PIECE: Artisan Films logo
STUDIO NAME: DogStar
ART DIRECTOR: Cary Bynum, Bynum & Partners
DESIGNER/ILLUSTRATOR: Rodney Davidson
CLIENT: Artisan Films

The client requested a heroic mark which resembled the great Russian posters of the past.

(below)
NAME OF PIECE: Napster Statistics Recording Industry Statistics series
STUDIO NAME: StudioNaka
ART DIRECTORS: Dean Nakabayashi, Joe Miller
DESIGNER/ILLUSTRATOR: Dean Nakabayashi
CLIENT'S PRODUCT/SERVICE: Information strategy design

Dean Nakabayashi says, "Being a part-time DJ in a San Francisco nightclub, I am always around music. I find that listening to music can often give me visual ideas. Sometimes I listen to a track and try to picture the visual parallel of it. The challenge in developing this series was transforming complex and complicated data into an experimental, yet easily understood form. With the introduction of Napster, online music sharing became a reality to millions of people across the world. The standard telephone cord symbolizes the essential connection to the Internet, and we can easily see from the number of cords exactly how many users connect to the Napster system in one second. Typographic elements also show how many files can be downloaded in that second."

NAME OF PIECE: Olympic bid poster and bus
STUDIO NAME: Tharp Did It
ART DIRECTORS: Rick Tharp, Lindon Leader
DESIGNER: Rick Tharp
ILLUSTRATORS: David Schuemann/Addison
CLIENT: Bay Area Sports Organizing Committee
CLIENT'S SERVICE: Promoting San Francisco as a site for the 2012 Olympic Games

"The San Francisco fog rolling through the Golden Gate Bridge" was the inspiration for this piece, explains designer Rick Tharp. This American tribute to the Olympics uses the national colors along with a recognized landmark to create a visual impact.

NAME OF PIECE: *The Observer* magazine
DESIGNER: Wayne Ford
CALLIGRAPHER: Etsuko Nakata
SPECIAL TECHNIQUE: Hand-drawn calligraphy was scanned and refined in Adobe Illustrator 5.0 and then saved as EPS files.

Combining kanji characters and the national colors of Japan, this design is both traditional and bold.

NAME OF PIECE: Silicon Valley Bank 1999 annual report
STUDIO NAME: Cahan & Associates
ART DIRECTOR: Bill Cahan
DESIGNER: Todd Simmons
CLIENT: Silicon Valley Bank
CLIENT'S SERVICE: Investment banking

Bill Cahan explains, "Silicon Valley Bank provides banking services to entrepreneurs and the companies they build. This year, SVB wanted to celebrate the entrepreneur and demonstrate their understanding of the personal sacrifices a person makes to bring their 'big idea' to fruition. The design approach for this piece is intended to be very frank and matter-of-fact, while at the same time fresh and somewhat magazine-like, an aesthetic that the Y-generation entrepreneur might appreciate. The brochure was saddlestitched to give it a feeling of immediacy and intimacy, something you wouldn't expect from a typical bank."

NAME OF PIECE: Amnesty International poster
STUDIO NAME: Karl Design
DESIGNER: Andreas Karl
CLIENT: Amnesty International Germany
CLIENT'S SERVICE: Human rights organization

According to designer Andreas Karl, Amnesty International's initials inspired this design, as did the organization's reputation as a champion of human rights. The powerful poster uses no colors and only icons to communicate its unmistakable message.

AMERICANSSIDEBYSIDE

AFTER THE TWIN TOWERS
AMERICA'S
HEARTS AND MINDS
FIND THEM STANDING
TALLER THAN EVER
ALL THOSE WE'VE LOST
IN THIS HORRIFIC ACT
ARE MARTYRS
ARE BEAUTIFUL
OUR HEROES
FOR THEM
WE ARE JOINED TIGHTER
THAN HISTORY CAN KNOW
THEY WILL WATCH US
REBUILD
RECOVER
PREVAIL
JUST AS THE WORLD EVEN NOW
SEES AMERICANS
STANDING
TALL
AND UNITED
SIDE
BY SIDE

NAME OF PIECE: *Americans Side by Side* poster
STUDIO NAME: Suka & Friends Design, Inc.
DESIGNER: Gwen Haberman
COPYWRITER: Steve Susi
SPECIAL TYPE TREATMENT: Helvetica Bold Condensed type was modified in the left tower.

The terrorist attacks in the United States on September 11, 2001, inspired this poster.

NAME OF PIECE: General Magic annual report
STUDIO NAME: Cahan & Associates
ART DIRECTOR: Bill Cahan
DESIGNER: Bob Dinetz
CLIENT: General Magic
CLIENT'S PRODUCT: Voice-enabled technology
SPECIAL FEATURES: Accordion fold

"Though General Magic has unique technologies and interesting products, what seemed most compelling was simply the idea of your own voice being the next interface with the digital environment. Ironically, people have always tried to control their televisions, cars and computers by speaking to them. We made a case for voice as the most natural way to communicate throughout the world. Rather than confine the message to a narrow application or product, it was this broad idea that would be associated with General Magic," says Bill Cahan.

Everyone has a voice.

Quick type treatments depend on two things: readability and movement.

Senator Tall

ABCDEFGHIJKLMNOPQRSTUVWXYZ
abcdefghijklmnopqrstuvwxyz
1234567890

Scala

ABCDEFGHIJKLMN
OPQRSTUVWXYZ
abcdefghijklmn
opqrstuvwxyz
1234567890

Stone Serif

ABCDEFGHIJKLMN
OPQRSTUVWXYZ
abcdefghijklmn
opqrstuvwxyz
1234567890

Birch

ABCDEFGHIJKLMNOPQRSTUVWXYZ
abcdefghijklmnopqrstuvwxyz
1234567890

Veljovic

ABCDEFGHIJKLMN
OPQRSTUVWXYZ
abcdefghijklmn
opqrstuvwxyz
1234567890

C0 M0 Y0 K100
C43 M90 Y0 K0
C45 M0 Y80 K0

C91 M43 Y0 K0
C0 M91 Y76 K0
C0 M0 Y0 K100

C50 M0 Y60 K0
C100 M15 Y20 K20
C80 M5 Y30 K0

C30 M65 Y75 K0
C65 M35 Y15 K0
C35 M20 Y80 K0

C50 M60 Y70 K0
C30 M40 Y45 K5
C75 M0 Y20 K0

C55 M0 Y10 K5
C0 M35 Y20 K10
C5 M5 Y10 K0

C70 M0 Y30 K20
C40 M20 Y20 K5
C0 M0 Y0 K0

C0 M20 Y20 K75
C0 M10 Y10 K40
C0 M5 Y5 K25

quick

You may have only seconds with potential consumers, and those few seconds will determine whether they will decide to buy your product or not. If you have been through the cereal aisle in your local grocery store, you'll understand. You have but a few moments to grab the buyers' attention and convince them that they need this product before they pass on to the next one. Quick design is not willing to waste the viewer's time.

"We listen to our clients, ask good questions and distill the relevant information. Tip: ask the client to tell you the most important three or four key messages in thirty seconds or less. This removes the clutter and usually gets to the heart of the matter quickly."

—Bob Prow

DEFINITION ➔

quick (adj.)

1. Learning, thinking, or understanding with speed and dexterity
2. Perceiving or responding with speed and sensitivity
3. Occurring, achieved, or acquired in a relatively brief period of time

QUESTIONS FOR CLIENT ➔

➤ What is your message in thirty seconds or less?
➤ Is your copy concise, clear and to the point?
➤ How long will the consumer have to make a decision about your product or service?

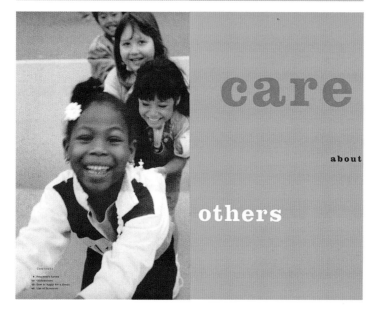

volunteer

SHARE

our

your

success

time

care

about

others

(left)
NAME OF PIECE: McKesson Foundation brochure
STUDIO NAME: Howry Design Associates
ART DIRECTOR: Jill Howry
DESIGNER: Todd Richards
ILLUSTRATOR/PHOTOGRAPHER: David Powers
CLIENT: McKesson Foundation, Inc.
CLIENT'S SERVICE: Nonprofit foundation for youth initiatives

Jill Howry explains, "Walking down any urban street in America today we are confronted with a barrage of social challenges. Our objective was to encourage McKesson employees to become ambassadors within their own communities by volunteering their time for a cause, in this case children at risk and their families. The McKesson Foundation empowers employees to help make a difference in the lives of the less fortunate through healthcare and educational initiatives."

(below)
NAME OF PIECE: Team Invacare icon
STUDIO NAME: Brokaw Inc.
DESIGNER: John Naegele
CLIENT: Self promotion
CLIENT'S PRODUCT: Health care equipment

John Naegele says that the concept behind this logo is "empowerment—we wanted to capture the feeling of unrelenting aspiration to be the best. The characters are actually stylized 'i's for Invacare. The strong figures with chests projected outward are full of confidence. The red swoosh works twofold: it can be interpreted as a stylized sun providing radiance for the team members, or as a stylized wheel in motion—a reference to a wheelchair."

NAME OF PIECE: Y Wines
STUDIO NAME: dossiercreative inc
CREATIVE DIRECTOR: Don Chisholm
DESIGNER: Peter Woods
CLIENT: Vincor International
SPECIAL FEATURE: Metal hang tags with metal chain

Peter Woods explains, "This label was designed for the Y generation—that slice of the 20- to 26-year-old demographic which consumes the least amount of wine. It poses the question, 'Why drink wine?' and responds with a red and white answer freed from the usual stuffiness associated with traditional wine label language and oenophilic gobbledygook."

(left)
NAME OF PIECE: DuPont Photomasks 2000 annual report
STUDIO NAME: Savage Design Group
CREATIVE DIRECTOR: Paula Savage
DESIGNERS OF PIECE: Bo Bothe, Dahlia Salazar
PHOTOGRAPHER: Jack Thompson
CLIENT: DuPont Photomasks, Inc.
CLIENT'S PRODUCT: Microimaging technology

Bo Bothe explains that to highlight changing technology, "we created a contrast between products used in the past and the ones we use now that utilize DPI technology. DPI has gone from being merely a supplier of images on quartz to providing a technology that requires their involvement from design to production and helps customers save both cost and time.

(below)
NAME OF PIECE: Del Monte Foods annual report
STUDIO NAME: Howry Design Associates
ART DIRECTOR: Jill Howry
DESIGNER: Ty Whittington
CLIENT: Del Monte Foods
CLIENT'S PRODUCT: Processed fruits and vegetables

Del Monte wanted to convey the idea that their products cater to fast-paced lifestyles. Each spread changes to maintain the viewer's interest, similar to quick cuts on television.

DEL MONTE: CREATIVE SOLUTIONS FOR BUSY LIFESTYLES

$130,000,000 WORTH OF DINNER DECISIONS ARE MADE EVERY DAY BETWEEN 4:00PM AND 7:00PM

HUNGRY?

NAME OF PIECE: Mohawk Navajo promotion
STUDIO NAME: Howry Design Associates
ART DIRECTOR: Jill Howry
DESIGNER: Ty Whittington
CLIENT: Mohawk Paper Mills
SPECIAL PRODUCTION TECHNIQUE: Silver overprint type

The phobias depicted in this paper promotion make an immediate impression.

Andale Mono
ABCDEFGHIJKLM
NOPQRSTUVWXYZ
abcdefghijklm
nopqrstuvwxyz
1234567890

Serifa
ABCDEFGHIJKLMN
OPQRSTUVWXYZ
abcdefghijklmn
opqrstuvwxyz
1234567890

BOVINE POSTER
ABCDEFGHIJKLMN
OPQRSTUVWXYZ
1234567890

Kaufmann
ABCDEFGHIJKLM
NOPQRSTUVWXYZ
abcdefghijklmn
opqrstuvwxyz
1234567890

Insignia
ABCDEFGHIJKLMN
OPQRSTUVWXYZ
abcdefghijklmn
opqrstuvwxyz
1234567890

Regatta Condensed
ABCDEFGHIJKLMNOPQRSTUVWXYZ
abcdefghijklmnopqrstuvwxyz
1234567890

CO M55 Y100 K0
CO M0 Y100 K0
C40 M0 Y15 K0

CO M19 Y10 K0
CO M0 Y20 K0
C40 M5 Y10 K0

C60 M30 Y100 K10
C35 M80 Y30 K0
C80 M70 Y40 K60

C75 M35 Y45 K50
C45 M37 Y85 K0
C15 M45 Y75 K0

C15 M5 Y25 K0
C25 M15 Y60 K0
C50 M15 Y40 K5

CO M65 Y25 K0
CO M30 Y10 K0
C65 M10 Y5 K0

C100 M40 Y5 K0
CO M50 Y100 K0
C10 M95 Y10 K0

C10 M0 Y0 K40
C50 M40 Y100 K15
C10 M20 Y100 K0

RETRO ✳ color

RETRO

Hindsight is 20/20, or so they say. The retro style captures the essence of a past or place, but gives it a unique new spin. When creating a retro look, reminisce with the audience about a past which brings back fond memories, then add your own twist. Tip: go to the library and do your homework well. Misunderstanding the era can lead to an ineffective—and possibly offensive—design.

> "A good thing about being an in-house designer is that once I built up a reputation, upper management began to trust my judgment. But there are still times when communication breaks down. I find that if I visually show them what they want and they can see that it doesn't work, then they tend to rely on and trust my opinion more. Unfortunately, that means more 'wasted' work on my end up front, but payoff later."
>
> —Kimberly Conger

DEFINITION ✳

retro (adj.)

1. Retroactive
2. Involving, relating to, or reminiscent of things past; retrospective

QUESTIONS FOR CLIENT ✳

➤ What era do you want to concentrate on? What new twist can you bring to the design?

➤ How old is your target audience? Define and characterize them as clearly as possible.

➤ Why do you want to associate with qualities from the past? Are you celebrating classics or touching on a history that your audience strongly associates with?

NAME OF PIECE: Free
STUDIO NAME: Erwin Zinger Graphic Design
DESIGNER: Erwin Zinger
ILLUSTRATOR: Sander Lameyer
CLIENTS: Uitgeverij Rotterdam (publisher), Free Record Shop
(music retailer)

Erwin Zinger explains, *"For this project, the target group's age
range was 15 to 27 years old. So the design had to be appealing
to teenagers, but also to older people. That's why I combined
colors, typefaces and design elements to be appealing to
both ages."*

(bottom)
NAME OF PIECE: TCM Summer of Darkness
STUDIO NAME: BAD Studio
ART DIRECTOR: Scott Banks
DESIGNER/ILLUSTRATOR: Kevin Fitgerald
CLIENT: Turner Classic Movies
CLIENT'S SERVICE: Cable television network

The inspirations for this piece were *"film noir posters by Saul
Bass and Paul Rand,"* reveals art director Scott Banks. This
piece is a well-designed retrospective tribute to the masters.

(right)
NAME OF PIECE: Appleton Dallas poster
STUDIO NAME: AdamsMorioka, Inc.
DESIGNER: Sean Adams
CLIENT: Appleton Papers

Sean Adams describes the inspiration for this piece as a "1964 Tokyo Olympics poster by Yusaku Kamekura, as well as pop culture references like cowboys, tiki gods and white bread."

(below)
NAME OF PIECE: Logo for Fontmart.com
STUDIO NAME: Born to Design
ART DIRECTOR: Todd Adkins
CLIENT: FontMart.com
CLIENT'S SERVICE: Online type foundry and retro clip art resource

Todd Adkins says, "The logo was heavily inspired by retail signage of the 1950s, since the client wanted to build the business around the concept of a 1950s-era supermarket. To keep with the overall theme of the client's business, the bulk of the piece was hand-drawn (just like in the good old days). It also incorporates a piece of the retro clip art the client sells, as well as two fonts from the FontMart.com library which have a definite retro look to them."

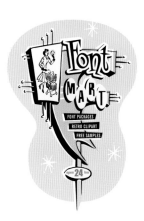

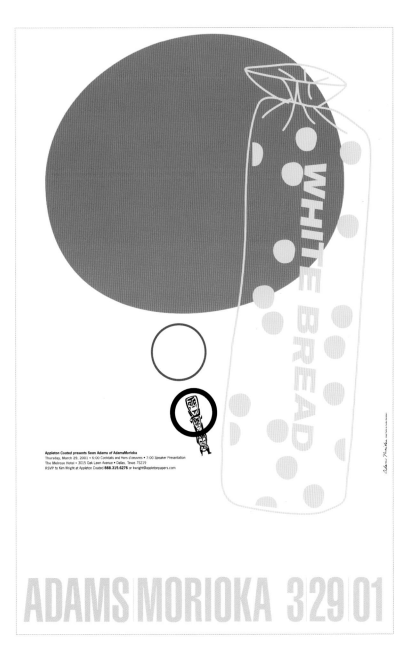

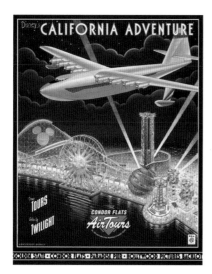

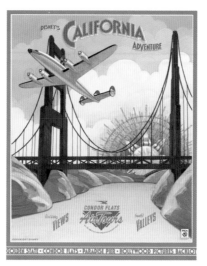

NAME OF PIECE: Disney's California Adventure promotion
STUDIO NAME: Disney Design Group
DESIGNER: Darren Wilson
ILLUSTRATOR: Jim Hseih
CLIENT: Disneyland Resort
SPECIAL PRODUCTION TECHNIQUES: Printed on tin as well as paper

When Darren Wilson was creating this design, he tried to "come up with a retro/vintage look for the art, to represent the different lands in the new park." He was inspired by old travel magazines and posters. Image © Disney.

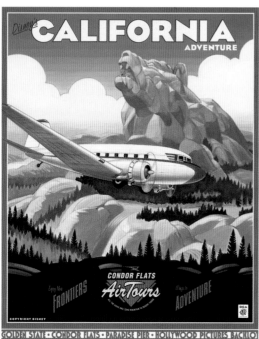

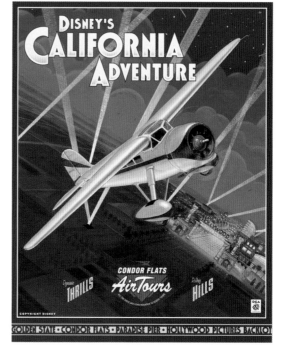

NAME OF PIECE: Center for Nonprofit Management
2000 annual report
STUDIO NAME: Prejean LoBue
ART DIRECTOR: Gary LoBue, Jr.
DESIGNERS: Gary LoBue, Jr., Kevin Prejean
ILLUSTRATORS: Kevin Prejean, Gary LoBue, Jr.
CLIENT: Center for Nonprofit Management, Dallas
SPECIAL PRODUCTION TECHNIQUES: "We determined that a
unique divider sheet was required to "pace" the front
end of the annual. As what we envisioned did not exist,
we mimicked a stock of our own design. Additionally, to
achieve the effect of an old or vintage booklet pulled
from an attic, we mimicked the look of a worn or sun-faded
perimeter edge to each page," explains Gary LoBue, Jr.

*The call to action that typified posters produced by the Works
Progress Administration during the 1930s and 1940s inspired
the design for these pieces.*

Soft*type

Bellevue
ABCDEFGHIJKLMN
OPQRSTUVWXYZ
abcdefghijklmn
opqrstuvwxyz
1234567890

Mrs Eaves
ABCDEFGHIJKLMN
OPQRSTUVWXYZ
abcdefghijklmn
opqrstuvwxyz
1234567890

Linoscript
ABCDEFGHIJKLM
NOPQRSTUVWXYZ
abcdefghijklmnopqrstuvwxyz
1234567890

Houston Pen
ABCDEFGHIJKLM
NOPQRSTUVWXYZ
abcdefghijklmnopqrstuvwxyz
1234567890

Berkeley
ABCDEFGHIJKLMN
OPQRSTUVWXYZ
abcdefghijklmn
opqrstuvwxyz
1234567890

Galliard
ABCDEFGHIJKLMN
OPQRSTUVWXYZ
abcdefghijklmn
opqrstuvwxyz
1234567890

C5 M0 Y15 K0
C27 M11 Y61 K0
C56 M67 Y16 K11

C0 M0 Y0 K0
C47 M11 Y0 K0
C27 M6 Y0 K0

C55 M35 Y0 K7
C15 M35 Y0 K0
C0 M0 Y15 K0

C27 M9 Y0 K0
C0 M27 Y9 K0
C0 M0 Y51 K0

C6 M38 Y11 K0
C0 M6 Y43 K0
C11 M15 Y0 K0

C0 M0 Y47 K18
C27 M0 Y23 K0
C0 M5 Y27 K0

C9 M0 Y6 K34
C0 M34 Y72 K0
C13 M83 Y56 K0

C47 M0 Y38 K18
C0 M6 Y9 K27
C47 M34 Y0 K27

Soft * color

Soft

Soft design is both visually pleasing and quietly assertive. This style can be quiet and calm, or melodious. Listen to some classical music while designing your piece. If you find the right classical composer, inspiration may strike in a moment. Better yet…have your client come with a CD already picked out. Tip: a soft color scheme can be bold and daring. Try the unusual, and you might be pleasantly surprised.

"To me, it's all about relationships—the relationship of designer to client and person to person. You inevitably get in sync with your client and develop a language, a style, and—most importantly— a history all your own. With that bond, you can overcome any adversity, whether it's a simple miscommunication between a nonvisual person and a visual person, or someone screwing up royally."
—David Wilder

Definition *
soft (adj.)
1. Not rough, rugged, or harsh to the touch; smooth; delicate
2. Pleasing to the eye
3. Having, or consisting of, a gentle curve or curves
4. Quiet; undisturbed; peaceful

Questions for Client *
➤ Are you willing to take some small risks?
➤ Do you want your design to be peaceful? Do you want to appeal to the audience on an intimate or emotional level?
➤ Choose and define an emotion you want to be associated with.

(left)
NAME OF PIECE: Diaper Gang
STUDIO NAME: Hutter Design
DESIGNER: Lea Ann Hutter
CLIENT: Julie Gang Photography
SPECIAL FOLDS/FEATURES: A baby diaper pin was inserted into two small die-cut holes on the front to complete the diaper theme.

Lea Ann Hutter says, "My client, Julie Gang, licensed her photography for use in three small baby books, Bundles of Joy, It's a Boy! and It's a Girl! She received several hundred copies of each book and wanted to use them for a direct-mail promotion. The books are small, only 3.25" x 3.75" (8cm x 10cm), so the challenge was to package them in a way that would get attention. Each diaper box is constructed from a single sheet of paper, printed on one side in two colors. The combination of an unusually shaped box with a diaper pin and a book of great child photography immediately got noticed. The promotion was a great success."

(below)
NAME OF PIECE: Sleepy type
STUDIO NAME: Emma Wilson Design Company
DESIGNER: Emma Wilson

Emma Wilson says, "Picture yourself on a nice, cushy, cool cloud bobbing casually about the sky...you are feeling sleepy, very sleepy..."

It's a Boy!
A Book of Quotations

Babies drool. You will too!

To see a portfolio of beautiful babies, just call!
T: 212-925-3351 Julie Gang F: 212-941-1738

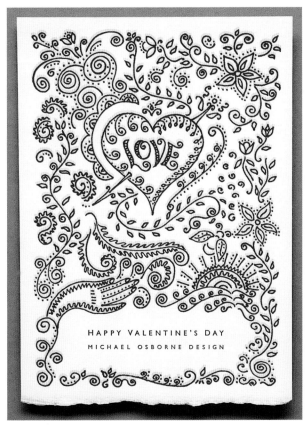

NAME OF PIECE: MOD Valentine card, 2001
STUDIO NAME: MOD/Michael Osborne Design
ART DIRECTOR: Michael Osborne
DESIGNERS: Michael Osborne, Alice Koswara
ILLUSTRATOR: Alice Koswara
CLIENT: Self promotion
SPECIAL PRODUCTION TECHNIQUE: Letterpress printing

The inspirations for this card were henna tattoos, according to Michael Osborne. This decorative and embellished card uses soft flowing lines to communicate love.

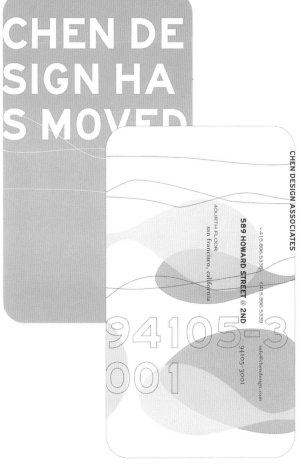

NAME OF PIECE: Chen Design Associates moving card
STUDIO NAME: Chen Design Associates
ART DIRECTOR: Joshua C. Chen
DESIGNERS: Leon Yu, Joshua C. Chen, Kathryn Hoffman, Leon Yu
PHOTOGRAPHER/ILLUSTRATOR: Leon Yu

Joshua Chen explains, "The announcement of our new studio address was more than just that—we wanted to also visually convey our growth: a great increase in space, a new level of design, a realization of a long-held dream." The team quietly reinforced the message of continued commitment to excellent design and service.

NAME OF PIECE: Fairy Tale Weddings guest flyer
STUDIO NAME: Disney Design Group
DESIGNER: Natalie L. Bert
CLIENT'S SERVICE: Wedding coordination
SPECIAL FOLDS/FEATURE: Custom created die cuts for the overall shape

Natalie L. Bert explains, "The client wanted a whimsical, fun piece that would be sent to the bride's guest list, a piece that would remind them of what they would need to bring for a trip to Orlando and explain how to purchase their Disney theme park tickets before they arrive." Image © Disney.

(top)
NAME OF PIECE: Linda Loftus corporate identity
STUDIO NAME: CADDGraphics
DESIGNER: Julie Bateman
CLIENT: Linda Loftus, Sutton Group Realty
CLIENT'S SERVICE: Commercial and industrial real estate agent

My educational background was in photography, which had inspired me to experiment with photo collages for backgrounds in various projects," explains Julie Bateman. "The client saw some of my other work and asked me to create an identity for her in that style. I incorporated various local landmarks and recognizable buildings with a dynamic color scheme."

(bottom)
NAME OF PIECE: Uwajimaya Village logo and brochure
STUDIO NAME: Michael Courtney Design
ART DIRECTOR: Michael Courtney
DESIGNERS: Michael Courtney, Angie Moretti
CLIENT: Lorig Associates
CLIENT PRODUCT/SERVICE: Real estate development

Michael Courtney says, "The project is located in Seattle's International District—an entire city block with a Pacific Rim market, specialty stores and new apartments. Our studio designed the look and feel of the piece to attract an upscale audience and to convey the idea of a contemporary 'village.' We thought the moon added charm and an unexpected twist to the piece."

Russell Square
ABCDEFGHIJKLMN
OPQRSTUVWXYZ
abcdefghijklmn
opqrstuvwxyz
1234567890

Engravers Gothic
ABCDEFGHIJKLMN
OPQRSTUVWXYZ
1234567890

OCRA
ABCDEFGHIJKLMN
OPQRSTUVWXYZ
abcdefghijklmn
opqrstuvwxyz
1234567890

Industria
ABCDEFGHIJKLMNOPQRSTUVWXYZ
abcdefghijklmnopqrstuvwxyz
1234567890

Modula Tall
ABCDEFGHIJKLMNOPQRSTUVWXYZ
abcdefghijklmnopqrstuvwxyz
1234567890

Techno
ABCDEFGHIJKLMN
OPQRSTUVWXYZ
abcdefghijklmn
opqrstuvwxyz
1234567890

C100 M20 Y0 K50
C0 M60 Y95 K0
C0 M0 Y0 K100

C0 M30 Y100 K10
C100 M45 Y0 K20
C0 M0 Y0 K0

C0 M50 Y100 K0
C81 M48 Y25 K9
C50 M32 Y20 K0

C75 M0 Y5 K0
C0 M0 Y0 K80
C0 M0 Y0 K0

C100 M60 Y0 K0
C70 M30 Y0 K0
C0 M0 Y0 K0

C0 M10 Y70 K15
C35 M0 Y0 K35
C0 M0 Y0 K100

C85 M35 Y0 K20
C10 M20 Y100 K0
C0 M75 Y100 K0

C60 M0 Y0 K5
C80 M90 Y0 K0
C30 M0 Y100 K20

Techno ■ color

Techno

Techno as a design style is very popular today in the music industry as well as with today's youth. The traits associated with techno—whirring music and a quick beat with bright colors—give the translated design a very modern and trendsetting appeal. Your main concern should be whether this style will limit your audience.

> "I think success or failure in this business is based on getting lots of information about the project up front, then boiling it down to a simple, concise message that the client and art director can agree on. That way the work is critiqued on the basis of message and not on the execution."
> —John Pattison

Definition ■

techno (n.) tech·no
 1. Any of various styles of dance music characterized by electronic sounds and a high-energy, rhythmic beat

Questions for Client ■

➤ Do you want the audience to feel like your product or business is trendsetting and current?
➤ Do you want to have your design look very modern and mechanical?
➤ Does your audience tend to be younger?
➤ Is your audience made up of people who have all the latest high-tech gadgets, are music-oriented, or are simply interested in being ultramodern or futuristic?

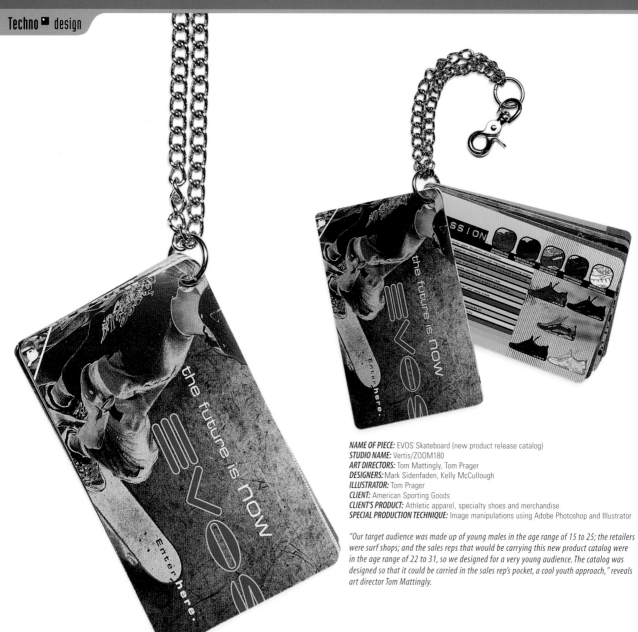

NAME OF PIECE: EVOS Skateboard (new product release catalog)
STUDIO NAME: Vertis/ZOOM180
ART DIRECTORS: Tom Mattingly, Tom Prager
DESIGNERS: Mark Sidenfaden, Kelly McCullough
ILLUSTRATOR: Tom Prager
CLIENT: American Sporting Goods
CLIENT'S PRODUCT: Athletic apparel, specialty shoes and merchandise
SPECIAL PRODUCTION TECHNIQUE: Image manipulations using Adobe Photoshop and Illustrator

"Our target audience was made up of young males in the age range of 15 to 25; the retailers were surf shops; and the sales reps that would be carrying this new product catalog were in the age range of 22 to 31, so we designed for a very young audience. The catalog was designed so that it could be carried in the sales rep's pocket, a cool youth approach," reveals art director Tom Mattingly.

NAME OF PIECE: Fong & Fong Printers promotion
STUDIO NAME: Howry Design Associates
ART DIRECTOR: Jill Howry
DESIGNERS: Robert Williams, Ty Whittington
PHOTOGRAPHERS: Robert Williams, Ty Whittington
CLIENT: Fong & Fong Printers
CLIENT'S PRODUCT/SERVICE: Commercial printer

Donuts and coffee were the inspiration for this promotional piece. The analogous color scheme with small repeating shapes suggest electronic rhythms.

DESIGNING WEBSITES://
FOR EVERY AUDIENCE

< ilise benun > AUTHOR OF
SELF-PROMOTION ONLINE

NAME OF PIECE: *Designing Websites for Every Audience*
STUDIO NAME: F&W Publications
ART DIRECTOR/ DESIGNER: Lisa Buchanan

"This book was written to help designers understand and design web sites for the end user. The author divided the types of users into six categories: the browser, the entertainment-seeker, the shopper, the transactor, the information-seeker, and the connection-seeker. I wanted the cover to have a high-energy techno feel, while portraying each type of user on the cover. I made the images of the users' faces blurred, but a square around their eyes is crisply in focus, symbolizing the clarity and understanding in communication this book will bring to both the designer and ultimately the end user," says Lisa Buchanan.

STUDIO NAME: Memsis, Ltd.
NAME OF PIECE: Memsis Ltd. identity system
DESIGNER: Kristin Miaso
CLIENT: Memsis, Ltd.
CLIENT'S SERVICE: Web design and IT services

Kristin Miaso says, "I wanted to position Memsis, Ltd. as a cutting-edge firm that offered clients smart services with a contemporary, clean and vibrant look. The four dots above the 'i' represent the four key members of the company."

(below)
NAME OF PIECE: ClickBack logo
STUDIO NAME: Campbell Fisher Design (CFD)
ART DIRECTOR: Mike Campbell
DESIGNER/ILLUSTRATOR: Chris Bohnsack
CLIENT: Sitewire
CLIENT'S PRODUCT: Internet user tracking software

Mike Campbell explains, "The name for this Internet tracking software is derived from kickback because the software identifies each click the user makes and returns this valuable information back to the marketing group. The logo utilizes the letter 'k' to read as both the letterform and a directional browser arrow, creating a memorable visual pun."

memsis ltd.

11 University Road
Belfast
BT7 1NA

T 028 90 806999
F 028 90 806060

Co. Reg No: NI 34627

www.memsis.com

memsis ltd.

INTERNET FACILITIES MANAGEMENT

INTERNET FACILITIES MANAGEMENT
Registered Office: 11 University Road, Belfast BT7 1NA

clickback

NAME OF PIECE: Computer Voices/Speaking Machines exhibition catalog
STUDIO NAME: Vangool Design & Typography
DESIGNER: Janine Vangool
ILLUSTRATORS: Émile Morin, Jocelyn Robert, and David Rokeby
PHOTOGRAPHY: Don Lee
CLIENT: Walter Phillips Gallery, Banff Centre for the Arts
CLIENT'S SERVICE: Public art gallery

According to Janine Vangool, "The gallery exhibition Computer Voices/Speaking Machines featured an audiovisual installation which used electrical relays to transmit Internet audio and imagery, and a piece that explored the capabilities of language-enabled computer communities in which the gallery participant attempts to have a dialogue with computers. The exhibition catalog needed to visually interpret the audio experience of the artworks. The die cut at the center of the catalog is the graphic representation of the path of communication between the participant and the speaking machines. The open circle interacts with a photograph of an ear, in which the hole is the center for listening. The hole as a metaphor for sound is reinforced with graphic devices such as radiating circles and lines leading to and from the center of the publication.

NAME OF PIECE: *System on Silicon* book series and collateral
STUDIO NAME: Chen Design Associates
ART DIRECTOR: Joshua C. Chen
DESIGNERS/PHOTOGRAPHERS: Max Spector, Leon Yu
CLIENT: Morgan Kaufmann Publishers
CLIENT'S PRODUCT: Technical books
SPECIAL TECHNIQUES: Ultraviolet printing on poster and brochure

Joshua Chen explains, "The central concept aims to visually represent systems on a chip by bringing all content elements into a single space (text blocks of differing sizes). They are oriented in the same fashion on all books and collateral. Abstract, dynamic photo images create a sense of complexity and intrigue without relying on the traditional visual clichés of high technology."

(top right)
NAME OF PIECE: Recording Industry Statistics series
STUDIO NAME: StudioNaka
ART DIRECTORS: Dean Nakabayashi, Joe Miller
DESIGNER/ILLUSTRATOR: Dean Nakabayashi
CLIENT: Self promotion
CLIENT'S PRODUCT/SERVICE: Information strategy design

Dean Nakabayashi explains, "The challenge in developing this series was transforming complex and complicated data into an experimental, yet easily understood form. The statistics are integrated into the cassette tape, and an informative presentation of the inner structure of the cassette player gives the viewer a simple interpretation of an otherwise complex machine."

(bottom right)
NAME OF PIECE: Blake Little promotion 2001
STUDIO NAME: AdamsMorioka, Inc.
ART DIRECTOR: Sean Adams
DESIGNER: Volker Dürre
CLIENT: Blake Little
CLIENT'S PRODUCT/SERVICE: Photographer

This promotional piece uses rectangular shapes of blue to communicate a driving sense of rhythm to its modern audience. These shapes and the sans serif fonts work together to indicate a trendy techno beat.

(below)
NAME OF PIECE: a•game identity
STUDIO NAME: Campbell Fisher Design (CFD)
ART DIRECTOR: Greg Fisher
DESIGNER/ILLUSTRATOR: Chris Bohnsack
CLIENT: Health Links USA
CLIENT'S PRODUCT/SERVICE: Golf supplements

Chris Bohnsack says, "The product is a formula made to help golfers focus on their game, so we based the logo on the idea of a golf ball coming into focus."

There are many different approaches you can take to give your piece a distinctive typographic style. Some designers look for rules to bend and ways to tweak the expected, while others visually interpret the written content. Here are some unique tips that might inspire you, too:

{ Joshua Chen reveals two of his typographic secrets: he uses "lettering from old family crests and store-bought rub-down letters." }

{ Stefan Sagmeister once made type out of photographs. }

{ JOSHUA CHEN EXPLAINS A CUSTOM CREATION HE MADE: "THE TITLES WERE TYPESET, THEN DISTRESSED USING A COPY MACHINE." }

{ When asked how he achieved a unique typographic effect, Stefan Sagmeister simply stated that it was "drawn, stamped, and photocopied." }

{ Scott Banks discloses that he uses "lots of top-secret clip-art sources." }

{ For one particular project, says Emma Wilson, "all the typefaces were taken from various typography books. Some of the type I distressed by photocopying, removing toner with tape, copying again, scanning, and redrawing in FreeHand." Wilson also simply sketches out new typefaces, then refines them in FreeHand. }

Typographic

Movement is the main player in a typographic design style. Think about where and how you want the audience's eye to travel when planning your design. Don't be timid—use type in unconventional ways. Turn it upside-down, make it vertical, have it follow a contour line or even an angle. Be careful, though, not to direct your audience's eyes off the page and away from your intended message.

> *"We try to look beyond the tactical suggestions and solutions made by the client and get them to focus on describing their concerns. If we can get them to back away from trying to solve the problem themselves, it opens the door for us to revisit the project knowing their concerns. Then we can find the best possible solution, given their input."*
> —Steve McKeown

{DEFINITION}

typographic (adj.)

1. The composition of printed material from movable type
2. The arrangement and appearance of printed matter

{QUESTIONS FOR CLIENT}

➤ What fonts best complement your business's intended image?
➤ Where do you want the audience's eye to travel?
➤ Is the copy good enough to warrant special typographic treatment?

NAME OF PIECE: Beethoven/Copland
STUDIO NAME: Chen Design Associates
ART DIRECTOR: Joshua C. Chen
DESIGNER: Leon Yu
PHOTOGRAPHERS: Terrence McCarthy, Joshua Robison
ILLUSTRATOR: Leon Yu
CLIENT: San Francisco Symphony/Michael Tilson Thomas

Joshua Chen explains, "Music director Michael Tilson Thomas paired the works of two great mavericks in this live recording. Our interpretation produced a design that innovatively balanced a refined elegance with symbols of the creative frenzy that is so often its wellspring. Working for MTT was a very positive experience, given that he is a creative person as well. He really trusted us to bring to the table the very best concepts we could come up with."

NAME OF PIECE: AIGA *Future of Visual Communication* event postcard
STUDIO NAME: Peg Faimon Design
DESIGNER: Peg Faimon
CLIENT: AIGA Cincinnati

Peg Faimon used the Rosetta Stone to represent the beginnings of formal communication through the use of typography. She says, "This image is utilized in a very 'modern' way to communicate the progression of changes in visual communication into the computer age."

NAME OF PIECE: Impostor poster
STUDIO NAME: BAD Studio
ART DIRECTOR: Scott Banks
DESIGNER: Suzanna Schott

The inspiration for this piece was "fine art and European movie posters," reveals art director Scott Banks. An innovative approach to poster design, the type simulates a ransom note with its cut-out appearance. Also, the embellishments in the corners and the mysterious type in the shadow all add to this piece's elusive quality.

NAME OF PIECE: meth*od*o*lo*gy calendar
STUDIO NAME: Chen Design Associates
ART DIRECTOR: Joshua C. Chen
DESIGNERS: Joshua C. Chen, Kathryn A. Hoffman, Leon Yu, Gary E. Blum
COPYWRITERS: Joshua C. Chen, Kathryn A. Hoffman
ILLUSTRATORS: Gary E. Blum, Elizabeth Baldwin
PHOTOGRAPHERS: Joshua C. Chen, Leon Yu
SPECIAL PRODUCTION TECHNIQUES: The cover is die-cut and hand-assembled with bookbinding tape. The calendar pages are bound by a metal clip and the entire piece is sealed by an elastic band that doubles as a stand for the calendar when opened. Each calendar was hand-stamped with an individualized serial number.

Joshua Chen explains, "This calendar is unique in its approach to communicating twelve principal thoughts. Each month the style changes....The cover uses a clean minimal approach, and is careful not to overstate itself to the viewer."

NAME OF PIECE: La Grande Epicerie de Paris
STUDIO NAME: Lewis Moberly
ART DIRECTOR: Mary Lewis
DESIGNER: Bryan Clark
CLIENT: Le Bon Marché
CLIENT'S SERVICE: Food retailer

Mary Lewis explains, "The brief was to create a new identity for La Grande Epicerie de Paris, the leading Parisian food hall. The client wanted it to be modern, stylish and simple—allowing the products and fresh produce to be the hero. To make the name more recognizable as a brand mark and to focus on the Parisian provenance, 'de Paris' has been emphasized. Black lettering on an ivory background aims to reflect the store's confidence as a food specialist."

NAME OF PIECE: *The Pocket Muse*
STUDIO NAME: F&W Publications
DESIGNER: Lisa Buchanan
PAGE MAKEUP: Matthew DeRhodes
SPECIAL PRODUCTION TECHNIQUES: Faux leather spine and a glossy varnish over the image and label

According to Lisa Buchanan, "The goal for this book was to create a fun, visually appealing package that would target writers. I decided that shape and texture were extremely important, so we used a faux leather spine on this 5" x 7" book, as well as matte and glossy spot varnishes. The use of black and white photography and the fun type treatments are factors that contribute to variety within the book and keep the audience's attention—no two pages are alike."

NAME OF PIECE: Dugena Watches logo
STUDIO NAME: FCB Design
DESIGNER: Andreas Karl
CLIENT: Dugena Watches Germany

Andreas Karl explains, *"The old Dugena logotype, which was born in the German 1960s, was nothing to write home about. (I love this American phrase!) When I worked on a redesign the G reminded me of a watch face showing the time 12:15. I simply changed some parts of the letter...and the new look was born."*

(bottom)
NAME OF PIECE: *De wens van de Petemoei of een pleidooi voor de Passie* (Godmother's wishes or a pledge for passion)
STUDIO NAME: Erwin Zinger Graphic Design
DESIGNER: Erwin Zinger
CLIENT: N.V. Nederlandse Gasunie
CLIENT'S SERVICE: Transport of fuel
SPECIAL TYPE TREATMENT: "For the title I used the existing typefaces Frutiger and New Baskerville and manipulated them," says Zinger.

Erwin Zinger explains that this piece is about *"creative management. It shows how following the rules leads to boring management. When passion arrives it becomes much brighter and more fun."*

DUGENA®

"De wens van de PETEMOEI een pleidooi voor de passie,"

over creatief management

Feestelijke bijeenkomst ter gelegenheid van het afscheid van mr. drs. C.W.A. Hendrikse als Directeur Personeel, Organisatie en Algemene Zaken van de N.V. Nederlandse Gasunie
Donderdag 22 juni 2000 Gasunie-gebouw Concourslaan 17 Groningen

Rubino
ABCDEFGHIJKLMN
OPQRSTUVWXYZ
abcdefghijklmn
opqrstuvwxyz
1234567890

FILOSOFIA unicase
ABCDEFGHIJKLMN
OPQRSTUVWXYZ
abcdefghijklmn
OPQrSTUVWXYZ
1234567890

Hypnopaedia

Batak
ABCDEFGHIJKLMN
OPQRSTUVWXYZ
abcdefghijklmn
opqrstuvwxyz

Dirty
ABCDEFGHIJKLIVIN
OPORSTUVWXYZ
abcdefghijklmn
opqrstuvwxyz
1234567890

Brothers
ABCDEFGHIJKLMN
OPQRSTUVWXYZ
abcdefghijklmn
opqrstuvwxyz
1234567890

CO M15 Y60 KO
CO M17 Y30 K100
C100 M10 YO KO

CO M70 Y15 KO
CO M47 Y75 KO
C5 MO Y27 K27

CO M40 Y100 K35
C75 MO Y15 K10
CO M10 YO KO

CO M30 Y100 K10
CO M47 Y10 KO
CO M60 Y23 K30

CO M35 Y27 KO
CO M50 Y100 K45
C60 MO Y50 KO

C40 MO YO KO
C10 M80 YO K5
C70 M100 Y90 KO

C30 MO Y70 K10
C10 M5 Y30 KO
CO M55 Y50 K5

CO M25 Y60 K5
C35 M50 YO K30
C20 M10 Y10 K5

UNUSUAL color

abnormal, atypical, bizarre, memorable, out-of-the-ordinary, rare, uncommon

artistic, flashy, messy, obscure

UNUSUAL

Unusual design often has an element of the bizarre that makes it memorable. Usually the first of its kind, this style will either hit it big and be embraced for its rareness (it might even be mimicked or copied)—or it will be rejected for being too strange. Either way, this style will grab attention.

"Keep clients involved throughout, so they feel as though they are part of the design process. Absorb their comments and carefully apply them when and where they are applicable, without being detrimental to the designer's ideas and style."
—*Michael Cole*

DEFINITION

unusual (adj.)
1. Not usual or common or ordinary
2. Being definitely out-of-the-ordinary and unexpected; slightly odd or even a bit weird
3. Not commonly encountered

QUESTIONS FOR CLIENT

➤ How unusual can you afford to be?
➤ How much creative license does the designer have?
➤ Review some 'firsts' that made it big, and others that bombed. (Try *Genius Moves* by Steven Heller for a historical collection of innovative designs that began to set trends.)

NAME OF PIECE: Marshall Crenshaw CD
STUDIO NAME: Sagmeister Inc.
ART DIRECTOR: Stefan Sagmeister
DESIGNERS: Stefan Sagmeister, Veronica Oh
PHOTOGRAPHER: Tom Schierlitz
CLIENT: Razor & Tie
SPECIAL PRODUCTION TECHNIQUES: Holographic CD surface
SPECIAL FOLDS/FEATURES: Small booklet, gatefold

Stefan Sagmeister explains, "With an album titled Miracle of Science we thought it fitting to use a hologram for the CD itself. By printing a small gatefold booklet, the CD is visible even in the store."

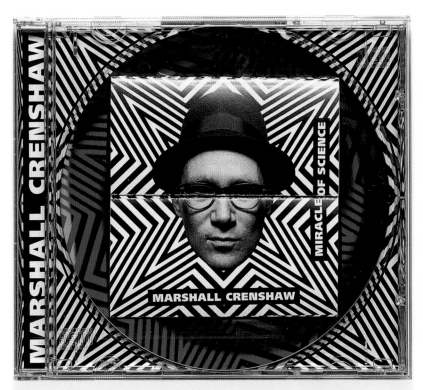

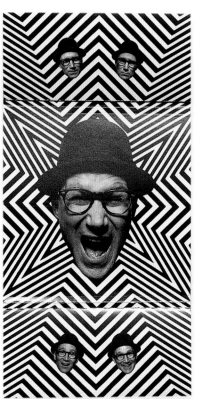

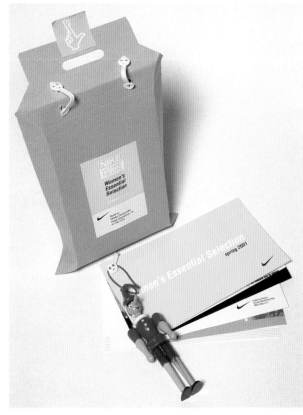

NAME OF PIECE: Recording Industry Statistics series, Music Genre Sales
STUDIO NAME: StudioNaka
ART DIRECTORS: Dean Nakabayashi, Joe Miller
DESIGNER/ILLUSTRATOR: Dean Nakabayashi
CLIENT'S SERVICE: Information strategy design

Dean Nakabayashi explains, "Having a rather large music library myself, I was really interested to find out what was in the music collections of other people in the United States. The graph clearly shows the percentages of music genres that were purchased in the U.S. in a fun way by integrating it into the photograph of the existing music archive of a true music fanatic. Additional statistics show the percentages of music purchases by gender."

STUDIO NAME: Matite Giovanotte
NAME OF PIECE: Nike Vetrine News: Essential Selection Spring 2001
ART DIRECTOR: Giovanni Pizzigati
DESIGNER: Elisa Sangiorgi
CLIENT: Nike Italy
CLIENT'S PRODUCT/SERVICE: Direct mailer
SPECIAL FOLDS/FEATURES: Special packaging, Pinocchio keepsake

The concept behind the piece, explains designer Elisa Sangiorgi, was a book about lies (from an existing Nike campaign). This piece, complete with a toy Pinocchio, is an unusual yet effective approach for an athletic audience.

NAME OF PIECE: meth*od*o*lo*gy notecards
STUDIO NAME: Chen Design Associates
ART DIRECTOR: Joshua C. Chen
DESIGNERS: Joshua C. Chen, Kathryn A. Hoffman, Leon Yu, Gary E. Blum
COPYWRITERS: Joshua C. Chen, Kathryn A. Hoffman
ILLUSTRATORS: Gary E. Blum, Elizabeth Baldwin
PHOTOGRAPHERS: Joshua C. Chen, Leon Yu

"These notecards were a spinoff of the meth*od*o*lo*gy calendars using the same visuals," explains Joshua Chen. The particular cards that are shown above are highlighted because of their unique interpretations. The card on the left uses the word "balance" as a stepping stone to communicate that the image of the person is calmly balancing multiple objects. Spontaneity, the theme of the card on the right, is expressed through unusually spaced type, abstract lines, kinetic movement, and an inexplicably backward E.

NAME OF PIECE: Criminal Record poster
STUDIO NAME: BAD Studio
DESIGNER/ILLUSTRATOR: Scott Banks
CLIENT: Criminal Records
CLIENT'S SERVICE: Independent record store

This intriguing and very unusual poster has a humorous edge with artistic roots. It begs the ironic question, "Where do you think the holes in CDs come from, anyway?"

NAME OF PIECE: 1999 Affymetrix annual report
STUDIO NAME: Howry Design Associates
ART DIRECTOR: Jill Howry
DESIGNER: Todd Richards
PHOTOGRAPHER: Robert Schlatter
CLIENT: Affymetrix, Inc.
CLIENT'S PRODUCT: Affymetrix GeneChip®

Jill Howry explains, "In general, people are fearful and skeptical of genomics. Our goal was to have people think differently about genetics by pointing out how this revolution relates to each and every one of us on a basic human level. Through understanding ourselves and what makes us distinct as individuals, science will be able to apply this knowledge of the human genome for the betterment of humankind." The inspiration for this piece comes from the type of photography used for passports, mug shots, and in photo booths.

NAME OF PIECE: *Feelings* CD
STUDIO NAME: Sagmeister Inc.
ART DIRECTORS: Stefan Sagmeister, David Byrne
DESIGNERS: Stefan Sagmeister, Hjalti Karlsson
PHOTOGRAPHY: Tom Schierlitz
MODEL MAKING: Yuji Yoshimoto
CLIENT: Warner Bros. Music, Inc.

This round-cornered *Feelings* CD package includes a sophisticated, color-coded "David Byrne Mood Computer" printed under the actual CD. You can determine your own mood by spinning the CD, which has an arrow printed on it. The arrow will land on a David Byrne figure that is either happy, sad, content or angry, thus revealing your current mood.

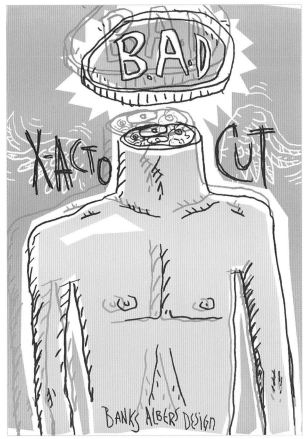

NAME OF PIECE: Bad X-Acto Cut
STUDIO NAME: BAD Studio
CLIENT: Self promotion

When asked what the inspiration was for this unique poster, Scott Banks simply states, "Client frustration." This unusual poster spiced with humor is a portrayal of an extremely bad x-acto cut...to the head! Mirroring the content, the choice of the color scheme is also out-of-the-ordinary.

NAME OF PIECE: *The Observer* magazine
STUDIO NAME: *The Observer*
DESIGNER: Wayne Ford
ILLUSTRATOR: Gillian Wearing

The cover was based upon a feature about British artist Gillian Wearing. Wearing was asked to recreate one of her own artworks, this time using the magazine identity and a portrait of her by Gaultier Deblonde.

Wembley
ABCDEFGHIJKLMN
OPQRSTUVWXYZ
abcdefghijklmn
opqrstuvwxyz
1234567890

Linotype Didot
ABCDEFGHIJKLMN
OPQRSTUVWXYZ
abcdefghijklmn
opqrstuvwxyz
1234567890

Leawood
ABCDEFGHIJKLMN
OPQRSTUVWXYZ
abcdefghijklmn
opqrstuvwxyz
1234567890

Peignot
ABCDEFGHIJKLMN
OPQRSTUVWXYZ
abcdefghijklmn
opqrstuvwxyz
1234567890

Linotext
ABCDEFGHIJKLMN
OPQRSTUVWXYZ
abcdefghijklmnopqrstuvwxyz
1234567890

Locarno
ABCDEFGHIJKLMN
OPQRSTUVWXYZ
abcdefghijklmnopqrstuvwxyz
1234567890

C0 M0 Y0 K100
C0 M90 Y85 K0
C0 M0 Y0 K0

C95 M10 Y20 K0
C100 M0 Y30 K43
C0 M30 Y94 K0

C60 M0 Y35 K0
C100 M0 Y60 K38
C15 M43 Y0 K0

C70 M40 Y0 K0
C100 M79 Y0 K11
C0 M50 Y100 K0

C80 M70 Y0 K0
C100 M95 Y0 K35
C20 M0 Y90 K0

C35 M85 Y50 K35
C65 M30 Y90 K45
C5 M60 Y90 K0

C30 M55 Y90 K25
C0 M90 Y100 K0
C40 M0 Y0 K100

C25 M35 Y35 K0
C55 M5 Y55 K0
C30 M75 Y100 K0

Vintage ▶ color

VINTAGE

Vintage...a style from history with enduring appeal. It is the best of its kind and people are drawn to it for its recognizable feel or classic look. Be sure to visit a local thrift store before you begin. There are aisles and aisles of inexpensive inspirations, and you may discover a forgotten classic that inspires your style.

"Asking a set series of questions early on is the key to making sure that both the client and designer are on the same page. And while briefs will differ slightly depending upon the project, they shouldn't tell the designer how to work. Briefs are only a way of identifying objectives and defining a scope of work from the onset of the project, leaving no arbitrary or confusing decisions for later."

—Dean Nakabayashi

Definition ⊳

vintage (adj.)

1. Characterized by excellence, maturity and enduring appeal; classic
2. Old or outmoded
3. Of the best or most distinctive

Questions for Client ⊳

➤ What is your product's connection to the era you are representing?

➤ What mood are you trying to establish with this design?

➤ Does your product or service have a reputation for being mature and stable?

➤ Is your product something new with a classic feel, or does it have a long-standing history?

NAME OF PIECE: 500 Watts poster
STUDIO NAME: 500 Watts
ART DIRECTOR: Bob Slote
DESIGNERS: Bob Slote, Tom Maiorana
ILLUSTRATOR: Bob Slote

This piece was to be "a leave-behind and self-promotion," explains art director Bob Slote. By angling the focus on vintage cameras, and by placing type slightly off the page, the designer managed to produce a work that is both captivating and effective.

WHO

When I first thought of looking for partners to start a design studio, my aim was very simple: I wanted to hang out with bright people, do cool work for demanding clients, and have a good time doing so.

Erik Spiekermann

Mission Statement

To design is much more then to assemble, to order, or even to edit; it is to add value and meaning, to illuminate, to simplify, to clarify, to modify, to dignify, to dramatize, to persuade, and perhaps to even amuse.
Paul Rand

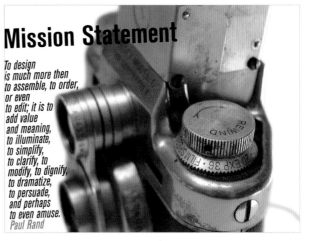

NAME OF PIECE: *The Observer* magazine
STUDIO NAME: *The Observer*
DESIGNER: Wayne Ford

An image taken from a fashion story lent itself to the cover, according to Wayne Ford. A comple-mentary color—selected from a detail on the model's dress—was used for the logo, which then was combined with a short cover line that sat well within the dark area of the fifties-inspired skirt. The resulting design is truly reminiscent of an earlier age.

NAME OF PIECE: Aurora ChillMan poster
STUDIO NAME: BAD Studio
DESIGNER: Scott Banks
CLIENT: Aurora Coffee
CLIENT'S SERVICE: Independent coffee house

Designer Scott Banks explains, "This place serves damn good coffee, so I created the 'anti-Starbucks' poster."

NAME OF PIECE: Recording Industry Statistics Series, Record History
STUDIO NAME: StudioNaka
ART DIRECTORS: Dean Nakabayashi, Joe Miller
DESIGNER/ILLUSTRATOR: Dean Nakabayashi
CLIENT'S SERVICE: Information strategy design

"Records may be vital in the career of a disc jockey, but not too many DJs know the underlying history and evolution of the discs we see today. I created a simple timeline highlighting the advancements of recording discs since their introduction. I illustrated the timeline of events on the record disc itself, using the grooves of the discs as markers for the timeline. This idea is analogous to how we determining the age of a tree with a ring cross-section," explains Dean Nakabayashi.

NAME OF PIECE: Geron 1997 annual report
STUDIO NAME: Cahan & Associates
ART DIRECTOR: Bill Cahan
DESIGNER: Bob Dinetz
CLIENT: Geron Corporation
CLIENT'S SERVICE: Biotechnology

Bill Cahan explains, "While presenting Geron's science in an understandable format was a basic need, the intent was to highlight the inescapable process of aging and how it affects the quality of our lives. Geron also wanted to feature some of its employees, showing how disease in their own families gives their work a personal perspective. To support this theme, life stories, company milestones and science platforms are depicted in a handmade, intimate manner."

NAME OF PIECE: Turner Classic Movies 2001 recipe calendar
STUDIO NAME: BAD Studio
ART DIRECTOR: Scott Banks
DESIGNERS: Scott Banks, Mark McDevitt
ILLUSTRATOR: Mark McDevitt
CLIENT: Turner Classic Movies

The inspirations for this piece were "old recipe calendars of the 1940s and 1950s," explains art director Scott Banks. By combining a historical image with a new design, this package really brings the viewer back to the times of black-and-white television, when women were shown in aprons perfecting the art of homemaking.

Dear Fellow Shareholders:

In fiscal 1997, Xilinx recaptured the technological lead and stepped up the pace of innovation in the programmable logic industry. This Annual Report is purposely small. Its reduced size is meant to dramatize how Xilinx uses advanced integrated circuit (IC) technology to increase the density and reduce the size of its devices.

Throughout much of fiscal 1997, a semiconductor-wide inventory correction reduced customer demand. In addition, Xilinx was in the midst of a product transition. Our previously rapid growth slowed. By midyear, we were taking action to get back on track. First, we refocused our R&D resources on our core businesses: SRAM-based field programmable gate arrays (FPGAs) and Flash-based complex programmable logic devices (CPLDs). Second, we dramatically accelerated our adoption of leading-edge semiconductor manufacturing technology in order to increase gate densities, increase device speed, and reduce the cost per device.

These two steps enabled us to sample the industry's first 0.35 micron mixed voltage FPGAs. In addition, we shipped new logic

design software and began selling ready-to-use logic cores that reduce time to market for our customers. By our fourth fiscal quarter, revenue growth had returned to historic levels. For the fiscal year as a whole, revenues grew to a record $568 million, up slightly from $561 million in fiscal 1996. Net income was $110 million, or $1.39 per share, up from $102 million, or $1.28 per share, in fiscal 1996.

Accelerating Technology Leadership
Programmable logic companies' process technology has traditionally lagged by a generation or more the IC manufacturing technology used by memory com-

about two years, or a quarter of the time required for the last leap.* At the same time, we are leveraging advanced IC process technology to slash product prices. For example, a 10,000-gate Xilinx FPGA that sold for more than $100 in 1994 sells for approximately $10 today.

When transistors on semiconductor devices shrink below 0.5 micron in size, the devices themselves require power supplies lower than the current standard of 5 volts. In fact, each new generation of transistor size will require a correspondingly lower voltage. Xilinx is now the only programmable logic supplier with pin compatibility between devices of

ing the way logic itself is designed. Looking forward, customers will no longer design

large-density FPGAs one gate at a time. They will integrate complex logic designs into their products at the system-level. Xilinx has a superior understanding of the system-level challenges of programmable logic. We offer complete solutions based on that understanding and partner with our customers to guide them through the complexities of submicron IC technology. In addition, as customers design products using FPGAs of 100,000 gates or more, they need more sophisticated design software. They also implemented pre-implemented cores of logic that help reduce time to market. Xilinx provides both types of software as part of an integrated solution. In such a challenging technological

XILINX
1997 ANNUAL REPORT

Founded in 1984, Xilinx is the world's largest supplier of programmable logic solutions serving electronic equipment manufacturers worldwide with faster time to market and increased flexibility. The reduced size and densely packed cover of this annual report symbolizes a Xilinx semiconductor chip, physically demonstrating our focus on increasing density while reducing the size of programmable logic devices. The attached magnifier will help you read about Xilinx leadership in silicon, software, and support. Inside, the report shows how Xilinx has established a new competitive roadmap through the programmable logic landscape.

Signage on photos (as shown):
BURLINGAME theatre
NOW SHOWING
FOCUSED STRATEGY
FEATURING DENSITY AND PRICE LEADERSHIP

CAUTION STEEP RAMPS PROCEED AT YOUR OWN RISK

COMING SOON .25µ

Xilinx delivers the world's most comprehensive PLD solutions, based on the programmable logic industry's most aggressive technology roadmap for increasing gate densities and device speeds. Xilinx is also slashing the cost per gate at lower densities with high-volume FPGAs and in-system programmable CPLD solutions.

NAME OF PIECE: Xilinx annual report
STUDIO NAME: Cahan & Associates
ART DIRECTOR: Bill Cahan
DESIGNER: Kevin Roberson
CLIENT: Xilinx Inc.
CLIENT'S PRODUCT: Programmable logic devices

"The report cover, with its densely packed, reduced type, symbolizes a tiny semiconductor chip packed with information. The attached magnifying lens allows the reader to zoom in on the text and detailed charts. Inside, photos show a series of attractions along the 'Technological Highway' with the signage changed to reveal Xilinx's key messages," explains Bill Cahan.

NAME OF PIECE: Mickey Mouse and his pals mints
STUDIO NAME: Disney Design Group
ART DIRECTORS: Bob Holden, Patrick Scanlan
DESIGNER: Thomas Scott
ILLUSTRATORS: Mark McIntyre, Peter Emslie
CLIENT: Walt Disney Parks and Resorts Merchandise

Thomas Scott says, "These mints are shaped like Disney characters, so I decided to depict the actual mints on the tin. With the mint images showing full figures, I could use dynamic 'floating heads' of the Disney characters as the primary design element. Since the product appeals to an adult customer, I chose a nostalgic approach to the packaging. The packaging is reminiscent of the kinds of consumer products the Disney Company licensed in the 1930s. My desire was to make this new product look like something that had been available for decades (like the competing best-selling mint)." Image © Disney.

NAME OF PIECE: Christmas card
STUDIO NAME: Karl Design
DESIGNER: Andreas Karl
CLIENT: Self promotion

Andreas Karl explains the inspiration for this card: "When I was a little boy I got miniature models of aircrafts and sailing-ships for Christmas. You had to break hundreds of small numbered parts out of a plastic frame and glue them together. Periodically I ruined mother's dining room table." The concept of the old plastic break-apart pieces brings back fond memories for anyone fortunate enough to have gotten one of these models.

C100 M56 Y0 K0
C100 M0 Y79 K27
C0 M0 Y0 K0

C50 M30 Y0 K50
C60 M30 Y0 K40
C80 M30 Y0 K20

C76 M0 Y91 K0
C79 M94 Y0 K0
C0 M0 Y0 K100

C55 M10 Y0 K18
C100 M60 Y0 K18
C45 M0 Y30 K30

C0 M0 Y0 K0
C40 M15 Y0 K0
C70 M35 Y0 K0

C35 M0 Y25 K0
C70 M0 Y0 K0
C70 M40 Y0 K0

C55 M0 Y0 K0
C45 M0 Y30 K30
C20 M0 Y15 K10

C100 M95 Y0 K5
C60 M47 Y0 K0
C35 M10 Y0 K0

C0 M38 Y80 K0
C0 M100 Y90 K20
C20 M90 Y100 K30

C0 M85 Y85 K30
C0 M15 Y95 K0
C0 M0 Y0 K100

C0 M98 Y84 K0
C0 M27 Y83 K0
C0 M6 Y31 K0

C0 M90 Y75 K6
C0 M0 Y0 K100
C0 M0 Y0 K0

C10 M15 Y35 K0
C0 M40 Y45 K35
C0 M15 Y27 K55

C0 M60 Y100 K35
C0 M85 Y60 K50
C0 M18 Y100 K15

C5 M70 Y100 K0
C8 M53 Y90 K0
C10 M35 Y90 K0

C0 M20 Y30 K10
C5 M5 Y50 K0
C0 M40 Y45 K35

Warm COOL

Colors are powerful—and sometimes misunderstood—aspects of design that can quickly clarify or confuse your message. Warm or cool colors can subconsciously affect the way your client feels, enhancing emotions such as anger, sadness or fear. Sometimes, if an object or concept already has certain colors associated with it, opposite colors can be used to produce a jarring or memorable effect. If you or your client would like to learn more about colors and their effects on design, refer to *Pantone's Guide to Communicating With Color.*

> *"We work hard to create a common visual vocabulary. Often we create 'attitude boards': visual representations of the story we're trying to create; the mood, the feeling, the attitude of the project and maybe even what the competition looks like. We do this to get a response from the client about the direction we're recommending. These visuals represent what we're trying to say before we have all the words to describe them."*
>
> —*Michael Courtney*

Definition ❄

warm (adj.)

 1. Inducing the impression of warmth; used especially of reds and oranges and yellows

cool (adj.)

 1. Inducing the impression of coolness; used especially of greens and blues and violets

Questions for Client ❄

> ➤ How will having a cool or warm color scheme impact your design?
> ➤ Are you trying to associate with a particular emotion? What color scheme will portray this abstract idea?
> ➤ What sensations do you want your audience to experience? Can you draw from your physical surroundings?
> ➤ Does your company or product have any existing associations with color? Decide whether this will work for you or against you.

NAME OF PIECE: 25th Anniversary Celebration header board
STUDIO NAME: David Evans and Associates, Inc.
DESIGNER: Sanjana Kapur
CLIENT: David Evans & Associates, Inc.
CLIENT'S PRODUCT/SERVICE: Architectural and engineering consultants

This poster was created for the 25th anniversary celebration of DEA in Arizona. Sanjana Kapur explains, "The focus is transportation design. I included images of roads and bridges, with the background of Arizona's landscape. All the elements meet together as one unit."

NAME OF PIECE: Crawford & Company 2001 annual report
STUDIO NAME: Corporate Reports Inc.
DESIGNER: Ronda Davis
CLIENT: Crawford & Company
CLIENT'S SERVICE: Diversified services to insurance companies, self-insured corporations and government entities
SPECIAL PRODUCTION TECHNIQUE: Spot gloss varnish on images and color blocks
SPECIAL FOLDS/FEATURE: Fold-out front cover

The concept was determined by the client. Ronda Davis tried to enhance the message and by using interesting color combinations and typography inspired by Rolling Stone magazine. She was also inspired by listening to Matthew Carter speak about designing his font, Mantinia, at the HOW Conference in Atlanta.

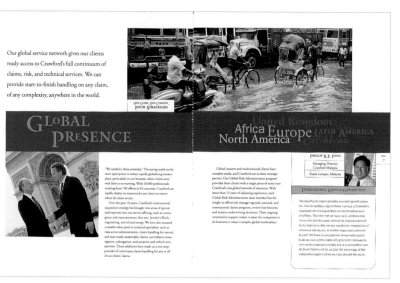

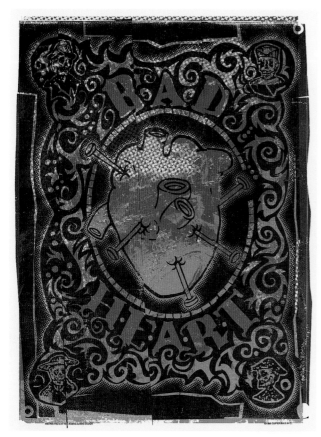

NAME OF PIECE: BAD Heart
STUDIO NAME: BAD Studio
DESIGNER: Kevin Fitzgerald
CLIENT: Self promotion

"Mexican Day-of-the-Dead art" inspired Kevin Fitzgerald's design for this piece. Using primarily black against different shades of warm colors, this piece uses an analogous color scheme to portray its concept even more effectively.

NAME OF PIECE: Italian Design 2001 poster
STUDIO NAME: Peg Faimon Design
DESIGNER: Peg Faimon
PHOTOGRAPHERS: Peg Faimon, John Weigand
CLIENT: Miami University

Peg Faimon explains, "I was inspired by the architectural details of Italy, both classical Rome and modern Milan. The strong use of red was inspired by many of the printed pieces I saw there."

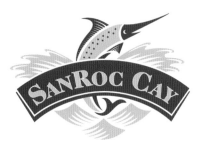

(top)
NAME OF PIECE: Blake Little 2000 promotion
STUDIO NAME: AdamsMorioka, Inc.
ART DIRECTOR: Sean Adams
DESIGNER: Volker Dürre
CLIENT: Blake Little
CLIENT'S SERVICE: Photography

"The clarity and richness of Blake's photography" was the inspiration for this promotion, says art director Sean Adams. Its simple use of color and type make the impact of its cool, rich colors even stronger.

(bottom left)
NAME OF PIECE: San Roc Cay logo
STUDIO NAME: DogStar
ART DIRECTORS: Lynn Smith/Perry Harper & Perry
DESIGNER/ILLUSTRATOR: Rodney Davidson
CLIENT: San Roc Cay
CLIENT'S PRODUCT/SERVICE: Gulf resort

Rodney Davidson explains, "This mark was designed to be etched out of a granite entrance way as well as work in print. After creating the mark in FreeHand, I used Adobe Photoshop to simulate the mark etched in granite. I printed the logo on a T-shirt and wore it to my client meeting as my presentation."

(bottom right)
NAME OF PIECE: DesignEire logo
STUDIO NAME: Jeff Fisher LogoMotives
ART DIRECTOR: Nikita Jones, DesignEire
DESIGNER: Jeff Fisher
CLIENT: DesignEire
CLIENT'S PRODUCT/SERVICE: Web design, graphic design, MS
 Office templates and animation services

Jeff Fisher explains the evolution of this logo: "After the presentation of ten other concepts the client and I just were not clicking. Traditional Irish, Celtic, computer and technology images were not successfully branding the company. Going back over the client's instructions, the phrases 'professional image, clever flair, creative and technical talent, and credibility with corporate clients' made me realize that I needed to go in a completely different direction and create a very strong, bold, corporate look."

(right)

NAME OF PIECE: Gemeente Tynaarlo stationery
STUDIO NAME: Erwin Zinger Graphic Design
DESIGNER: Erwin Zinger
CLIENT: Gemeente Tynaarlo (City of Tynaarlo)
SPECIAL PRODUCTION TECHNIQUES: Erwin Zinger says, "The envelopes are printed first and then folded; therefore I could use color to the end of the envelope."
SPECIAL FOLDS/FEATURES: When folded, the name of the city appears at the top of the letter. When put into an envelope, the logo appears in the address zone.

According to Erwin Zinger, "The image of the flower is from a flower which grows only here in Holland. It symbolizes the unique atmosphere of the city."

(below)

NAME OF PIECE: Dan Anderson Homes logo
STUDIO NAME: Jeff Fisher LogoMotives
DESIGNER: Jeff Fisher
CLIENT: Dan Anderson Homes
CLIENT'S PRODUCT/SERVICE: Home construction

Jeff Fisher explains, "The client wanted the design to convey the idea that he was building single family homes on smaller pieces of property. The graphic developed from that concept."

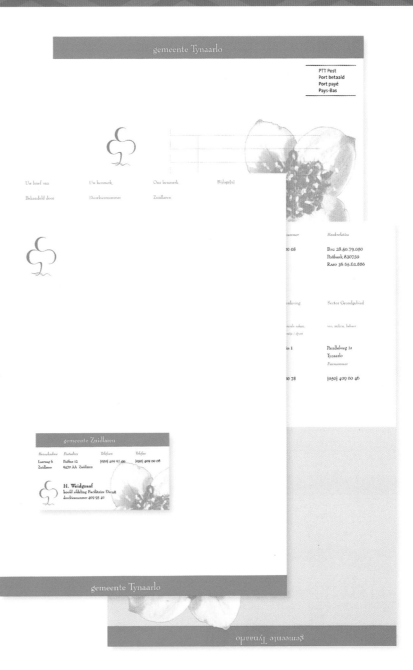

Xtreme typography refuses to follow the rules. Often displaying movement and energy, these type treatments disregard any sense of normalcy and sometimes push readability to the limit. Tip: Review the basic rules of typography, then break them.

OL Headline Gothic

ABCDEFGHIJKLMNOPQRSTUVWXYZ

abcdefghijklmnopqrstuvwxyz 1234567890

Garish Monde

ABCDEFGHIJKLMN
OPQRSTUVWXYZ
abcdefghijklmn
opqrstuvwxyz
1234567890

Runic MT

ABCDEFGHIJKLMNOPQRSTUVWXYZ

abcdefghijklmnopqrstuvwxyz

1234567890

Novarese

ABCDEFGHIJKLMN
OPQRSTUVWXYZ
abcdefghijklmn
opqrstuvwxyz
1234567890

OSKAR

ABCDEFGHIJKLMN
OPQRSTUVWXYZ
1234567890

C100 M0 Y10 K65
C0 M50 Y100 K0
C0 M0 Y5 K35

C0 M20 Y83 K0
C90 M45 Y0 K0
C0 M0 Y0 K100

C60 M0 Y50 K0
C100 M0 Y0 K50
C0 M0 Y100 K45

C70 M35 Y0 K0
C0 M0 Y70 K10
C100 M55 Y0 K35

C0 M0 Y0 K100
C0 M100 Y100 K0
C60 M100 Y0 K0

C85 M100 Y0 K10
C10 M0 Y100 K27
C100 M50 Y0 K0

C65 M0 Y20 K0
C48 M24 Y100 K0
C90 M45 Y0 K0

C0 M0 Y0 K100
C0 M0 Y0 K80
C0 M90 Y75 K0

XTREME COLORS

SYNONYMS *intense, maximum, ultimate, extraordinary, action-oriented, athletic*
SIMILAR SECTIONS *kinetic, quick, powerful*

XTREME

This is a section for the thrill-seeker, and many times, the athlete. Often on the cutting edge of design, this style is very generational, typically aimed toward a younger audience. It's for the person who is pursuing the intense moments in life, continually setting higher and higher goals. Xtreme design pushes the boundaries, and can be simply shocking.

> *"When we get as specific and concrete as possible we can avoid misunderstandings. Sometimes we use a creative brief sheet with questions to clearly set down and agree upon what we are setting out to accomplish. Sometimes clients cannot completely articulate what they want until they see something. That's OK too. Respond to the work itself. Listen. Educate. Pick your battles."*
>
> —Joshua Chen

DEFINITION

extreme(adj.)
1. Of the greatest possible degree or intensity
2. Far beyond a norm in quantity or amount or degree; to the utmost degree
3. Beyond a norm in views or actions

QUESTIONS FOR CLIENT

➤ What word of your message do you want to come across most strongly?
➤ Are there any colors that are mandatory to use in the design?
➤ Is your audience young or sports-oriented?

At Rawlings, we bagged a few home runs of our own in 1998

— and not just in the baseball category. During the race to crown a new home run champion, Rawlings successfully marketed our long-standing relationships with Major League Baseball and star slugger Mark McGwire.

. . .

But the year's biggest wins were achieved at the **grassroots** level of the team sports market, where we used

PROVING OUR METTLE IN ALUMINUM BATS

Rawlings successfully introduced new aluminum bat models in 1998, including an adjustable-weight model for the adult softball market. But the big news in bats this year was the new NCAA guidelines about bat performance. Rawlings and Major League Baseball are purchasing testing equipment which will be used to assist the NCAA in enforcing its new rules.

► For details, see page 13

AMERICA'S PASTIME...

Rawlings

BACK IN ITS PRIME

NAME OF PIECE: Rawlings Sporting Goods annual report
STUDIO NAME: ProWolfe Partners, Inc.
DESIGNER: Bob Prow
CLIENT: Rawlings Sporting Goods

Mark McGwire, the Cardinals, and designer Bob Prow's love for baseball all played into the design of this piece. Prow explains, "Rawlings' main business is baseball products. As goes baseball, so goes Rawlings. Before our presentation to the client, the writer provided his initial draft of the text. He captured the mood and atmosphere of the entire year in one incredible paragraph. I reworked the design around that paragraph. They loved it!"

(top right)
NAME OF PIECE: Nike Vetrine News: *Rome City Attack*
STUDIO NAME: Matite Giovanotte
ART DIRECTOR: Giovanni Pizzigati
DESIGNER: Elisa Sangiorgi
CLIENT: Nike Italy
SPECIAL FOLDS/FEATURES: Synthetic grass cover, working whistle

Art director Giovanni Pizzigati based the concept for this piece on an existing Nike campaign. The synthetic grass on the cover and the attached whistle are both exciting and unique enticements to open and explore.

(bottom right)
NAME OF PIECE: Nike Vetrine News: Spring 2001
STUDIO NAME: Matite Giovanotte
ART DIRECTOR: Giovanni Pizzigati
DESIGNER: Elisa Sangiorgi
CLIENT: Nike Italy

The imprint of the shoe was the inspiration for this piece, according to art director Giovanni Pizzigati. The impending impact of the sole of the shoe communicates a sense of urgency.

(below)
NAME OF PIECE: Javelin logo
STUDIO NAME: DogStar
DESIGNER: Rodney Davidson
CLIENT: Javelin
CLIENT'S SERVICE: Entertainment marketing

Rodney Davidson explains, "I wanted the mark to be entertaining, so I used a whimsical approach to an ancient symbol."

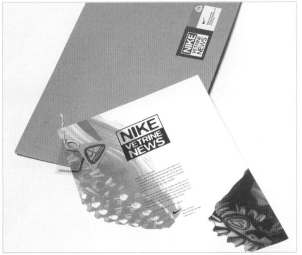

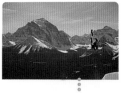

ATHLETICS
AND THE
AESTHETIC
SURFACE

SARAH COOK

[SNOWBOARDING] embodies all those elusive elements of cool that marketers and media people find so attractive—young people, rebellion, exotic locations, great clothes, exciting action, slang, music. Its spirituality makes it ideal for the 1990s, combining surfing's sense of proximity to nature with the hard-edged cynicism of skateboarding.[1]

The ego is first and foremost a bodily ego: it is not merely a surface entity, but is itself the projection of a surface.[2]

The ego is a kind of meeting point between the social and the corporeal; it is the site through which

the body is produced as a determinate type according to the requirements of culture. It is in turn one of the sites of social resistance and transcription of the social by the corporeal.[3]

If we are to believe the thinkers quoted above, snowboarding is all about ego—one that is not only marketable and tied to an identifiable social and cultural sphere, but one that also leaves room for the body (the rider) to leave a mark on that social and cultural surface. This mark (a transcription, or, in Freud's words, a projection of a surface) is commonly seen to be both that of the skateboarder—defiance, resistance, cynicism—and that of the surfer—freedom and fun. With snowboarding the "fastest growing sport in America" the market rarely stops to acknowledge that it is the riders that leave this mark, that have created this surface image. After all, an ego is a personal thing. We each have one, and it is stored within our bodies and projected through what we chose to do with them. And what snowboarders choose to do with their bodies is ride.

▸ **Fresh Off Movie Shot at Lake Louise, 1999**
DURATES PHOTOGRAPH, 20 1/8" × 42 13/16"
Michael McPhee

[SNOWBOARDING] has evolved rapidly, shifting underneath every time the market got heavy, drawing from different sports technologies, fashions and cultures. While the market has new snowboarders in recent years have been attracted to the sport's cool image. Long ago it was written snowboarders were attracted to its small inclusive community. Now, with everyone out there boarding, plus the distinctly un-alternative Olympic image thrown in, the original associations fading away. (Snowboarding is no longer an identity-forming image, it is just something that people do.)

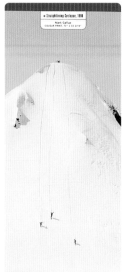

I believe that no matter how much the "mainstream" has come to snowboarding, the sport still presents, in most mountain towns in Canada and the US, an 'identity-forming image.' The impetus behind organizing an exhibition about this image was a recognition that the look of snowboarding—the graphic design, the photographs, the ads and the boards—has been propelled by the input of the riders themselves. This recognition goes beyond pro snowboarders deciding which images appear on the base of their pro-model boards, to a discovery that snowboarders, in general, make up a larger body of artistically minded people than one might find in an examination of any other sport. Why is this? Is it a particular relationship to the landscape? Is it to be found in the roots of snowboarding itself? The exhibition **First Descent: Art and Artifacts from Snowboard Culture** poses these questions and more.

SARAH COOK, GUEST CURATOR

▸ **Sume, 1999**
COLOUR PRINT, 24" × 18"
Trevor Graves

▸ **Straightlining Cyclonse, 1999**
COLOUR PRINT, 73" × 32 13/16"
Mark Gallup

ART and ARTIFACTS from SNOWBOARD CULTURE

✳ **WALTER PHILLIPS GALLERY**
BANFF, ALBERTA, CANADA
▸ DECEMBER 3 1999 – JANUARY 23 2000

✳ **BELLEVUE ART MUSEUM**
BELLEVUE, WASHINGTON, USA
▸ FEBRUARY 12 2000 – APRIL 22 2000

NAME OF PIECE: *First Descent:* Art and Artifacts from Snowboard Culture
STUDIO NAME: Vangool Design & Typography
DESIGNER: Janine Vangool
CURATOR: Sarah Cook
PHOTOGRAPHER: Michael McPhee
CLIENT: Walter Phillips Gallery, Banff Centre for the Arts and the Bellevue Art Museum
SPECIAL FEATURES: Curved corners

Janine Vangool says, "The gallery exhibition 'First Descent' explored the art and artifacts created through the sport of snowboarding. Snowboard graphics and merchandise development were presented, along with art and photography celebrating the sport. The exhibition brochure reflects the style and energy of the sport and its culture. The text switches between horizontal and vertical formats, re-creating the twists and turns of the sport. The shape of the open brochure, with its curved corners, echoes the shape of a board."

FIRST DESCENT
ART AND ARTIFACTS FROM SNOWBOARD CULTURE

NAME OF PIECE: *Mountain of Madness* CD
STUDIO NAME: Sagmeister Inc.
ART DIRECTOR: Stefan Sagmeister
DESIGNERS: Stefan Sagmeister, Veronica Oh
PHOTOGRAPHER: Tom Schierlitz
CLIENT: Energy Records
SPECIAL PRODUCTION TECHNIQUES: Red-tinted jewel case

Stefan Sagmeister tells the story that inspired this piece:
"When I first arrived in New York, I saw an old, quite
distinguished-looking man coming toward me on the
sidewalk. Just as he passed me, he freaked and started to
shout obscenities at nobody in particular. When the singer of
the H.P. Zinker told me that the lyrics of the album deal with
schizophrenia and the different ways the city can make you
sick in the head, the old man came to mind again. My friend
Tom Schierlitz took a calm picture and a frantic picture of an
old man. Then we printed the calm image in green, and
overprinted the frantic image in red. If you put the image into
a red-tinted plastic case—because of the fact that red and
green are complementary colors—the green image turns
black and the red image becomes invisible."

BERTRAM
ABCDEFGHIJKLMN
OPQRSTUVWXYZ
1234567890

KidTYPE Paint
ABCDEFGHIJKLMN
OPQRSTUVW XYZ
abcdefghijklmn
opqrstuvwxyz
1234567890

Kabel
ABCDEFGHIJKLMN
OPQRSTUVWXYZ
abcdefghijklmn
opqrstuvwxyz
1234567890

Marydale
ABCDEFGHIJKLM
NOPQRSTUVWXYZ
abcdefghijklm
nopqrstuvwxyz
1234567890

Kidprint
ABCDEFGHIJKLMN
OPQRSTUVWXYZ
abcdefghijklmn
opqrstuvwxyz
1234567890

Tekton
ABCDEFGHIJKLM
NOPQRSTUVWXYZ
abcdefghijklmn
opqrstuvwxyz
1234567890

CO M50 Y87 K0
C40 M0 Y15 K0
CO M5 Y75 K0

C51 M94 Y0 K0
CO M0 Y0 K100
CO M0 Y0 K0

C100 M60 Y0 K6
C76 M0 Y91 K0
C43 M91 Y0 K0

C100 M80 Y0 K0
CO M0 Y100 K18
CO M0 Y0 K0

C10 M0 Y80 K0
C95 M90 Y0 K0
C100 M10 Y0 K5

CO M50 Y90 K0
CO M20 Y100 K0
C20 M0 Y90 K0

C85 M25 Y0 K0
CO M75 Y60 K0
C10 M0 Y85 K0

C76 M0 Y91 K0
C60 M0 Y27 K0
CO M0 Y100 K18

Youthful

Youthful design is not necessarily targeted toward children, but suggests a child's carefree view of life by using bright colors and a fun, playful typographic style. The goal of this style is to take the audience back to an age of innocence, a time when stress was a quickly melting ice cream cone. Tip: bring crayons and paper to the first client meeting so that the client—as well as the designer—can revert to childhood.

> *"Gather as much information from the client as possible. Ask what they like and what they think their piece should look like. Give them paper so they can sketch. Show them examples of work you've done for other clients and what the intent of the piece was. Ask for a company mission statement and do research. Brainstorm with the client."*
>
> *—Kristin Miaso*

Definition •

youthful (adj.) youth·ful

1. Characterized by youth; young
2. Of, relating to, or suggesting youth
3. In an early stage of development

Questions for Client •

➤ Do you want the audience to feel like your design is fun-loving and whimsical?

➤ Get out some old photo albums. Which pictures make you smile? Why?

➤ What time period in life are you trying to revert to? What are your favorite memories from that time in your own life?

T I D B I T S

(top left)
NAME OF PIECE: DogStar pro-bono logo
STUDIO NAME: DogStar
DESIGNER: Rodney Davidson

Designer Rodney Davidson explains, "When I was growing up, we had a chihuahua named Tidbit. Since tidbits usually describe the budget involved in a probono project, I thought a caricature of Tidbit would be perfect."

(top right)
NAME OF PIECE: The Food Chain logo
STUDIO NAME: Jeff Fisher LogoMotives
DESIGNER: Jeff Fisher
CLIENT: triangle productions!
CLIENT'S PRODUCT/SERVICE: Theatrical productions

"The original logo, for the New York production of the play *The Food Chain* by playwright Nicky Silver, included three fish in a single straight line, with the smaller fish eating the next larger image. After reading the play, I felt it conveyed more of a 'vicious circle,' so I adapted the graphic to promote the Portland production," explains Jeff Fisher.

(bottom)
NAME OF PIECE: Bikecenter
STUDIO NAME: CAPDESIGN
DESIGNER: Carlo Albert Perretti
CLIENT: Bikecenter
CLIENT'S SERVICE: Bike sales and repairs
SPECIAL TECHNIQUES: Hand-drawn typeface

This logo contains a funny-looking man standing in a victorious pose with his bike raised above his head. According to Carlo Albert Perretti, he's saying, "I've done it!"

Via dell'Edilizia - Z.I.
85100 Potenza

BIKECENTER
di Maurizio Russo e Michele Summa snc
Via dell'Edilizia - Z.I. - 85100 Potenza
097169195 - P.IVA 01207490762

(above)
NAME OF PIECE: McCarthy Education Services brochure
STUDIO NAME: ProWolfe Partners, Inc.
ART DIRECTOR: Bob Prow
DESIGNERS: Bob Prow, Karin Caracci
CLIENT: McCarthy Construction Company

Bob Prow explains, "The purpose of this brochure was to promote McCarthy's expertise as a building contractor for schools. For me, kids and fun were the inspiration. The challenge was fitting the fun in with the company's new visually integrated branding program. We met the challenge by using photos of employees' children and a game of hopscotch to convey fun, growth and the future. Fortunately, our client was game for the idea."

(right)
NAME OF PIECE: North Star Pediatrics logo
STUDIO NAME: Born to Design (for Flack Design)
DESIGNER: Todd Adkins
CLIENT: North Star Pediatrics, P.C.

Designer Todd Adkins describes the inspiration for this piece as, "Babies, what else? I wanted to stray from the more cliché approaches to pediatric medical care and go straight for the heart of the parent, which is the child itself. The softness, innocence and wide-eyed wonder of an infant was the perfect way to show that the client truly understands the focus of their business."

North Star
PEDIATRICS, P.C.

(left)
NAME OF PIECE: Blue Martini comic book/product
awareness brochure
STUDIO NAME: NIA Creative
ART DIRECTOR: Thomas Anderson
DESIGNERS: Ted Babcock, Thomas Anderson
ILLUSTRATORS: John Heebink, John Estes
CLIENT: Blue Martini Software

Thomas Anderson explains, "This humorous approach to marketing Blue Martini Software uses an innovative comic book storyline to dramatically express the infinite ways this product is better than its competitors."

(below)
NAME OF PIECE: Black Dog Furniture Design logo
STUDIO NAME: Jeff Fisher LogoMotives
DESIGNER: Jeff Fisher
ILLUSTRATOR: Brett Bigham
CLIENT: Black Dog Furniture Design
CLIENT'S PRODUCT: Home and garden furniture

"This logo evolved from the illustration the client, Brett Bigham, had created of his dog, Adobo. When asked to design a logo for the business, I immediately envisioned the o in the word 'dog' representing the wagging of the dog's tail. The font and other graphic elements were selected to complement the illustration," says Jeff Fisher.

(top)
NAME OF PIECE: KidStuff PR logo
STUDIO NAME: Jeff Fisher LogoMotives
DESIGNER: Jeff Fisher
CLIENT: KidStuff Public Relations

Jeff Fisher remarks, "This logo was inspired out of desperation when I received a fax from a woman in Waunakee, Wisconsin. Lisa Orman wrote that she had an immediate need for a business identity, as The Wall Street Journal *was doing a front-page mention of her business the following week. To make a long story short, when the newspaper article appeared, the company had a fun and professional-looking Web presence. In the print version of the logo the letter K is positioned to playfully kick the dot of the i, as a child might kick a ball. On the Web version, the K actually does kick the dot and it bounces across the top of the logo."*

(bottom)
NAME OF PIECE: Children's Writer's Word Book
STUDIO NAME: F&W Publications
DESIGNER: Lisa Buchanan

"This cover was actually a redesign of an existing one that seemed outdated. In this situation, you must really step away and force yourself to not follow a similar path. I decided that an illustrated youthful look would be most appropriate, and then I happened to come across a pre-existing illustration that fit this project perfectly. I like the dynamic movement and the bright youthful colors," says Lisa Buchanan.

YOUTHFUL

227

Following are some special production techniques that designers have used to add that extra oomph to their design:

•Tube packaging
•Silver polyester cover
—Giovanni Pizzigati

•Hexachrome printing
—Ryan Lorei

•Binding with grommet and washer
•Subtle spot varnish on vellum
•Foil stamp
•Sculptured embossing
•Deckled die cut on printed stock to mimic parchment paper
—Patrick Ho

•Screw and post in the upper-left corner
•Ink color slightly darker than the paper
—Theresa P. Van Ert

•Punch
•Diestamping
•Blind and hot-foil embossing
•Special binding with metal clip
—Thilo von Debschitz

•Copper foil stamp
—Michael Osborne

•Worn or sun-faded perimeter edge to pages
—Gary LoBue, Jr.

•Angled cut set up with a jig on the guillotine cutter
—Peg Faimon

•Two-color scratch panel
—Laurenz Nielbock

•Foilprinting
—Erwin Zinger

•Offline spot dull varnish
•Metallic dull varnish
—Christopher Gorz

•Thermography
•Color laser
—Joshua Chen

•Dry trap varnishes
—Bo Bothe

•Silkscreened slipcase
—Stefan Sagmeister

•Silver overprint type
—Jill Howry

•Holographic CD surface
—Stefan Sagmeister

•Rub-and-view ink
—Erwin Zinger

•Acid etching
•Laser cutting
•Foil stamping
•Debossing
•Holepunching
•Hand-applied labeling
—Joshua Chen

•Synthetic grass
•Whistle
—Elisa Sangiorgi

•One spot color used effectively on a colored paper stock can produce the apparent visual effect of two or more colors. Put two stocks in close proximity using the same technique and the effect is multiplied.
•Specify a very fine-line screen for all screen tints; this will also produce the apparent visual effect of more color.
—Gary LoBue, Jr.

•Metallic and black duotint
•Four-digit metallic ink for over-printing (eliminates need for dry trapping)
—Joshua Chen

Z!NG

Z!NG is any style that goes the extra mile to get a special reaction. One of your major concerns may be budget, but this can be overcome given enough time to research different prices and options. The sky is the limit, so dream big!

> *"Cry, beg, and cajole."*
> —Stefan Sagmeister

DEFINITION ●

zing (adj.)

1. Dazzling style; flamboyance; flair
2. Vigorous spirit; energy or excitement
3. Extraordinary

QUESTIONS FOR CLIENT ●

➤ How much money can you spend?
➤ How crazy can you get?
➤ What are the limits of the project?
➤ Is "wowing" your audience a determining factor in getting their support or sale?

NAME OF PIECE: S, H & E annual report
STUDIO NAME: Erwin Zinger graphic design
DESIGNER: Erwin Zinger
PHOTOGRAPHERS: John Stoel, John Welling
CLIENT: N.V. Nederlandse Gasunie
CLIENT'S SERVICE: Sale and transport of fuel
SPECIAL PRODUCTION TECHNIQUE: Rub-and-view ink

When creating this design, Erwin Zinger wanted to "make visible the invisibility of gas. That's why I used the rub-and-view ink, which becomes visible when heated."

NAME OF PIECE: Ronald Duarte: *Durante o Túnel*
STUDIO NAME: ponto p design
ART DIRECTOR: Fabiana Prado
PHOTOGRAPHER: Wilton Montenegro
CLIENT: Ronald Duarte
CLIENT'S SERVICE: Contemporary artist
SPECIAL PRODUCTION TECHNIQUES: The cover was printed in plain black, then plastified; the title was silkscreened in varnish. The plastic brace was handmade by the artist from PET bottles, which he cut and heated according to his usual techniques. The four-fold page was created by combining two triple pages—a technique made necessary by the limitations of the printing facility, which could not handle paper larger than 66 cm (26").

Durante o túnel means "during the tunnel." This brochure was created for an exhibition which was displayed in an all-black room and illuminated by spotlights. The same concept was carried through to the catalog. Fabiana Prado adds, "To individualize the catalog, the artist created a plastic brace to include with each copy. Thus the catalog browser could more easily envision the texture, transparency, and rigidity of the works in the exhibition."

NAME OF PIECE: *Cutting the Christmas Tree* invitation
STUDIO NAME: Q
ART DIRECTOR: Thilo von Debschitz
DESIGNER: Schwarzschild
CLIENT: DGZ DekaBank, Frankfurt
CLIENT'S SERVICE: Wholesale banking

Thilo von Debschitz explains, "Our client wanted to invite VIP business and press partners to their annual Cutting the Christmas Tree *event (dinner with the bank's representatives, followed by a chance to cut down a tree). The inner pages were printed and then hand-stitched with loden felt material, and the invitation was personalized on the first page by hand."*

EINLADUNG ZUM CHRISTBAUMSCHLAGEN

für

und Begleitung

am 2./3. Dezember 2000, Hotel „Die Weyberhöfe" in Aschaffenburg

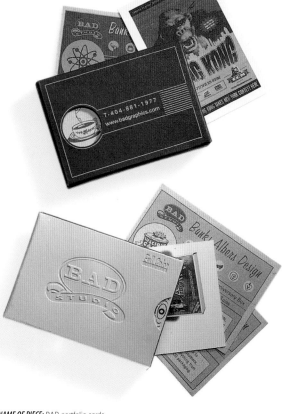

NAME OF PIECE: Big BAD Boxes
STUDIO NAME: BAD Studio
ART DIRECTOR: Scott Banks

Scott Banks explains, "We entertain people with our design; why not design the box it comes in, as well? We also use these boxes to ship out the freebies we give away at our web site."

NAME OF PIECE: BAD portfolio cards
STUDIO NAME: BAD Studio
ART DIRECTOR: Scott Banks
DESIGNERS: Scott Banks, Mark McDevitt
ILLUSTRATOR: Mark McDevitt
SPECIAL PRODUCTION TECHNIQUE: Two colored foils on the outside of the box
SPECIAL FOLDS/FEATURE: Custom box with round die-cut

These unique baseball-type cards showcase different pieces of BAD Studio's work on one side; on the other, they explain the concept behind the design. Wonderfully creative, this piece is sure to catch any potential client's eye.

NAME OF PIECE: Mohawk Paper *Heart & Soul* CD promotion
STUDIO NAME: Chen Design Associates
ART DIRECTOR: Joshua C. Chen
DESIGNERS: Joshua C. Chen, Max Spector, Leon Yu, Kathryn Hoffman
PHOTOGRAPHERS: Max Spector, Norman Abbey
ILLUSTRATORS: Max Spector, Leon Yu, Joshua Chen
CLIENT: Mohawk Paper Mills Inc.
SPECIAL PRODUCTION TECHNIQUES: Letterpress, fluorescent spot colors, metallic ink, spot varnishes, die-cut circle and holes

"The central concept for this piece, which was given away at the Mohawk show party in San Francisco, was a comparison statement: Mohawk is to paper as San Francisco is to music. A set of ten paper 'CDs' fanning out from a clear free-standing case constitutes Heart and Soul. *Each CD design revolves around a little-known piece of San Francisco music history or trivia as it displays the performance range of Mohawk's papers under a variety of on-press and off-line processes," says Joshua Chen.*

NAME OF PIECE: WebAppFactory corporate identity system
STUDIO NAME: Chen Design Associates
ART DIRECTOR: Joshua C. Chen
DESIGNER: Max Spector
CLIENT: WebAppFactory, Inc.
CLIENT'S SERVICE: Web applications and software development
SPECIAL PRODUCTION TECHNIQUES: Acid etching, laser cutting, foil stamping, debossing, holepunching, and hand-applied labeling

Joshua Chen says, "The concept for the new WAF logo and corporate identity centers on the visual marriage of 'industrial' and 'high tech.' The trademark employs a series of holes, which fit onto a very simple, modular grid to make up the letterforms WAF. The holes themselves symbolize rivets, holes from a punch card, or electronic circuitry. Symbolic of the company as a whole, they are individually solid elements, but not as important as the mark that comprises them."

NAME OF PIECE: Wang:Hutner stationery system
STUDIO NAME: Wang:Hutner Design
ART DIRECTORS: Maria Wang-Horn, Sue Hutner
DESIGNERS: John Milly, Eric Villarama, Tanya Lumbi, Rick Gaston

Maria Wang-Horn explains, "The story behind the development of the Wang:Hutner Design logo says a lot about who we are and how we work. Our approach to design has a lot in common with the classical notion of the five elements: earth, wind, fire, wood and metal. We believe that good design has five key characteristics that correspond to each of the elements and produce harmony and balance in our work: discipline, flexibility, passion, grounding and durability. So, when we developed an identity for ourselves, we symbolized this with the five overlaid circles that make up the WHD mark."

Abbott Laboratories
D46E, LFCP4
200 Abbott Park Road
Abbott Park, Illinois 60064

AdamsMorioka
370 South Doheny Drive, #201
Beverly Hills, CA 90430
www.adamsmorioka.com

BAD Studio
1123 Zonolite Road, Ste. 18
Atlanta, GA 30306
www.badgraphics.com

Born to Design
1937 Wayfield Drive
Avon, IN 46123
www.born-to-design.com

Brokaw Inc.
425 W. Lakeside Avenue
Cleveland, OH 44113
www.brokawinc.com

CADDGraphics
274 Bradford Street
Barrie, ON L4N3B8
Canada
www.caddgroup.ca

Cahan & Associates
171 2nd Street, 5th floor
San Francisco, CA 94105
www.cahanassociates.com

Campbell Fisher Design (CFD)
3333 E. Camelback Road, #200
Phoenix, AZ 85018
www.cfd2k.com

CAPDESIGN
Viale Marconi 82
Potenza 85100
Italy

Chen Design Associates
589 Howard Street, 4th floor
San Francisco, CA 94105
www.chendesign.com

Corporate Reports Inc.
6 Lenox Pointe
Atlanta, GA 30324
www.corporatereport.com

Creative House
317 Adelaide Street West
Studio 801
Toronto, ON M5V 1P9
Canada
www.creativehouse.com

David Evans & Associates
2828 SW Corbett Avenue
Portland, OR 97201
www.deainc.com

Disney Design Group
Feature Animation Building
200 Animation Drive
Lake Buena Vista, FL 32830
www.waltdisneyworld.com

Dogstar
626 54th Street South
Birmingham, AL 35212
www.pavarodney.com

dossiercreative inc.
611 Alexander Street, Ste. 305
Vancouver, BC
Canada V6A 1E1
www.dossiercreative.com

Dutro Communications
P.O. Box 4057
Logan, UT 84323

Emma Wilson Design Company
500 Aurora Avenue North
Seattle, WA 98109
www.emmadesignco.com

Erwin Zinger Graphic Design
Bunnemaheerd 68
Groningen 9737RE
The Netherlands

Geyrhalter Design
6751/2 Rose Avenue
Venice, CA 90291
www.geyrhalter.com

F&W Publications
4700 E. Galbraith Rd.
Cincinnati, OH 45236
www.howdesign.com

Group 55 Marketing
3011 W. Grand Boulevard, Ste. 329
Detroit, MI 48202
www.group55.com

Howry Design Associates
354 Pine Street, 6th floor
San Francisco, CA 94104
www.howry.com

HSR Business to Business
300 E-Business Way, Ste. 500
Cincinnati, OH 45241
www.hsrb2b.com

Hutter Design
2 West 47th Street, 14th floor
New York, NY 10036
www.hutterdesign.com

Jeff Fisher LogoMotives
P.O. Box 17155
Portland, OR 97217
www.jfisherlogomotives.com

Karl Design
Rotlintstrasse 3
Frankfurt, D-60316
Germany

Leftloft
Via Pisacane 57
Milano, IT 20129
Italy

Lewis Moberly
33 Gresse Street
London W1P2LP
United Kingdom

Matite Giovanotte
Via Degu Orgoguosi A5
Forli I 67A00
Italy

Memsis Ltd.
11 University Road
Belfast, BT71NA
Northern Ireland
www.memsis.com

Miaso Design
P.O. Box 31225
Chicago, IL 60631
www.miasodesign.com

Michael Courtney Design
121 East Boston
Seattle, WA 98102
www.michaelcourtneydesign.com

Michael Osborne Design/MOD
444 De Haro Street, Ste. 207
San Francisco, CA 94107
www.modsf.com

NIA Creative
970 Terra Bella Avenue #9
Mountain View, CA 95110
www.niacreative.com

NRTC
2121 Cooperative Way
Herndon, VA 20171

The Observer
119 Farringdon Road
London EC1R 3ER
United Kingdom
www.observer.co.uk

O Design
10540 NW 26th Street, Ste. G201
Miami, FL 33172
www.odesign-firm.com

Pat Taylor Inc.
3540 S Street NW
Washington, DC 20007

Peg Faimon Design
725 High Meadow Lane
Oxford, OH 45056

Ponto P Design
Avenida Niemeyer, 965/701
Rio De Janeiro RJ 22451-221
Brazil

Pow Wow Productions
903 Colorado Ave.
Ste. 220
Santa Monica, CA 90401

Prejean LoBue
305 La Rue France
Lafayette, LA 70508
www.prejeanlobue.com

ProWolfe Partners
1121 Olivette Executive Pkwy.,
Ste. 100
St. Louis, MO 63132
www.prowolfe.com

Q
Sonnenberger Strasse 16
65193 Wiesbaden
Germany
www.q-home.de

Rahmin Eslami Design
4891 Oaklawn Drive, No. 2
Cincinnati, OH 45227
www.rahmineslami.com

Sagmeister Inc.
222 West 14th Street
New York, NY 10011

Savage Design Group
4203 Yoakum Boulevard, 4th floor
Houston, TX 77006
www.savagedesign.com

Smith Design Associates
P.O. Box 8278
Glen Ridge, NJ 07028
www.smithdesign.com

STUDIO INTERNATIONAL
Buconjiceva 43
Zagreb 10000
Croatia

Suka & Friends Design, Inc.
560 Broadway, Ste. 307
New York, NY 10012
www.sukadesign.com

Surburbia Studios
590 Beaver Lake
Victoria, BC V8X 3X1
Canada
www.suburbiastudios.com

StudioNaka
411 Park Avenue, #122
San Jose, CA 95110

TBS Superstation
1050 Techwood Drive
Atlanta, GA 30318
www.tbssuperstation.com

Tharp Did It
50 University Avenue, #21
Los Gatos, CA 95030
www.tharpdidit.com

Thinking Cap Design
10 College Avenue, #200
Appleton, WI 54911
www.thinkingcapdesign.com

Vangool Design + Typography
746-5A Street NW
Calgary, AB T2N 1R4
Canada
www.vangooldesign.com

Vertis/Zoom 180
2004 McGaw
Irvine, CA 92614

Wang Hutner Design
604 Mission Street, 7th floor
San Francisco, CA 94105
www.wanghutner.com

Westlake Advertising Agency
725 Lakefield Road, Ste. D
Westlake Village, CA 91361
www.westlakeadvertising.com

500 Watts
650 Delancey Street, Ste. 413
San Francisco, CA 94107
www.500watts.com

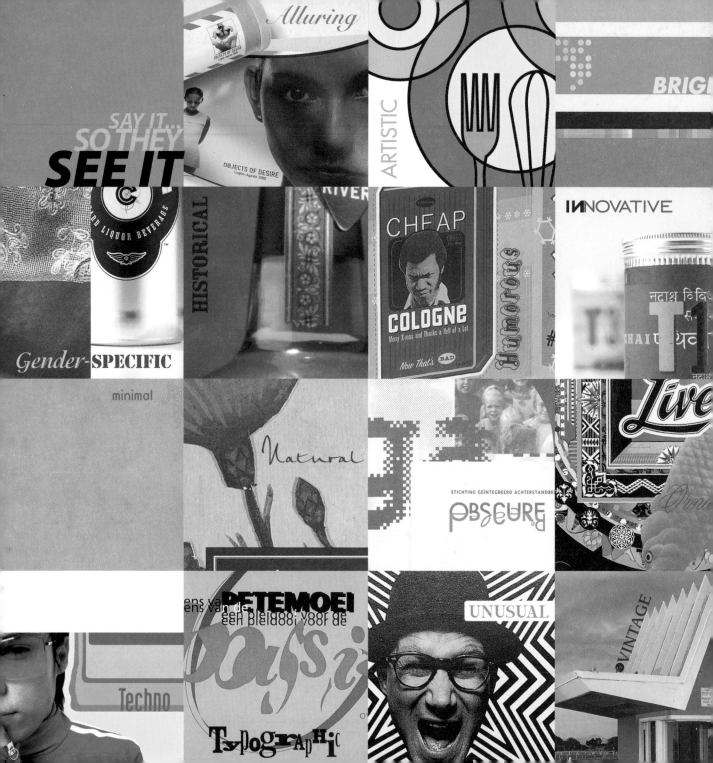